The Digital Museum

The Digital Museum: A Think Guide

Edited by Herminia Din and Phyllis Hecht

Published in cooperation with the Media and Technology Committee,
a Standing Professional Committee of the American Association of Museums

AMERICAN ASSOCIATION OF MUSEUMS

John Strand, Publisher
Lisa Meyerowitz, Associate Editor
Susan v. Levine, Designer

The digital museum : a think guide / edited by Herminia Din and Phyllis Hecht.
 p. cm.
 Includes bibliographical references and index.
 ISBN-13: 978-1-933253-09-1 (pbk. : alk. paper)
 1. Museums--Data processing. 2. Museums--Computer network resources. 3. Museums--Technological innovations. 4. Museum techniques. 5. Digital electronics 6. Digital preservation.
I. Din, Herminia, 1968- II. Hecht, Phyllis, 1951-
 AM133.D54 2007
 069.0285--dc22
 2007034445

CONTENTS

EXHIBITIONS AND ONLINE TECHNOLOGY

THEORY AND EVALUATION

Acknowledgments

In late 2005 we began thinking about the need for a new publication on museums and technology. It was a conversation over coffee with several colleagues at the American Association of Museums (AAM) Annual Meeting in Boston in April 2006, however, that clinched it for us. Everyone agreed that the time was right—in fact urgent—for a new book on the issues surrounding the integration of technology into museum practice. We returned to our homes—in Anchorage and Washington, D.C.—determined to get the project off the ground, to shape the concept, write the proposal and invite contributors. As board members of AAM's Media and Technology Committee since 2002, we had already collaborated on a number of projects, and we knew that despite the distance, we could make this happen. Now, after a whirlwind eighteen months, four time zones and countless hours on Skype, the book has come to fruition.

We could not have accomplished it without the collaboration, expertise and passion of our colleagues, the authors of this publication, to whom we extend our sincere gratitude. We would like to express our appreciation to Selma Thomas, who supported our efforts to build on existing museum literature with this new contribution to the field. We would also like to thank John Strand, Lisa Meyerowitz, Joelle Seligson and Susan v. Levine, of the publications department at AAM, for thoroughly understanding the need for this book, their editorial and design expertise and their words of publishing wisdom throughout the process. Finally, we would like to thank our husbands, Darrell Bailey and Randall Packer, for their support and encouragement throughout the process. We are fortunate to have worked with such a creative, energetic and supportive group of people over the past months, without whom we could not have completed this publication.

Herminia Din and Phyllis Hecht

Preface

In 1997 and 1998 the museum community read
The Wired Museum and *The Virtual and the Real* (both published by the American
Association of Museums) with interest and anticipation. These publications
offered museum professionals and students a glimpse into how technology was
being introduced and integrated into museum life. Museum collections were
being digitized, data integration was being discussed and the World Wide Web
seemed to offer endless possibilities for sharing information. Issues of copyright,
authorship and museum authority became new topics of discussion.

Ten years later, the material in these volumes remains historically significant and
the issues still relevant. In the years since these books were published, however,
the museum experience has changed dramatically; audience expectations have
risen and the museum-going public has increased worldwide. Museums offer
interactive learning experiences and audience participation is encouraged, not
only in the physical space but online as well. Museum professionals are initiating
new methods of distributing content and achieving new levels of outreach into
the community. In the process, they have been compelled to re-examine—
philosophically and practically—the essence of the museum's mission with the
assimilation of technology.

This publication offers museum professionals, museology scholars and museum
studies students an in-depth investigation into how and why museums are
experimenting with new technology. The authors explore a wide range of
concepts about the digital museum from exhibition experiences and online

tools to the strategic integration of technology into daily operations and new business models. Together, these essays also demonstrate the urgent need for the integration of technology into today's museum training programs.

The essays in this book reveal the transformation of historical museum traditions, inspire dialogue and critical thinking and spark the imagination. They are food for thought—a "think guide" for today's museum professionals and for future generations studying museums, technology, communications and other related fields. We hope this book will expand current museum literature and foster an understanding of the evolution of the digital museum.

Herminia Din and Phyllis Hecht

Introduction

Selma Thomas

The current discussion on technology in museums
has been informed by two decades of debate. It takes place within a context
of constant change and adaptive persistence. Contemporary media specialists
engage new formats, new audiences and new protocols, as did their peers ten
and twenty years ago. The essential dichotomy remains between museum—
collector of real objects—and media—electronic approximation of the "real."
But museums, those nineteenth-century monuments to culture and civic pride,
also have become community assets, learning centers and international archives.
Much of this transformation has been stimulated by the digital revolution of the
past ten years.

In this publication, Herminia Din and Phyllis Hecht have invited colleagues with
a wide spectrum of perspectives to share their insights into a dramatically altered
landscape. While the individual chapters cover a range of topics, together they
allow us to consider both the internal and the external aspects of museums. One
might wonder about the shelf life of a book on "the digital museum" but, as
the editors remind us, the focus on technology is really an attempt to examine
museums at a particular moment, a time when the challenge inherent in digital
technologies forces us to consider what it means to be a museum in the twenty-
first century.

After more than four decades of digital formats, technology today is no longer an
isolated tool consulted to accomplish specific tasks. Instead, it has become infra-
structure, essential to all aspects of museum operations and fostering better colla-
boration and access; and, like all infrastructure, digital technology must be suppor-

ted, maintained and replaced when it becomes obsolete. The assertive presence of the digital has forced museum professionals—including curators, collections managers, educators and security officers—to master a new set of tools. It has forced museum administrators to expand their organization charts, to incorporate webmasters and IT managers. More critically, emergent digital technologies have challenged basic museum assumptions, altering the meaning of "audience," "venue," "collections," even "mission." Visitors have become online users, engaging with museums via the Web, where they explore digital collections. At the same time, museums, armed with new digital tools, have imagined a more active role for themselves in community and even international affairs. But, as the essays in this volume make clear, digital technologies are not static, and museums must develop an adaptive if judicious response to these ever-changing tools.

CHANGING BUSINESS

Several authors explore the impact of digital technologies on museum operations, reminding us that technology—no matter what its application—is, first, a management tool. Writer Len Steinbach, for example, suggests a process that might help museums examine the real cost of adopting—or not adopting—new digital formats and advises readers to regard this publication as a "think guide," rather than an outline of best practice. Günter Waibel also recommends an institutional overview, arguing that the increased complexity and volume of digital collections require museums to develop a system-wide coordination of policies, procedures and commitments. Nik Honeysett cautions that any museum engaged in such long-term planning must accept the Internet as a primary vehicle for outreach and build accordingly, committing resources to its digital assets and recognizing the Web as a critical venue.

Because many museums, according to Angela Spinazze, especially small museums, find the actual cost of digital technology beyond their reach, she suggests that open source solutions could instigate cost-effective and productive collaborations. Authors Susan Chun, Michael Jenkins and Robert Stein further explore potential models and opportunities for open source and open access software. Institutional partnerships can help museums—small and large—to develop their digital resources and enrich their online presence, reducing both the cost and complexity of meeting the digital challenge. The same technologies create an opportunity for data collection and evaluation, allowing museums to learn more about their visitors and facilitate closer engagement between institutions and their audiences, a subject that author Sherry Hsi explores.

CHANGING AUDIENCES

The significance of the online museum—to institutions and to their audiences—has been debated from the Internet's earliest days. The second generation of Web tools has only intensified that debate. In the early 1990s, museum professionals worried about the role of the "virtual" museum online. Would it compete with the bricks-and-mortar museum for visitors, funds and programs? Would it dilute the brand of the museum, that monument to civic and cultural pride? Would it demean the value of the collections by circulating tiny pixilated images? Could museums, with their commitment to "real" objects, protect the authenticity of those objects while developing Web-based programming? And what about visitors? Would they want to see the real thing if they could see digital versions of the collections online?

Despite these misgivings, most institutions came to recognize the inexorable presence of the Web, as well as its potential for supporting public programs. Many institutions developed robust interactive sites, inviting visitors to explore online exhibits, examine digital collections and engage in educational activities. Some of their concerns resolved themselves. The quality of digital images—measured in terms of color and clarity—improved significantly. The primacy of the bricks-and-mortar museum endured and, in fact, seemed to lend credibility and authority to the online museum.

Several authors in this book examine the significance of the online museum and, in particular, the online visitor. Deborah Howes notes that museums are uniquely qualified to create appealing Internet programming, as they know how to develop creative content, and suggests activities that museums might develop to foster more online engagement. Matthew MacArthur tackles the issue of authority, noting that visitors trust information coming from museums, and asks, "How is that trust affected if users are allowed to have a greater voice on our websites and even in our galleries?" Jonathan Finkelstein writes that much of that trust is built on personal interaction, citing the "human assets" of museums: tour guides, storytellers, educators, curators. He examines the significance of real-time communication and posits the Web as a gathering place that can support multiple exchanges.

In little more than a decade, the Web has assumed a critical importance to museums, particularly as they relate to audiences. Schoolchildren meet historical characters on electronic fieldtrips. Conservationists examine artifacts and discuss them with curators in a videoconference. Museum educators invite local audiences to create

a podcast or an online exhibition, adding new voices and new interpretations to their public programs. Authors Allegra Burnette and Victoria Lichtendorf interview colleagues and discuss the teen website of the Museum of Modern Art (MoMA) to gain insights into teen-focused programs and the benefits of promoting further connections with teens online. The real significance of online visitors, it seems, is that they have invigorated the relationship between museums and their publics by insisting on an active and responsive pursuit of knowledge.

CHANGING VENUES

Even though the Web has matured into a rich and robust venue that supports manifold functions, the physical museum remains the public face of the institution—housing and exhibiting artifacts and welcoming visitors. The museum exhibition is both the most public and the most traditional form of programming, offering access to artifacts and generating public discourse on related topics. Here the museum invites audiences to explore ideas, stories and collections in an environment that has been carefully curated and designed. In the past three decades, museums have embraced technology as a tool to enhance this environment, giving visitors multiple forms of engagement and narrative paths. Over time technologies will transform the current exhibition experience even more fundamentally.

Several chapters in this volume explore contemporary and emerging technologies to examine both the real and conceptual role of venue. Peter Samis considers the integration of analog and digital technology to create a comprehensive interpretive plan in the museum gallery, suggesting that museums should meet the visitors where they are with what he calls "just-in-time" information. Daniel Spock and Michael Mouw examine the theatrical aspects of exhibitions in their essay, arguing that the digital technologies used to support exhibitions—while dependent on intricate show control—are most appropriately invisible, in quiet service to the story. They describe the museum exhibit as a carefully and artfully crafted environment, a "story theater" that works best by immersing the visitor into an experience.

A new generation of digital technology—handheld devices—promises to alter both the environment and the visitor experience of the exhibition, since it allows visitors to determine the course of their own narrative in ways that the first generation could not support. Authors Robin Dowden and Scott Sayre explore the significance of this development on visitors and galleries. Their analysis of "what used to be called the mobile phone" suggests that the (relatively) recent

shift from analog to digital technology has given visitors the means to personalize their tours of traditional museum offerings. But they remind us that museums can adopt the same tools to create more nuanced educational opportunities.

Mobile devices might challenge the physical boundaries of museum programming, but they also can define a new intellectual range, allowing museums to focus on content development and put the technology, literally, in the hands of the visitor. In this way, they are bringing the protocol of the online museum to site-based programs.

CHANGING WORKPLACES

It might be helpful to recall that interactive media existed before the Web. Museums used laserdiscs and compact discs, controlled by external computers, for almost two decades. These were reliable and responsive tools that allowed curators and educators to develop layered programs in which visitors could follow their own paths of exploration. These programs offered the appearance of interactivity; but, in fact, visitors could follow only those links that had been programmed into the disc. The Web, even in its earliest iteration, rendered these multimedia programs obsolete. By changing the definition and the process of "interactivity," the Web transformed visitor expectations. Where laserdisc programs might invite visitors to choose from one of six selections, the Web offered an endless array of selections. Perhaps more significantly, the interface design of the first interactive programs took their design cues from print and film models. Font, color, graphic design—these mirrored the aesthetics of earlier media. But the Web invented the concept of "browsing," along with a medium-specific set of standards. As museums began constructing their own websites, they also began adapting their in-house multimedia programs. They abandoned the old version of interactivity and replaced it with programs offering direct links to online programs.

The reverberations of this shift were felt in-house, when design staffs grew to accommodate Web programmers and designers, colleagues with new digital skill sets. The first generation of interactive designers was ad hoc, emigrating from print and graphic design to create interfaces for laserdisc and CD platforms. Their replacements came to the job as digital natives and their new programming skills—especially HTML and Flash—quickly became essential tools for museum Web teams. If this chronology seems like ancient history, it still reminds us that technology shifts, no matter how incremental, demand new technology skills, and not every practitioner can adapt intuitively. Museums hoping to leap over the latest digital divide, into Web 2.0 and beyond, will have to review their

organization charts and position descriptions, to evaluate their staffing needs. As Herminia Din and Phyllis Hecht suggest, employee training and retraining in technology is critical if museums want to stay up-to-date with their audiences. While there are various avenues for training, all require institutional commitment and investment. Moreover, as Holly Witchey cautions, staff training must include a discussion on ethics. New technology platforms affect changes in the workplace, and both institutions and individuals need to develop guidelines that help them conduct their business in a professional and ethical manner. Witchey offers several approaches—borrowed from business ethics—for museums to consider.

Several other authors advise museums to look outside their own world for resources, including technical and financial resources, to develop new approaches and new agenda. Susan Edwards and David Schaller, for example, propose that museums—experts in content—partner with digital game developers (and others), borrowing the skills and resources in these for-profit ventures to reach out to younger audiences. Writer Lawrence Swiader, likewise, urges museums to become agents of social change through technology. Swiader describes a multimedia event, which combined a site-specific installation—"wall-sized images of the escalating genocide in Darfur" projected onto the United States Holocaust Memorial Museum's facade—with a live webcast and an ongoing forum on the museum's website, all in the service of social action.

TOWARD THE FUTURE

The presence of digital technology in museums is both pervasive and permanent. While the actual technologies continue to morph, museums will continue to adjust to both the promise and the challenge inherent in digital media. The future, of course, remains to be written, but it is useful to have a "think guide" for museums to lead the way.

The inherent promise of digital technology is improved preservation and access. If an earlier generation of intranet technology fostered multidisciplinary collaboration among departments, the new generation of open source software has the capacity to support stronger institutional partnerships. This cooperation would allow greater inclusion, enabling museums to create an online collaboration that is greater than the sum of its parts and developing a robust digital resource for multiple users.

The very terminology—"users" instead of "visitors"—suggests a more active and inclusive community, one that invites members of various publics to add

their voices to museum programs. It also suggests new roles for museums. They might become agents of social change or community archives; they might become laboratories that help the public master the tools of digital discourse, all in the service of the very traditional, and still meaningful, goals of preservation and access. But even with this altered landscape, museums will continue to produce gallery exhibitions and audiences will continue to welcome them, though the visitor experience will be transformed—perhaps enlivened—by the presence of digital tools.

Digital museums do not exist in a cultural vacuum. Rather, they are cultural and civic institutions, responding and contributing to change, helping their visitors and staff make sense of new tools and directions. Institutions that are uncertain about their mission, goals or audiences will have problems confronting the digital challenge. There is too much choice, too much change and too much uncertainty for museums to remain confused about the implications of the digital age for themselves and their audiences. Hopefully, this volume of essays will help current and future museum professionals to clarify a productive course of action.

Preparing the Next Generation of Museum Professionals

Herminia Din and Phyllis Hecht

Technology-based programs and services abound in museums today, whether the institution's focus is art, history, science, natural history, zoology, youth or general audiences. These new programs range from collection, exhibition and website projects geared to a public audience to event scheduling and membership processes designed for in-house staff. Some of these technology-based initiatives—such as security or building automation systems— are necessary just to open and operate the physical structure every day, while others—websites, podcasts, audio tours and e-mail newsletters—bring in new and diverse audiences or ensure the return of regular visitors. A whole host of other projects cater to distance learners who may never set foot in the building. Museum professionals—both current and new—must consider the infusion of technology taking place in all aspects of museum practice in preparing for a career or future advancement in the field.

TECHNOLOGY GROWTH IN THE MUSEUM

Museums first entered the technological arena in the 1960s with the goal of capturing, standardizing and automating information about collection objects. Registrars and curators were charged with entering text records about the collection into newly created databases. Museums began to organize conferences and discuss the potential of applying computer technology to museum practices. A growing awareness of the challenges associated with this emerging, fast-paced field ensued, and the introduction of technology into museum practice had begun.[1]

Through the next decades, museums experienced a major transition. The initial databases evolved into complex collection management systems that affected policies and processes throughout the museum. Museum staff began to digitize images of objects in their collections. Data dictionaries and metadata entered the museum professional's vocabulary. More computerized systems were introduced into daily life to manage assets such as audio, video, educational content, membership statistics, finances and merchandise, to name a few. The introduction and expansion of these many systems led to innovations in internal museum procedures and workflow. Along with the Internet and digital imaging, these systems also increased opportunities to develop programs (e.g., exhibition kiosks, websites, videoconferencing) that enhance the experience of the museum visitors and reach new and diverse audiences. Meanwhile, museum professionals were faced with the challenge of understanding the potential of these new tools and using them to best support the museum's mission. The digital revolution had arrived in the museum world.

MUSEUM EXPERIENCES THROUGH TECHNOLOGY

It is not unusual today for museum visitors to encounter technology-driven programs immediately upon arrival. An electronic welcome sign in a variety of languages, a digital display presenting the events of the day and a touch-screen kiosk with images, text and maps to help plan a tour for each visitor or family member are all possible options greeting people as they walk through the front door. Venturing further inside, visitors may come upon a theater showing an orientation video, a stand offering audio guides with extensive information or a handheld device that not only provides rich media interpretation but also tracks the visitor's location, customizing content in real time. Walls featuring video screens offer immersive experiences and interactive games on exhibition kiosks engage participants with in-depth information about nearby objects or quizzes on current social issues. A media art installation may give the viewer a glimpse of real-time Internet data reconfigured into an audio and video piece, while other digital exhibits allow visitors to contribute to an artwork using computer equipment nearby. Hands-on activities may afford the opportunity to operate a robot or learn to design a computer chip.

Many of these experiences are designed not only as learning tools but also to promote social interaction among visitors. Digital projections on the exterior of the building may attract a crowd of people to the museum at night, while websites, blogs, wireless technologies and podcasts extend the museum beyond its walls. As the use of technology-driven initiatives in the museum continues to

grow, an ever-increasing demand for new skills, responsibilities and collaborations among museum staff becomes more urgent.

NEW COLLABORATIONS

Each of the above examples involves the cooperation of more than one individual, more than one department and perhaps more than one institution, as well as a variety of skills and experiences. The digital display at a museum entrance with event scheduling information, for instance, may involve the expertise of personnel in the areas of education, marketing, editing, graphic design, installation, digital imaging and information technology. In an ideal setting, architects, designers, computer specialists and usability experts select a perfect location for the digital display and install it within the museum. Many considerations would have gone into this decision, such as network connections, lighting, legibility, accessibility and aesthetics.

Once the display is operable, up-to-date content must be available for delivery to the viewer. A content-provider writes material appropriate for the medium at hand, perhaps inputting this information into a database that is already part of the museum's data strategy plan. The museum's content management system allows for editing, approvals, release and maintenance of the information in a systematized, online workflow. Digital images, appropriately sized and in the correct file format, are selected for display with the text information. The end result is that the museum visitor, who has come to expect easy access to up-to-date, accurate information about events, is presented with such.

With the introduction of technology into the museum, staff at every level and department confront new challenges. As the field continues to evolve and absorb the effects of new media and technology, current museum professionals must continually refresh their skills to reflect this transition and emerging museum professionals must understand what is now required.

NEW ROLES, RESPONSIBILITIES AND CHALLENGES

Museum professionals have been training and retraining since the 1960s to keep up with the demands required by the introduction of new technologies. In our experience, we have seen registrars become collection information managers, graphic designers become Web managers and data processing personnel become systems managers. Meanwhile, curators organize new media exhibitions, archivists explore methods of preserving digital data and educators write content for the Web and develop virtual exhibitions, while legal experts research new

issues of copyright and authorship brought on by the digital age. New challenges continually arise with the growth of technology in the museum.

An informal review of qualifications and responsibilities required in currently posted museum job descriptions reveals the need for an assortment of competencies related to technology, including specific software skills, management, strategic planning and teamwork.[2] Drawing from these postings, **curatorial positions**, for instance, may require experience with cataloguing objects and using automated collection management systems, as well as the ability to conceptualize and realize interactive exhibitions, write text for audio, video and film scripts and work effectively with diverse groups. A **museum educator** may need a strong knowledge of current educational uses of digital media; the ability to develop and oversee all interpretive programming of podcasts, blogs and audio tours; the ability to develop videoconferencing and other distance-learning programs; and a strong interest in working collaboratively. A position for a **communications officer** may require knowledge of best practices in new technology and Web-based marketing; knowledge of print, broadcast and Web media organizations' operating procedures, programs and personnel, as well as skill in writing for such media; and a collaborative management style. A job description for a **collections information manager** often requires knowledge of specific applications and may include significant understanding of information technology and relational database structure including substantial experience with reporting and database software such as Crystal Reports and Powerbuilder, experience with Microsoft Access, Adobe Photoshop and The Museum System (TMS), the ability to develop long-term strategic data management plans and a desire to function in a team environment. **Museum librarian** duties might include experience in applying MARC and other meta scheme alternatives as appropriate, technical skills for the application of appropriate technologies in support of innovative library services, coordination of the library's Web presence and the ability to work as part of a skilled team and communicate with a broad range of library patrons. An **archivist** may need to have strong computer skills for the organization, storage and retrieval of digitized collections and knowledge of best practices and standards for digitization and preservation of library collections. **Development staff** may need to be proficient in database management, spreadsheets and word processing, as well as fundraising and membership software, such as Raisers' Edge. **Exhibition preparators** may be required to run and maintain computerized exhibition areas, design audiovisual systems and show an interest in new media and technology. A **conservator** may be required to understand the importance of digital and electronic media for preservation and delivery purposes. Announcements for

interns and fellows often ask for computer literacy with relevant desktop programs and familiarity with the use of databases.

Taking these job requirements into account, we must consider how current and aspiring museum professionals can obtain the proper training and be best suited for a career in today's museum. How will aspiring museum professionals gain an appreciation for and in-depth knowledge of, not only the power of technology, but also its necessity for the survival of the museum in the twenty-first century?

STRATEGIES NOW AND FOR THE FUTURE

Academic institutions, museums and professional organizations are all integral to the education of the next generation of museum professionals. Over the past decade, museum training has evolved to reflect the changing environment of the museum. The time is now ripe for the next transition: a new venture to prepare museum professionals for the reality of museum operations and structure in today's world. The new model of training we propose involves expanded course curriculum, further integration of higher education and museums, increased faculty and innovative uses of old and new technologies.

Paving the Way

In 1971, the International Committee for the Training of Museum Personnel of the International Council of Museums (ICTOP/ICOM) published the ICOM Basic Syllabus—guidelines for professional training courses in museology and university programs in museum studies. Over the years, this syllabus was updated; however, in 1996, "in response to fundamental changes in the nature and structure of museums worldwide, ICTOP/ICOM established a working party to analyze the implications of the paradigm shift relative to the training and professional development needs of the field."[3] The resulting document, ICOM Curricula Guidelines for Museum Professional Training, which was adopted formally by the ICOM Executive Council in June 2000, addresses the learning needs of museum professionals today and how they might change in the future.[4] Divided into five areas of competency—general competencies, museology, management, public programming and information and collections management and care— the document outlines knowledge and skills critical for museum professionals to have and acquire throughout their careers. Information technology including knowledge of e-mail, websites, multimedia formats and database management is listed as a main topic in the general competencies as necessary for all museum professionals.[5]

One way that aspiring museum professionals can gain these competencies and learn about museum practice is through a variety of degree and certificate programs currently offered throughout the world. Museum studies, museum education and museum informatics are some of the higher education programs available, while library science, arts management, art history, history, anthropology, cultural studies and communication programs, among others, also offer courses of related interest. A review of more than 80 museum-related academic training programs in North America reveals that several museum studies programs have introduced technology training as a component of their curriculum. A few of these programs list technology-related classes specifically as museum studies courses, while others promote cross-departmental instruction with class offerings in programs such as computer science, information management, library science, graphic design, communications or business. As part of the course of study, many programs also require students to intern at a museum to learn specific skills, gain an understanding of the museum culture and obtain hands-on experience.[6]

Beyond formal education and practical internship experience, international, national and local museum-related organizations provide workshops, conferences and symposia to current and aspiring museum professionals.[7] A number of professional organizations specifically concentrate on technology-related issues and challenges faced by museums. Among them, Museum Computer Network (MCN), whose mission is to "help information professionals use technology to serve their institutions," hosts an annual conference, supports special interest groups, maintains a list-serv and offers additional resources to members.[8] The Media and Technology Committee of AAM plans programs for the association's annual conference, sponsors an awards competition (MUSE Awards) for outstanding museum multimedia projects and offers membership services.[9] MCN and the Media and Technology Committee host a blog entitled Musematic that aims to inspire discussion on the latest issues in museum technology.[10] Archives and Museum Informatics, a company that undertakes consulting, publishing and training in the field of cultural heritage, especially for museums, organizes the annual Museums and the Web conference and the International Cultural Heritage Informatics Meeting (ICHIM).[11] Ranging from discussions on digital asset management to evaluating how audiences learn from online content, these organizations have provided vital avenues for professional development.

In reviewing the course offerings of museum-related programs, considering the possibilities for museum internships and researching the activities of professional organizations, it is apparent that an evolution is taking place in the training

of museum professionals. We believe that the time is right to encourage the expansion of training initiatives, while introducing a broader scope of other possibilities.

Strategies for the Future

The importance of technology in the museum should become an integral part of preparing individuals for a museum career, whether students are planning to become registrars, curators, exhibition designers, fundraisers or educators. Training programs for museum professionals must encompass a balanced curriculum that leads to the understanding of the role of technology as it relates to topics such as the museum and society, cultural heritage issues, the creation of audience experiences, intellectual property concerns and information management.

A number of museum studies programs have begun integrating technology into their programs, although it is not yet proliferating. Some programs only offer one or two technology-related classes on a rotating basis. More often, these classes are offered by other disciplines. Students of museums studies might enroll in a library science course to learn about libraries and archives in the digital age or a computer science course to learn about integrated systems. Other museum studies programs have partnered with local training companies outside of the university, enabling students to enroll in workshops that will enhance their technical skills or learn real-life business concepts. Cross-departmental course offerings and partnering with outside companies are a good beginning in providing students with critical knowledge and skills not normally offered in the program. However, we question whether these options incorporate enough instruction that is relevant to the museum field. Will museum studies students gain an extensive understanding of the museum culture and vocabulary from classes in other disciplines? Are there ways to collaborate with other programs to ensure that issues of museum practice are included in the course instruction? Or, from a different perspective, are there ways to incorporate the topics from these cross-departmental classes into the museum studies curriculum itself? Although this option would involve expanding museum studies programs and require more resources, the training provided would ensure alignment with museum goals and current museum practice.

The addition of qualified faculty is a necessary step toward expanding museum studies programs. Some programs have already gone beyond traditional educators to hire museum professionals to extend the curriculum and bring practical experience to the classroom. Others have begun to incorporate online, distance

learning into the curriculum or to investigate the capabilities of the Internet2 network for video conferencing and communication.[12] These models not only introduce technology directly into the learning environment but also expand faculty resources to a global community of educators.

Providing hands–on experience for museum studies students is another critical aspect in preparing the next generation of museum professionals. The creation of specialized computer laboratory spaces could allow students to experiment with cutting-edge technologies, dramatically enhancing their skill sets and inspiring creative thinking. Teaming up with a local museum for student and professional collaborations beyond required internships could also provide necessary hands-on experience and benefit the museum and student alike. Today's students may come prepared with more specific technical skills than the in-house staff, while museum personnel can offer students mentoring opportunities and a view of daily operations. As students observe how audiences are served and how business processes work, the synergy between museum staff and students can inspire critical thinking and innovative ideas.

CONCLUSION

In 1997, multiple authors of *The Wired Museum* advocated technology training for museum professionals, stressing the need for acquiring computer skills, understanding the tools and knowing how to apply them. According to contributor Guy Hermann, "Users need to be taught about new technologies gradually, consistently, and persistently."[13] This is still true; however, as technology's effect on museums' business processes and strategic planning grows, staff need to understand the role of technology even more urgently. The training in specific technical skills is still important, but the focus should now be on understanding the conceptual underpinnings of technology in the museum.

Preparing for a career in the museum field today requires a convergence of academic and technical skill training, formal and informal learning, internships, fellowships, membership in professional organizations, networking with peers and colleagues and seeking out mentors. It requires an innovative multilevel approach in order to keep up with the museum's changing landscape. The integration of technology into all aspects of today's training is critical to the future success of the next generation of museum professionals and to the survival of the twenty-first-century museum.

NOTES

1. Katherine Jones-Garmil, "Laying the Foundation: Three Decades of Computer Technology in the Museum," in *The Wired Museum*, ed., Katherine Jones-Garmil (Washington, D.C.: American Association of Museums, 1997), 35–62.

2. Taken from selected excerpts of job descriptions from American Association of Museums' JobHQ, www.aam-us.org/aviso/index.cfm (accessed February 6, 2007) and Museum Employment Resource Center, www.museum-employment.com (accessed January 13, 2007).

3. See http://museumstudies.si.edu/ICOM-ICTOP/dev.htm (accessed January 11, 2007).

4. Ibid.

5. Ibid.

6. A comprehensive listing of museum studies programs can be found on the website of the Smithsonian Center for Education and Museum Studies (SCEMS), http://museumstudies.si.edu (accessed June 19, 2007).

7. The website of the American Association of Museums (AAM), www.aam-us.org, offers links to numerous organizations, such as AAM's Standing Professional Committees (SPCs), which represent specific disciplines, and Professional Interest Committees (PICs), which enable people and institutions with common interests or needs to develop professional associations. The website also lists regional associations and affiliate organizations.

8. Museum Computer Network (MCN), www.mcn.edu.

9. The Media and Technology Committee of AAM, www.mediaandtechnology.org.

10. Musematic, www.musematic.net.

11. Archives and Museum Informatics, www.archimuse.com.

12. Internet2 is a networking consortium that facilitates the development, deployment, and use of advanced Internet technologies. See www.internet2.edu/ (accessed June 19, 2007).

13. Guy Hermann, "Shortcuts to Oz," in *Wired Museum*, 90.

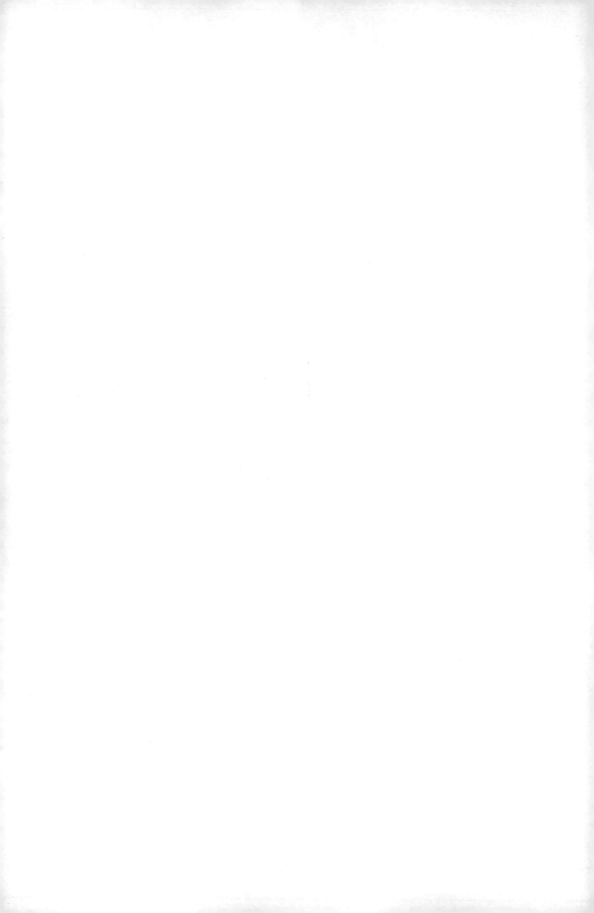

New Technologies as Part of a Comprehensive Interpretive Plan

Peter Samis

The problem: creating a semantic context for perception. In the first half of the twentieth century, museum curators and directors from Alfred Barr in New York to Grace McCann Morley in San Francisco knew that the meanings of the art of their time were far from self-evident, even to the educated Americans whom they hoped to cultivate as an audience. To be an advocate of modern art in those times was to act as an evangelist and an educator, alternately writing scholarly tomes and popularizing pamphlets, and devising innovative educational displays for use in the galleries and circulation on the road.

By the 1960s and 1970s, the gallery space had been pared back to a pristine white cube where, to quote Brian O'Doherty:

> Art exists in a kind of eternity of display, and though there is lots of "period" (late modern), there is no time. This eternity gives the gallery a limbo-like status: one has to have died already to be there. Indeed the presence of that odd piece of furniture, your own body, seems superfluous, an intrusion.[1]

Happily, in the twenty-first century, there are still embodied humans walking around art museums, and it is with these vibrant and varied individuals in mind that a museum might approach designing an interpretive plan.

Traditionally, interpretive plans have described for whom, how and why a museum interprets its collection, though not necessarily in that order. They acknowledge the diversity of visitors, both in their backgrounds and entrance

narratives—the stories people tell themselves of why they go to the museum and what they hope to get out of it. Ideally, they propose a variety of strategies tailored to a range of learning styles. And they often itemize optimal standards adopted by that institution as to tone of voice, type size and wall text length, multiple languages and other accessibility features.

Of course readers of this book are well aware that since the 1990s, museum interpretive initiatives are no longer confined to the traditional analog array of exhibition didactics. Digital technologies have invaded every aspect of our lives, and museum galleries, while they may be holdouts, are no exception. So what is the state-of-the-art in museum interpretation in 2007? What mix of analog and digital? Does it entail every trendy device—each "next new thing"—that comes our way? To what end? What does current research show our visitors respond to most? What do they expect from us? How can we augment their experience in our galleries most meaningfully, least invasively? This essay provides early answers to these questions, with examples.

Consider the following interpretive principles endorsed by Tate Modern in 2004:

- Interpretation is at the heart of the gallery's mission.
- Works of art do not have self-evident meanings.
- Works of art have a capacity for multiple readings and interpretation should make visitors aware of the subjectivity of any interpretive text.
- Interpretation embraces a willingness to experiment with new ideas.
- We recognize the validity of diverse audience responses to works of art.
- Interpretation should incorporate a wide spectrum of voices and opinions from inside and outside the institution.
- Visitors are encouraged to link unfamiliar artworks with their everyday experience.[2]

The first rule of thumb in devising an interpretive plan for your museum is to put yourself in your visitors' shoes—through direct observation, research (including interviews and/or focus groups) and openhearted empathy. Observation tells us that most visitors have developed well-established patterns in their use of museums. They read the wall texts we provide (whether they derive much benefit from them is another question), they rely on extended object labels (often too much, to the detriment of direct observation), they pick up brochures, some take audio tours. In fact, as of this writing, visitors consistently perform all of these activities in far greater numbers than they use computers, personal digital

assistants (PDAs) or other new media appliances.[3] With that humbling datum in mind, let us approach our problem—no, opportunity—space!

VISUAL VELCRO: HOOKING OUR VISITORS WHERE THEY ARE

When do people most want information regarding the artworks in an exhibition? Some—more and more, in fact—want information in advance of their visit to the galleries, via the Web, and a smaller number will take the time to return to the museum's website after their visit to learn more. But the vast majority of visitors want their information "just in time," when they're standing in front of the work. This need focuses our attention in planning for interpretive resources. If, as cognitive psychologists inform us, once a single "chunk" of information enters Short-Term Memory (STM), "[it] has between 3 and 20 seconds to reach Long-Term Memory [LTM]," our window of opportunity to hook into this new sensation is assuredly small. However, "Nothing enters LTM from STM unless it can be related, however tangentially, to something already in LTM."[4]

To illustrate, let us imagine the humble Velcro patch. It consists of a strip of tiny loops, originally inspired by a burr caught in dog fur or velvet's fuzzy surface.[5] Now imagine a sensory impression, in this case an artwork, arriving in your perceptual field. Unless the visual impression has a hook that can fit into one of the loops on your specific LTM "patch," it will glide right by and be forever forgotten. If there is something in the artwork, however, that strikes you—a figure, a vivid color, a bodily sensation resulting from the artwork's massive or minuscule scale, a memory trigger or implied narrative connection—then we can say that artwork has "Visual Velcro."[6] It has hooked into your cognitive structure and stands a chance of remaining in your memory.

Famous artworks have had the receptive Velcro surface primed in advance by repetition and media saturation: Extreme cases would be the Mona Lisa, van Gogh's self-portraits, Dalí's watches or Warhol's soup cans. But most artworks do not benefit from this Madison Avenue-like advance exposure. They live or die on the strength of the impression they make in the moment you stand before them. Different works in our galleries have varying degrees of Visual Velcro. (In the old days, we might have said some works are "more accessible" than others.) And while certain hooks are universal—anything with a face matches our internal wiring, for instance—others are generation- or culture-specific. Still other works seem as if they were made from a different miracle material of the mid-twentieth century: Teflon. Much of the minimalist art of the 1960s, for instance, still leaves viewers baffled. Their gaze just slips right off of it and on to the next

piece . . . and shortly thereafter, out of the gallery. But once a visitor has some scaffolding, the very pieces that seemed to merit no attention can become fascinating sensory experiences.[7]

The work of interpretation, then, is to give cognitive hooks to the hookless, and assure that these hooks are sufficiently varied so that they can successfully land in the mental fabric of a broad array of visitors. Once visitors have a framework, all kinds of sensory impressions, emotions and reflections can weave themselves into the fabric of perception. In fact, the more you know about a subject, the more you can learn about it (presuming the mental model you are working with accommodates the new information).[8]

USE OF MOBILE DEVICES FOR INTERPRETATION

The time-honored interpretive solutions in art museums over the past several decades have been wall texts, object labels and audio guides. Audio tours are specifically designed to fill the need for artwork-specific information just in time as you are standing in front of a work. They are typically lightweight and, when worn on a lanyard with headphones, leave your hands free. Yet research repeatedly shows that most people prefer not to take them. Only in blockbuster exhibitions does device usage go way up: as high as 30–60 percent of visitors. The thinking seems to be: "This is a once-in-a-lifetime opportunity. I made a special trip to see these [Egyptian mummies/relics of the *Titanic*/masterpieces by van Gogh/ Monet/Renoir], which will not be brought together again—the press assures me—for at least 20 years, so I had better get the most out of the hour I spend with them now." The decision to rent a tour is thus born of the confluence of two mutually reinforcing demand curves: the first born of a lifetime familiarity with the exhibition subject at a distance, the second of the need to get just-in-time information in the object's presence.[9]

Price is clearly a barrier to entry. With museum admission prices heading into the $20 range, laying out additional dollars for audio interpretation ironically feels more like a frill than a way to get the most value for your time and money. That is why museums like New York's Museum of Modern Art (MoMA) and the Whitney now offer free audio tours. Both institutions report that free tours for their permanent collection are used far more than pay tours in other institutions.

Age and form (the type of technology) are other discriminating factors. Research shows that visitors under 40 are far less likely to take an audio guide. That said, in a recent study, 79 percent of visitors owning MP3 players, who skew heavily

toward the under–35 set, said they would be more likely to download a tour to their own personal hardware.[10] In a recent experiment at San Francisco Museum of Modern Art (SFMOMA), visitors under 40 rated the podcast and cell phone versions of the audio tour 6.2 and 6.0, respectively, on a scale of 1 to 7—higher than the older users rated the "traditional" audio tour. The reasons cited included the ability to access information on demand, familiarity and comfort with the device and low or free cost.[11]

In fact, the tour these visitors accessed—either via downloadable podcast or cell phone—was virtually identical to that offered on the traditional audio tour. The only difference was the format in which it was delivered. An opportunity clearly exists to package and promote interpretive and contextual enhancement to visitors in this younger demographic in a way that synchronizes with their self-image and lifestyle.

Since 2001, many museums have developed PDA prototypes; fewer have found the format sustainable. SFMOMA first delivered artist videos on PDAs in its "Points of Departure" exhibition. Tate Modern has been offering handheld multimedia tours via PDA to their visitors since 2002. Perhaps the most effective aspect of these devices is not so much their ability to deliver video on demand but the way they extend the standard audio tour through their "Touch and Listen" feature (Fig. 1).

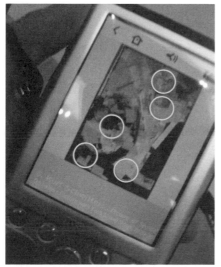

Figure 1. Tate Modern and Antenna Audio's "Touch and Listen" feature highlights information about art in the collection. *Photo by Peter Samis.*

This template enables visitors to use the image of the artwork onscreen as an interface to call up short commentaries about different aspects of the object they are observing. It is as if they were there with a curator or informed friend, pointing at the artwork and saying, "Tell me about this part" and "What about that?" The experience comes close to a conversation in its give-and-take rhythm; rather than getting stuck with an overlong commentary, the user initiates each request for more information—and that information is reliably targeted to specific regions of the artwork, following William Carlos

Williams's edict "No ideas but in things." When the voice talks, nothing happens onscreen: All the drama is in the object itself. The PDA is simply an intuitive, indexical form of visual menu.

Originally, these pilot multimedia tours were free of charge and focused specifically on the permanent collection; now they accompany special exhibitions as well and are offered for a fee. While price is surely a barrier and people hesitate to sign on, not knowing what they will be getting, those who actually take the tours give them enthusiastic reviews. Among the findings from a recent study conducted during a "Frida Kahlo" exhibition:

- Visitors looked longer, noticed detail, understood more.
- Audio commentary "guided your eyes" around the painting.
- Majority felt the guide encouraged them to spend longer in the exhibition.[12]

In this study, the time-honored wall label was criticized as a negative example: "The plaques by the side of paintings can be a bit distracting; with these [multimedia tours] you can look and listen." Similarly, in a recent Whitney Museum study, a visitor testified as to how a simpler, non-multimedia audio tour served to focus her attention on the specifics of an artwork:

> Well, you have a tendency, your eyes have a tendency to see everything in the room, so your eyes can be easily distracted by something else that you see, rather than, when you're forced to listen to something, you're actually looking at every detail in the painting or sculpture rather than, you know, glancing over things and ignoring them or forgetting them.[13]

In a tracking and timing study conducted at the Detroit Institute of Arts, museum curators, administrators and staff were asked how long they hoped visitors would spend in a given exhibition. Then, to add a dose of sobriety, they were asked how long they expected visitors to spend.[14] The results follow:

Hopes	20 minutes
Expectations	15
Actual (mean)	4:16
Actual (median)	3:20

Speaking of time commitments, initial research suggests very different profiles for those who take standard audio tours and those who choose instead to access

the same audio commentaries just in time on their cell phones. Older, veteran museum-goers who swear by audio guides choose them because the tours offer a customized "bubble" experience that will saturate them with sound and insight for 45 minutes or more and ensure they get full value from their exhibition investment. Cell phone tour users, on the other hand, seem to want to preserve their independence: they are more comfortable with an à la carte, "cafeteria-style" alternative, where they can call up and get on-demand doses of information about specific objects—at this point, without cost. No commitment required: They get to shape their experience, and their information flows, as they go.

So what does the future hold in store for the handheld tour? Millions of dollars have been spent on the quest for the holy grail of Wi-Fi "anytime, anywhere" push access, just so visitors do not have to use onscreen menus or enter object numbers to trigger the playback of multimedia content. It now appears certain that PDAs, which once enjoyed an aura of manifest destiny as the next museum interpretive device, are not long for this world—destined instead to give way to iPods, smartphones and, as of June 2007, that new synthesis, the iPhone. So the watchword in planning would be "Design for Experience, Not for Hardware."[15]

The surest way to hew true to that adage is to develop content that is hardware-independent, and not beholden to any one vendor or particular technology. In fact, the more that a museum's content obeys Web standards, the more likely it will play on visitors' own constantly evolving hardware, relieving museums of the headache of stocking, sustaining or leasing a fleet of aging players for their visitors.

What people really need, to use Second Story Interactive Studios cofounder Brad Johnson's term, is "on-demand variable mediation," not a single choice-point when they enter the museum—to rent an audio tour or not—but rather a series of available resources all along their route.[16]

FIXED-POSITION GALLERY INTERACTIVES

While handhelds offer the promise of mobility, most museum visitors do not want to walk through a museum with a custom tour or a cell phone held to their ear. For these other visitors, another class of interpretive technology—smart tables and other fixed-position gallery interactives—offers many benefits.

Smart tables first saw public use in MoMA's 1999 "Un-Private House" exhibition. Flavia Sparacino of the MIT Media Lab worked with MoMA and Cambridge-based NearLife to develop a circular sit-down table within the exhibition space.

When users moved a coaster bearing the image of one of the project houses to their "place setting" at the table, its RFID tag was read, identifying the project and triggering a projection of floor plans or related video commentaries on the table in front of them; these projections could in turn be sent to the lazy susan at the table's center, which was then rotated for others to share.[17]

A simpler, far more off-the-shelf implementation of a smart table idea took place in SFMOMA's 2001 exhibition "Points of Departure: Connecting with Contemporary Art."[18] Basically upturned touch screen kiosks in a piece of blond wood furniture that blended with the gallery, these tables aimed to augment static wall texts with living, breathing personalities that connected visitors just in time with artists and curators, and, through them, with distinctive perspectives concerning the art on display (Fig. 2).

The tables' content comprised three levels, corresponding to three sets of voices and kinds of questions:

Level	Speakers/Agents	Questions
1	Curator Videos	Why would anyone make this? What is it doing in this big important building?
2	Artist Videos	Why did I make this? How did I make this?
3	Visitor Activity	What would you be doing if you made this?

Each smart table was tailored to offer a 3–5 minute experience for the average visitor—though they contained about 20 minutes of content if all levels were fully explored.[19] They only treated the artworks visible in their immediate vicinity; to hear about artworks in other parts of the exhibition, you had to use the smart tables in those zones. The presence of actual curators and a lightness and variety of tone provided a welcome departure from the faceless, anonymous museum voice so common to museum wall texts. Curatorial commentary was ruthlessly pruned to sound-byte length, enabling the editing of multiple perspectives into each table. The artist videos were much appreciated by the visitors, as were the activities that gave visitors the chance to try out the artistic concepts.

Since that time, other museums such as the Indianapolis Museum of Art (IMA) and the Churchill Museum and Cabinet War Rooms in London have deployed far more technologically ambitious interactive tables to serve as a catalyst for group or collective experience. The IMA's "etx Perceptable," situated in what

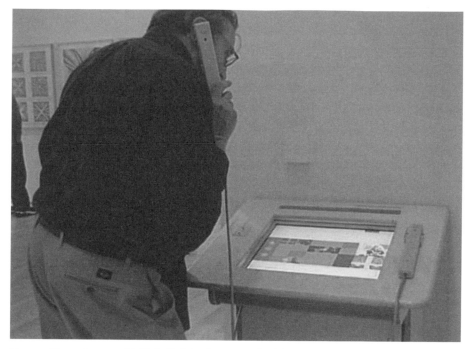

Figure 2. Man using smart table in "Points of Departure" exhibition, 2001, SFMOMA. *Photo by Peter Samis.*

was then called its "X-Room," allowed visitors to place one of three paddle-like tools over a changing array of artworks projected on a tabletop to trigger either associated artworks, interpretive information or maps displaying the artwork's location.

The Churchill Museum's "Lifeline Table" creates a 19-foot-long visual interface to a database of documents, photos, journals and letters that chronicle Winston Churchill's 90-year life (Fig. 3). Certain dates, often unknown in advance to users, trigger rewards or "Easter eggs," light and sound animations that spread across the table.

Tables of this scale dominate the gallery and so far have been almost exclusively deployed in history museums. It is unclear as of this writing how and when they might be adapted to an art museum setting.[20]

Other types of digital interactives that have worked remarkably well in art museum settings include the Philadelphia Museum of Art's interactive scroll and ceramic bowl facsimiles, which offer visitors a "kinaesthetic" experience of Japanese artifacts, and the Cleveland Museum of Art's wall-mounted, touch-screen exploration of the hidden layers of its early Picasso painting, *La Vie.*

Figure 3. The interactive Lifeline Table at the Winston Churchill Museum in London allows visitors to pass their fingers along touch strips at the table's edge to open virtual file folders containing documents about specific dates in Churchill's life. It is especially riveting as a chronicle of the day-by-day unfolding of World War II. *Photo by Peter Samis.*

DIVERSIFYING THE MENU: LEARNING LOUNGES AND INFOCAFÉS

Integrating the benefits of just-in-time context provided by educational technologies within the social spaces of the museum leads to what may be the next frontier: the design of interactive spaces where both analog and digital resources are available to enhance visitor experience.

At SFMOMA we have integrated "Learning Lounges" in two exhibitions since 2006. Visitor observation, surveys and interviews reliably indicate that these learning spaces work: They make the whole exhibition more meaningful. While exploring an exhibition, many cognitive threads open up; a learning lounge gives visitors the opportunity to reflect and review, to augment their emergent understandings while still in an art space, before they have to resume the hectic pace of the outside world. This is the point of maximum "wanting to know"—and the opportunity to hook the artworks into the fabric of viewers' lives.

Interestingly SFMOMA's research shows that use of analog resources trumps the digital in these hybrid lounges. People are far more likely to watch the artist video and read the illustrated FAQs on the walls than to sit down at a computer kiosk. Years of museum-going and a society that processes knowledge through video apparently predispose people to prioritize certain forms of literacy. Visitors

who do sit down at the computers often spend a long time there and rate them highly, but others say the computers remind them too much of work and require too much effort. Compared to straight linear video where all the decisions have been made, they do require effort. You must choose and choose again—and navigationally speaking, the kiosks are a bit of an unknown quantity. (That said, when no dedicated artist video exists, kiosk usage goes up considerably.)

I have a theory—which has not yet been put to the test—that something akin to the old Marshall McLuhan distinction between hot and cool media is at play here.[21] Art is hot and wall text and graphics are hot—they are familiar, almost handmade. But the glass pane of flat screen computer displays is cool. It speaks of a world quite remote from the handmade warmth in the galleries. So one can understand why some visitors—especially older ones—who come to the art museum to restore their souls by contact with something handmade and personal would shun technologies in this liminal zone. They might go home and check out the same program on the Web, but that is after they have left this place of refuge. As for the artist video, it may be playing on a similar flat screen, but it is made hot by the presence of the artist—the one who made all the objects you have just seen.

Video, text, graphics and seating all come together at Paris's new Musée du Quai Branly. There, a freestanding, leather-covered interpretive wall snakes like a spine through the heart of the permanent collection galleries, blending analog and digital resources with raised, texture-mapped graphics and commentaries in Braille for the visually impaired (Fig. 4).

In London, Tate Modern routinely posts exhibition-related wall graphics—and sometimes videos—to the wall of its upstairs café. The museum recently collaborated with Ab Rogers Design to develop a "Learning Zone" on the fifth-floor landing adjacent to the permanent collection galleries. The zone's bright red, high-impact plastic furnishings serve as a magnet for teen and 20-something audiences, who go there to play free association games with artworks, brief themselves on artists and movements through witty multimedia kiosks and catch a revolving selection of video screenings. Informality and participation are key here: heavy-handed, musty pedagogy has been banned, and visitor viewpoints are actively solicited via note cards, then filtered and posted in a set of hanging red bulletin board frames.

Learning lounges are inherently social spaces. Their use is not restricted to an individual, as audio tours often are. Moreover, they enable another behavior:

People use not just one or two interpretive resources but four, five or six—and the more they use, the more highly they rate the exhibition, and the more meaningful they say the art is for them.[22] There is clearly no single magic bullet. People are inherently diverse in their learning styles, generational inclinations, entrance narratives and comfort levels with the objects we present—but zones like these that combine analog and digital resources help to weave a cognitive-emotive tapestry around the artworks that invites and structures engaged inquiry. Through such environments we welcome and meet our visitors where they are.

ADDING THE HUMAN ELEMENT

While we are on the topic of social learning environments, let us not forget that museums have another interpretive asset in the galleries beyond object labels, wall texts, audio, video and computers: PEOPLE! Curators, museum educators, docents and animators of various stripes all serve as the ultimate analog interactive device: context-sensitive, responsive to visitor questions and observations in real time, with built-in Artificial Intelligence (AI)—minus the "A." The major drawback is that these in-person tours, even if offered several times a day, do not reach the majority of visitors.

More and more museums are experimenting with either replacing or supplementing their in-gallery security personnel with gallery attendants who know something about art and are encouraged to respond to visitor questions and converse with them about the works, all the while keeping their eyes on the objects. This extension of the museum guard's vocation beyond simple asset protection holds great promise, as gallery attendants are typically the only museum staff with whom our visitors come into contact when they are looking at art. Institutions ranging from the Phillips Collection to Tate, the Walker Art Center and the San Jose Museum of Art have seen fit to hire art students or artists to work in their galleries. The Guggenheim has adopted a hybrid solution, employing gallery guides to converse casually with visitors about the art even while they retain their traditional guard staff.[23] At SITE Santa Fe, a contemporary art space in New Mexico, the gallery attendants have been trained in Visual Thinking Strategies so they may facilitate visitors' interactions with a changing array of cutting-edge, contemporary art.[24]

Figure 4. At the Musée du Quai Branly, Paris, a leather wall (on the right) snakes through the entire length of the exhibition like a river, proposing a variety of analog and digital resources as well as seating, texts in Braille and raised texture maps related to the artworks exhibited nearby. *Photo by Peter Samis.*

CONCLUSION

Interpretive practice has clearly evolved and diversified over the past ten years to include an array of in-museum digital devices, both mobile and fixed. Yet none of these has supplanted those time-honored staples of gallery interpretation: wall texts, object labels and live tours. Surveys show that analog resources are still, along with linear film and video, the most frequently utilized interpretive resources in our museums—even if they are not necessarily the most highly rated![25] The discrepancy between visitor use patterns and satisfaction ratings is clear indication that a "teachable moment" is at hand. Research shows that visitor experiences are largely shaped by visitor expectations;[26] it follows that museums themselves must alter visitor expectations by actively promoting innovative interpretive resources as an essential part of the museum experience. The phenomenon may be partly generational: As we transition from a paper-centric generation to one of digital natives, the printed word may lose some of its primacy, and technology use will feel more natural. But as of this writing, a hybrid palette of complementary resources—both analog and digital—seems to offer the best chance of giving our visitors a cognitive scaffolding that hones their confidence and builds their capacity to experience even the most unfamiliar and challenging art.

NOTES

1. Brian O'Doherty, *Inside the White Cube: The Ideology of the Gallery Space* (San Francisco: Lapis Press, 1986), 15. (Originally published in *Artforum* in 1976.)

2. Gillian Wilson, "Multimedia Tour Programme at Tate Modern," in David Bearman and Jennifer Trant, eds., *Museums and the Web 2004,* conference proceedings (Toronto: Archives and Museum Informatics, 2004), www.archimuse.com/mw2004/papers/wilson/wilson.html.

3. Three recent studies conducted at the San Francisco Museum of Modern Art have consistently borne this out: Randi Korn and Associates, *Matthew Barney: DRAWING RE-STRAINT Interactive Educational Technologies & Interpretation Initiative Evaluation* (San Francisco: SFMOMA, 2006), www.sfmoma.org/whoweare/research_projects/barney/RKA_2006_SFMOMA_Barney_distribution.pdf; Marco Moncalvo, "Matthew Barney Learning Lounge: Visitor Monitoring Data, Analysis and Direct Observation Notes," (Internal document, SFMOMA, October 2006); and Mauricio Estrada-Muñoz, "Anselm Kiefer Learning Lounge: Visitor-Monitoring Data, Analysis and Direct Observation-based Notes," (Internal document, SFMOMA, February 2007).

4. S. Jay Samuels, "Some Essential Label-Writing Considerations for Museum Professionals: A Review of How People Learn and Remember, and What Kinds of Texts Are Most Effective." Paper commissioned by the Minneapolis Institute of Arts, 1988: 7–26. Cited in "Interpretation at the Minneapolis Institute of Arts: Policy and Practice," The 1993 Interdivisional Committee on Interpretation (Internal document).

5. For the tale of the invention of Velcro by Swiss engineer Georges de Mestral, see Wikipedia. "Velcro," *Wikipedia, The Free Encyclopedia*, http://en.wikipedia.org/w/index.php?title=Velcro&oldid=126397829 (accessed April 28, 2007).

6. My thanks to Mimi Michaelson for helping coin the concept of "Visual Velcro" during a series of conversations back in the 1990s.

7. To cite extreme examples, there is a world of difference between the mammoth scale, rich textures, complex materiality and plunging perspectives of a painting by Anselm Kiefer and the smooth touchless surfaces of a sculpture by Donald Judd. Similarly, Bill Viola's video works engage even novice viewers through a combination of human scale, recognizable characters and implied narrative. Nothing hooks us better than a story. Once viewers are hooked, they will follow you anywhere . . . or at least stay for a while. They have become *engaged viewers.*

8. As Thomas Kuhn theorized decades ago in his landmark *Structure of Scientific Revolutions,* some mental models, or paradigms, are more fruitful than others. A paradigm stands or falls on how comprehensively it encompasses the data available in the field it is intended to explain. If it excludes critical data, it probably needs revision. Thomas S. Kuhn, *The Structure of Scientific Revolutions,* 3rd ed. (Chicago: University of Chicago Press, 1996).

9. Unfortunately, no such calculus operates in exhibitions where the artist or exhibition topic is not famous. You might think people would come to the museum, see there is a special exhibition about an unfamiliar topic or artist, and say to themselves: "Well here's an opportunity to learn something new about a topic that is clearly important—it's on view here at the museum—but about which I know very little. I'll take an audio tour to fill in the gaps in my knowledge." However, it doesn't work this way. There is simply no prior, pent-up demand.

Experience shows that people may duck into the galleries, stroll around a bit and visually take in the unfamiliar material, but they are extremely unlikely to pay for a tour. A recent Antenna Audio study put it this way: "[Of those who take them], about two-thirds take audio guides only occasionally, choosing to use a guide when they are especially interested in the subject matter or if the price is right." Discovery Communications, Inc. *Antenna Audio Global Visitor Survey* (Unpublished study for internal and client use, 2006).

10. Discovery Communications (2006).

11. Randi Korn and Associates (2006).

12. TWResearch. "Evaluation of a Multimedia Guide Accompanying the Frida Kahlo Exhibition" (Unpublished evaluation report by TWResearch for Tate Modern, London, August 2005).

13. Jeffrey K. Smith, Izabella Waszkielewicz, Kathryn Potts and Benjamin K. Smith, "Visitors and the Audio Program" (Unpublished evaluation report for Whitney Museum of American Art, New York, December 2004).

14. Matthew Sikora and Kenneth Morris, "Gathering Visitor Feedback to Exhibition Design Before Designing the Exhibition" (Michigan Museums Association Annual Conference, Detroit, October 2005).

15. Gyroscope, Inc., "Museums in Transition: Emerging Technologies as Tools for Free-Choice Learning" (Richmond: Science Museum of Virginia and Gyroscope, Inc., 2006), 26, www.gyroscopeinc.com/News/articles/MuseumsInTransition.pdf.

16. Oakland Museum of California, *Creative Technology Colloquium* (Oakland: Oakland Museum of California, 2006), 18–19.

17. O. Omojola, "An Installation of Interactive Furniture," *IBM Systems Journal* 39 (2000), 3–4; and Flavia Sparacino, Kent Larson, Ron MacNeil, Glorianna Davenport, Alex Pentland, "Technologies and Methods for Interactive Exhibit Design: From Wireless Object and Body Tracking to Wearable Computers," www.archimuse.com/publishing/ichim99/sparacino.pdf.

18. The exhibition was the result of a unique collaboration between curatorial and education departments and benefited from the support of outside partners such as MIT's Media Lab, Steelcase, and Compaq. In the final analysis, the SFMOMA smart tables were not "smart" in the MIT sense; they only appeared smart to gallery visitors because they had a menu of engaging talking heads cycling through them.

19. Taken together, the six tables contained a total of two hours of content. For a more complete description of the "Points of Departure" exhibition and its development process, see Peter S. Samis, "Points of Departure: Curators and Educators Collaborate to Prototype a 'Museum of the Future,'" in *International Cultural Heritage Informatics Meeting: Cultural Heritage and Technologies in the Third Millennium,* vol. I, full papers, eds., David Bearman and Franca Garzotto (Milan: Politecnico di Milano, 2001), 623–638.

20. Second Story Interactive Studios has recently developed a new and equally ambitious interactive table for the National World War I Museum in Kansas City, Mo.

21. Marshall McLuhan, *Understanding Media: The Extensions of Man* (Cambridge: MIT Press, 1994). In a 1965 CBC television interview, McLuhan stated that "cool" characterized "a medium that uses all of you, but leaves you detached in the act of using you," http://archives.cbc.ca/IDC-1-74-342-1818/people/mcluhan/clip4.

22. What's more, in SFMOMA's Matthew Barney study, people familiar with Matthew Barney were *more* likely to use all these resources than people who had never heard of him. This echoes the rule I mentioned before, that people avail themselves of an interpretive resource like an audio guide if they already know something about the subject. Counterintuitive perhaps, but there it is. For a more in-depth evaluation of the range of interpretive devices and resources offered in SFMOMA's Matthew Barney exhibition, see Peter Samis, "Petroleum Jelly Served Seven Ways: Visitor Response to a Multi-Track Interpretive Approach to 'Matthew Barney: DRAWING RESTRAINT,'" in the proceedings of Museums and the Web 2007.

23. Ted Loos, "ART: Hi, Let's Talk Art. No, Really. It's My Job," *New York Times*, August 6, 2006.

24. See www.vue.org.

25. In the Randi Korn evaluation of interpretive resources for the "Matthew Barney" exhibition cited above, the podcast and cell phone tour rated most highly among an array of interpretive resources, while traditional analog texts ranked last.

26. John Falk and Beverly Sheppard, *Thriving in the Knowledge Age: New Business Models for Museums and Other Cultural Institution* (Walnut Creek, Calif.: AltaMira Press, 2006).

The Whole World in Their Hands:
The Promise and Peril of
Visitor-Provided Mobile Devices

Robin Dowden and Scott Sayre

Convergence is now. The device in the pocket or purse of the majority of museum visitors is quickly becoming a vortex of almost all emerging communication technologies. What used to be called a mobile phone is now a potential hub of all personal communication, a place where Web 2.0 meets Mobile 2.0, connected and identified by Where 2.0.[1] The foreseeable significance of this emerging hybrid, personalized, mobile, location–aware device on museum practice cannot be overstated. The hybrid mobile device will defy physical and institutional boundaries, redefine authoritarian sources and practices and forge new communities with or without the museum community's support. Just as the World Wide Web has redefined the public role of museums, hybrid mobile devices promise to improve by allowing museums to focus on content and strategy rather than hardware, while taking full advantage of the tools and technologies of a multi–networked world.

For more than 40 years, museums have been providing visitors with audio tours of their exhibitions. During this time, the technology has shifted from analog to digital, and the content from audio to multimedia. Major milestones in the evolution of the handheld platform include the introduction of the compact cassette in 1980 and the transition to digital systems in the 1990s. With the advent of digital players, audio guides became a significant part of the interpretative and educational strategies of museums worldwide. No longer restricted to linear tours, visitors could use digital technology to personalize their experiences through random access of content, thus broadening museums' opportunities for program development.

In 2004, Antenna Audio founder Chris Tellis described wireless personal digital assistant (PDA) platforms as "the most exciting development in museum education appliances in the past two decades." Viewed less as a replacement for the audio tour, PDAs heralded the next generation of museum technology, combining wireless, multimedia and location-based services.[2] A year later, mobile phones emerged as learning tools and viable alternatives to audio tour systems. Early projects included History Calls, conducted by Southern Utah University, Cedar City, Utah; Science Now, Science Everywhere, started by Liberty Science Center, Jersey City, N.J.; and Art on Call, produced by the Walker Art Center in Minneapolis.[3] Simultaneous with the emergence of mobile phones as interpretive devices, MP3 players, with a primary focus on Apple's iPod, began to be used by the public and were quickly adopted by museums as a vehicle to deliver podcast tours freely over the Internet.[4] Since that time, hardware has continued to evolve with devices capable of delivering multimedia vodcasts now followed by the iPhone, the first device to fully integrate all of the above.

Adapting to the digital convergence in hardware, network and software capabilities poses many challenges for all museums and vendors of such systems. Planning for today while preparing for the predictable future is unquestionably the most sustainable strategy. In order to do this, museums need to survey larger technology and social computing trends, determining where they intersect and how they will affect the content they create to extend and enhance the visitor's experience.

NEW FOUNDATIONS

Advances in hardware, networks and the applications they run are the structural underpinnings in the evolution of mobile technologies.

Devices

Industry continues to redefine the capabilities of hybrid mobile devices based on market trends and technological evolution. As technological literacy and expectations grow, the market strives to respond by delivering more integrated desktop and peripheral features in a single mobile device. While these expectations constantly change, the obvious goal is a user-friendly device that meets or exceeds the current capabilities of each tool through seamless integration and synergy.

Networks

The evolution of network technologies is essential to defining the current and future capabilities of mobile devices. While early mobile phones relied solely

on the cellular network of the subscriber and handheld computers depended on wireless local area networks (Wi–Fi), newer devices integrate a wide range of local services (Bluetooth, Wi-Fi, infrared triggers [IR], and Radio Frequency Identification [RFID] tags) with regional or global cellular network technologies (Global System for Mobile Communications [GSM], Code Division Multiple Access [CDMA], etc.). Emerging devices are capable of simultaneous multimodal operation allowing concurrent communication between local, onboard, global data sources and applications. This live integration will permit a museum visitor such capabilities as accessing a location-specific gallery map while also accessing a related interpretive audio program from another museum via cell phone or Geoblogging their experience while using their device's camera to take photos or video.

In addition to this integration, cellular networks are rapidly growing in bandwidth and multimedia capability. State-of-the-art 3G (3rd Generation) networks permit simultaneous voice and data transmission, including full-motion video. Plans and specifications are already in development for 4G, which would provide wireless broadband connectivity via Internet Protocol (IP) up to 1 gigabit per second (Gbps), well exceeding the speed of today's wired broadband. Future devices will also have the capability of sensing and automatically switching between networks depending upon the application and network availability. While Voice-over-Internet Protocol (VoIP) technologies like Skype and Vonage are currently the rage in the wired world, this technology is already moving into Wi-Fi–enabled mobile phones and may one day replace today's cellular networks. This shift could all but eliminate the museum visitor's concern about using up minutes to access content, since it would be delivered through a local Wi-Fi network.

Applications
On the other end of the local and global networks, visitors with mobile devices will be connecting with a growing number of intelligent server-based applications hosted both internally and externally by museums and other public and commercial services. A growing number of museums are using Interactive Voice Response (IVR) systems to provide audible information about their collections and programs over visitors' mobile phones inside and outside of the museum over cellular or Wi-Fi networks. Unlike traditional voicemail systems, most contemporary IVRs are open-standard, PC-based applications capable of full integration with other networked systems, including webservers, content management systems (CMS), digital asset management systems (DAMS) and other databases. With this integration, IVR-based systems can incorporate new

levels of two-way interactivity, annotation and personalization. One example is the Ear for Art program at the Tacoma Art Museum, Tacoma, Wash., that includes a number of multiple-choice looking games.[5] For instance, as visitors walk beneath the hundreds of blown-glass sculptures that comprise the large ceiling of Dale Chihuly's outdoor Seaform Pavilion, the IVR challenges them to count every instance of a signature sculptural form. When the visitor inputs the number they have found, the sytem provides feedback based on the visitor's response, followed by another visual challenge. A simple but highly effective way of further engaging the visitor, IVR-based programs, typically written in VoiceXML, can be customized to do everything from translating webpage content (text) to sharing voice comments to driving museum exhibitions with dynamic polling data or by using the keypad as a remote-control interface.

Concurrently, Web 2.0 applications such as weblogs, wikis and tagging are becoming increasingly accessible on phones with browsers, as are photo and video capabilities on a number of devices, thus supporting a new movement coined the Mobile Web.[6] The IVR and Mobile Web movements—which both embrace network-based applications and user-created content—are redefining the museum audience and the ways in which museum-goers interact with institutions and each other.

NEW HORIZONS

As mobile technologies become more networked with enhanced capabilities for personalization and context awareness, museums have the opportunity to transform the visitor experience and to redefine their own relationship to the public both inside and outside the walls of the institution.

Ubiquitous Access

In a networked world, content can be made available independent of time or physical location. Object and exhibition programming that was previously only available to visitors of a specific museum now has the capability of being simultaneously utilized for multiple purposes at multiple venues. For example, an audio interview with Chuck Close produced by the Walker Art Center could be accessed by a visitor standing in front of a Chuck Close portrait at the National Gallery of Art in Washington, D.C. The growth of freely distributed media resources via global networks will provide opportunities for new types of content aggregation and redistribution. Simultaneously, the ubiquitous nature of networked resources will greatly diminish or eliminate the need for media programming to be physically distributed with traveling exhibitions.

Multiple Channels, Multiple Devices

In a rapidly changing technological environment, it is becoming increasingly critical that museum-produced content transcends specific devices. To facilitate this type of transcendence, museums must develop sustainable information (text, audio, images, video) formatting and migration strategies based on shared standards. High quality, nonproprietary archives are key, but the ability to dynamically convert, reformat and share these resources is also necessary to simultaneously serve a multitude of devices through a range of channels (website, podcast, mobile phone, etc.). This is where content and digital asset management systems, as well as dynamic processing tools, play a key role in automating distribution and reformatting from one asset to many devices and applications. The Walker Art Center's New Media Initiatives department has developed a custom CMS that simultaneously feeds audio and text to its website, podcasts and Art on Call cell phone audio tour program. The Dallas Museum of Art's Arts Network initiative positions the museum's commercial DAMS as the hub of all media asset archiving and distribution for internal and external applications on a myriad of devices.[7]

Personalization

Personalization and customization are used to describe a variety of applications or services that individuals can use to tailor specific content. Whether driven by implicit data such as an individual's actions or requests, explicit settings or personal information provided by the user, the idea of delivering personalized content has great appeal. Mobile technologies by definition imply a personal as opposed to shared context of use, and are well suited to engaging museum visitors in individualized learning experiences. The technology lends itself to a wide range of possible applications, only a few of which are touched on here.

The use of personalized services delivered through mobile technologies suggests that museums could offer individual tours of their exhibitions, adapting the content to each visitor's needs and interests. Preferences could be used to tailor interpretative material, suggest related programming and direct visitors to additional online resources. In addition to facilitating access, personalized mobile technologies provide cultural institutions with a unique opportunity to establish a dialogue with their visitors. The Walker's Art on Call offers a TalkBack feature that allows visitors to leave audio comments that the center can, in turn, make available to other visitors. The program uses the phone's caller-ID to personalize sessions by eliminating redundant information and tracking entries—users can revisit their tour by visiting the Walker's website and entering their phone

number. Artworks are accompanied by images, links to deeper content and audio commentary created by the Walker and its visitors. The aggregation of a caller's selections provides the visitor with a continuity of experience and allows the Walker to develop a visitor profile based on his or her activity. In the future, this profile may be used to recommend additional content and other programs related to the visitor's interests. By offering personalized information and services, museums can learn more about their visitors and respond (and adapt) accordingly.

Geospatial Technology and Context-Aware Environments

Geospatial and global cellular network technology are poised to change the ways in which users receive, access and record shared and personal information via mobile devices. While early location-aware museum handheld projects focused with varying degrees of success on using visitor location to trigger or push object-specific data, geospatial technologies and Geography Markup Language (GML) will make this capacity available inside and outside of the museum's walls. Real-time positioning data, combined with GML and geotagging/blogging focused on marking and annotation, will allow museums and visitors to turn the museum inside out, bringing object information to the original context rather than context to the object. Imagine subscribing to a geographically tagged Really Simple Syndication (RSS) or GeoRSS feed on South American art while vacationing in Ecuador and having your device automatically alert you to objects you are familiar with in your local museum that were found in the specific area you are traveling. By selecting the object you would have access to images, interpretative data and other media provided by the museum, perhaps including text, voice and image annotations by other travelers and museum visitors. This type of "geoculturecaching" is possible today and will likely develop through the use of Web 2.0 tools like Flickr, Geoblogging and Google Earth, with or without museum participation. Museums can begin to prepare for this by developing proactive strategies for converting their point-of-origin data into geospatial coordinates.

Beyond determining a user's location, work is being done on developing context-aware devices that can automatically change modes and/or the content delivered based on location and other sensory triggers. These contextual modalities hopefully will improve ease of use as well as automatically enforce some social protocols, such as defining quiet zones and community spaces for open dialogue and exchange.[8]

CRITICAL CHALLENGES

The adoption of mobile technologies in museums faces significant obstacles. Questions about the digital divide, real-world technological constraints and uncertainty about acceptable use of personal technologies in museums are a few of the factors affecting development.

Technological Constraints

At a practical level, mobile technologies are limited by a variety of physical and technological constraints, including form factor (size/shape), battery life, screen resolution, processing speed, memory and network capabilities. Each of these areas is maturing at a different rate, with display and memory currently in the lead and batteries lagging far behind. Battery life, in particular, is a major concern for an industry interested in turning phones into media centers and for users who want their phones on continuously. The movement in museums toward cell phone audio tours is currently dependent on the visitor's perception of affordability as defined by the battery life of their phone and the cost of their network plan.

Cellular Standards and Restrictions

Today's cellular industry lacks standards when it comes to regional and international interoperability as well as broadband services. While basic digital voice and text services are universally available to many domestic mobile phone users, broadband cellular services remain a niche market. And within the broadband marketplace there are competing technologies and services, not all of them compatible. Because of this, most current phone-based museum programming is currently restricted to voice and text. Further complicating matters, cellular subscribers in remote areas of the United States still rely on analog services that may utilize handsets that are incompatible with digital services.

In many cases, the service plans of international visitors are unusable or extremely costly when traveling within the United States. Most U.S. service providers lag behind their European counterparts, many of which are already offering 3G broadband services that can be used universally throughout Europe and Asia. It is hoped that as U.S. subscribers begin to demand broadband services, the domestic industry will become more compatible with international broadband standards.

GPS Limitations and Privacy Concerns

Many phones are now capable of determining a user's location based on Global Positioning Systems (GPS). GPS is dependent on line-of-sight view to three or

more orbiting satellites in order to calculate the position of a device. Because of this, current satellite-based GPS is only reliable for outdoor applications and not a viable solution for most museum applications.

Mobile phone networks are also capable of determining the position of a mobile device based on triangulation of signal strength between cell towers. Different from satellite positioning, cellular tower positioning data is controlled by the service provider, and a phone location can be made visible to the phone's user as well as to the service provider. Because this triangulation does not rely on satellites, this information is available anywhere a reliable cell phone signal is present, indoors or outside. Service providers, however, also serve as the gatekeepers to this data, a factor that raises privacy concerns about making it publicly accessible. Some providers have begun to offer users the option of making their information publicly available, but this is far from becoming a usable data stream into which museums can tap.

The ability to acquire information about the visitor and his or her environment presents a unique ability to personalize the museum experience. Nevertheless, while museums hope their visitors will welcome receiving alerts and information related to their location and interests, there are significant privacy issues surrounding the implementation of these technologies. Bombarding visitors with unwanted information may be perceived as invasive and run counter to the experience and relationship the museum is attempting to engender. Context information needs to be gathered with the consent of users and must be stored securely to prevent misuse.

User Interface

One of the many advantages of using mobile phones as delivery devices is the familiarity and ease of using the keypad as a numeric input device. Unfortunately, the intuitive nature and standardization of mobile phones typically stops at the input of numeric codes. Many phone users only know how to access the basic functionality of their own phones, even though their phones may have a myriad of additional capabilities buried within their many modes and menus. While Short Message Service (SMS) texting and instant messaging might be innate for a teenage phone user, many adult users are not even aware of these capabilities, let alone understand how to use them. Similar to the historic problems people had programming VCRs, many non-techie users have no patience for non-intuitive interface design and see the inconvenience as far outweighing the advantages.

As hybrid mobile devices continue to assimilate more capabilities, so do the demands on the device's user interface. The more devices are integrated, the more modes or controls they need to have. Device intelligence may be part of the solution, creating technology that can automatically sense and morph from one function to another, as exemplified by Apple's iPhone, which can tell if it's being used as a phone by position and proximity to the user's face. This type of device intelligence is still in its infancy. In the meantime, museums can do little to control or address these issues other than maintain an awareness of their audiences' capabilities as well as that of their personal devices. At this time there is no immediate design solution in sight as long as the device industry continues to embrace competing, proprietary operating systems as well as a wide range of input devices (keypad, styluses and touch screens). We can hope that the market itself will eventually come to demand and expect the intuitive, interoperable devices from which we can all benefit.

Museum Etiquette and the Use of Personal Technology

With the proliferation of mobile devices has come the need to define new rules of museum behavior. Many museums ask visitors to refrain from using cell phones, and phone etiquette guidelines frequently encourage turning phones off in museums or leaving them behind entirely. Museum photography policies— already often misunderstood by the public—are further complicated by the convergence of phone and camera. As more museums experiment with mobile devices as a means to engage visitors, preconceptions of the gallery experience will change. Until then, visitors may be understandably confused by widely differing policies among seemingly similar institutions.

Today, the introduction to the Walker Art Center's Art on Call program asks gallery visitors to turn off phone ringtones and not to make personal calls. With the development of context-aware devices, it is easy to imagine a mobile device that silences itself when a visitor enters a gallery or sends the visitor a text message when a related program or service is available in a particular setting. Similarly, in museum galleries where photography is prohibited, it may be possible to temporarily disable the camera component of a visitor's phone in restricted galleries while simultaneously delivering an explanation for the policy.

CONCLUSION

Mobile phone capabilities are advancing at a rapid pace. The evolution in devices, combined with ubiquitous broadband, is turning the mobile phone into the gateway to our digital lives. Museums frequently have set the standards for

interactive technologies, from "smart tables" to handheld computer applications that controlled access to a wide range of multimedia. Now the public is setting the bar, carrying multimedia devices that make the Internet both personal and portable from almost anywhere in the world.

Museums are just beginning to take advantage of the possibilities of mobile phones. To do so conscientiously requires rethinking how we manage our information assets and leverage content synergy. Open standards-based approaches are key to separating the storage, processing and presentation of museum-related data. The use and repurposing of content across various media platforms—whether the printed brochure, the Web or the hybrid mobile device—not only maximizes its potential value but also ensures that visitors' preferred channels of communication carry the information deemed important to their interests.

NOTES

1. Tim O'Reilly, "What Is Web 2.0: Design Patterns and Business Models for the Next Generation of Software," September 30, 2005, www.oreillynet.com/pub/a/oreilly/tim/news/2005/09/30/what-is-web-20.html; Rudy De Waele, "Understanding Mobile 2.0," *Read/Write Web,* December 11, 2006, www.readwriteweb.com/archives/understanding_mobile_2.php; Brady Forrest and Nathan Torkington, "The State of Where 2.0," O'Reilly Media, Inc., June 2006, http://conferences.oreillynet.com/where2006/state_of_where_20.pdf.

2. Chris Tellis, "Multimedia Handhelds: One Device, Many Audiences," paper presented at Museums and the Web, Arlington, Va., April 2004, www.archimuse.com/mw2004/papers/tellis/tellis.html.

3. Matthew Nickerson, "1-800-FOR-TOUR: Delivering Automated Audio Information through Patrons' Cell Phones," paper presented at Museums and the Web, Vancouver, British Columbia, 2005, www.archimuse.com/mw2005/papers/nickerson/nickerson.html; Denise Bressler, "Mobile Phones: A New Way to Engage Teenagers in Informal Science Learning," paper presented at Museums and the Web, Albuquerque, N. Mex., March 2006, www.archimuse.com/mw2006/papers/bressler/bressler.html; and http://newmedia.walkerart.org/aoc.

4. See http://mod.blogs.com/art_mobs.

5. See www.tacomaartmuseum.org/page.asp?view=5867.

6. Ajit Jaokar, "Mobile Web 2.0: Web 2.0 and its Impact on the Mobility and Digital Convergence," December 25, 2005, http://opengardensblog.futuretext.com/archives/2005/12/mobile_web_20_w.html.

7. Homer Gutierrez and Jessica Heimberg, "Dallas Museum of Art Presents the Arts Network," paper presented at Museums and the Web, San Francisco, Calif., April 2007, www.archimuse.com/mw2007/abstracts/prg_325000879.html.

8. Richard W. DeVaul and Steve Dunn, "The Context Aware Cell Phone Project," www.media.mit.edu/wearables/mithril/phone.html.

Immersive Media: Creating Theatrical Storytelling Experiences

Michael Mouw and Daniel Spock

NEW MEDIA AND THE MUSEUM

The advent of such myriad innovations as the World Wide Web, CD-ROMs, podcasts and virtual reality (VR) has tended to erase the traditional barriers geography imposes on human existence. Yet despite the efflorescence of digitized resources museums offer today, the institutions themselves remain largely the landlocked, physical world destinations they have always been. Uncertain and anxious about the future, museums may well wonder if the museum visit itself is being rendered obsolete by technology. Does the future of the museum lie in some virtual sphere? Perhaps to some extent, but certain trends and time-honored human proclivities would seem to contradict this for now. Even though not all museums can be called popular, museum-going remains a popular activity overall, exceeding the attendance of theme parks, professional sports and casinos combined.[1]

While the virtual sphere, and particularly the Web, continue to blossom as methods of accessing and disseminating information, museums, we are coming to understand, are about something else altogether, something both more and less than a pure information-delivery medium. People continue to find value in traveling to the actual museum, but information seems to be only part of what they are after. Whether, as *New York Times* journalist Michael Kimmelman has suggested, it is because people still crave encounters with "the singular object" or because, as museum researchers John Falk and Lynn Dierking have discovered the museum-going experience serves as a powerful backdrop for social experiences with others, we now know the motivation will shift from person to person.[2] But if museums remain popular destinations, do they really need electronic media in

their galleries that merely mirror the kind of screen-captured browsing activity more easily accomplished at home or in the local coffee shop? What is so wrong with our reality that we need a virtual one? Indeed, recent studies suggest that museum-goers increasingly find the now ubiquitous interactive computer kiosks or touch screens less than compelling, the novelty factor apparently having worn off.[3] When it comes to new media, then, museums will be most effective when they use electronic technology in ways that accentuate their unique role as three-dimensional, geographically located places that bring together real people and real things.

STORYTELLING AS A VEHICLE

Exhibitions at the Minnesota Historical Society (MHS) have shown how electronic media has particular promise in museums as a storytelling medium. Storytelling, however, means something very different from a mere buzzword for traditional historiography. Historian and researcher Roy Rosenzweig has pinpointed the difference:

> [Historians], by training, have often been more suspicious of oral sources than of written documents. . . . And . . . have also been deeply invested in stories about the nation-state, institutions, and social groups—unlike the people we surveyed, who especially valued the past as a way of answering questions about identity, immortality and responsibility.[4]

Likewise, contrasting the ancient historians Herodotus and Thucydides, Robert D. Kaplan has written:

> [R]eality cannot be reduced to neat equations, whether moral or analytical. The world as it exists often rejects rationality, spare narratives, even truth. If we have learned anything in this age of speedier and increasingly numerous interactions between peoples with different historical experiences, it is that facts matter less than perceptions informed by raw emotions. It is what people believe that is crucial, not what they actually know. What is needed, therefore, beyond guiding philosophical principles, is a vivid appreciation of just what's out there, in the form of myths, passions, and irrationalities that in any age are central to decision making and, in a larger sense, to the human spirit itself. Romance, rather than being antithetical to realism, is a necessary component of it.[5]

Research at MHS has led to the conclusion that museum visitors most readily connect to history through the personal stories of others. Cognitively, what takes place is a series of comparisons between one's own experiences and another's. Emotionally, this is an empathic process involving the imagination. People are less interested, at least at first, in what happened, why and when. Rather they want to understand, through a process of personal introspection or through sharing an experience with others: What was it like? What would I do? How would I feel? Would I have made the same choices? Narratives with the kind of telling, and sometimes serendipitous, details that illuminate these kinds of questions resonate most strongly with museum visitors. As influential author Freeman Tilden, who taught interpretation at the National Park Service, suggested, the interpretive art aims not at *instruction* but *provocation*, implying an experience that transcends the mere acquisition of information to something that engrosses and compels the human spirit. Interpretive captivation, therefore, waxes or wanes on the affective response of the audience.[6]

In this sense, museums are most effective when they tap the experiential qualities one tends to associate with theater and fiction (as opposed to, say, the classroom): an experience of other people's dramas and dilemmas, those not necessarily rational but certainly universal aspects of the human experience. But history storytelling, as opposed to fiction, has the special advantage of being about real people who have faced real-life situations. If educational value is your chief concern, the good news is that dramatizations that draw an affective response are also more memorable than dispassionate, just-the-facts pedantry. In fact, the process of cognitive engagement through the memorable impression is fundamentally an emotional experience at its core. This idea, which can be traced back to philosopher William James, has found support among today's neuroscientists, perhaps most eloquently articulated by Antonio Damasio and Joseph Ledoux.[7] At MHS, studies conducted on viewers of three theatrical presentations showed distinct differences from those museum visitors who had not viewed the presentations. Viewers of the presentation tended to report more complex responses to survey questions, convey more detail about their visit and relate more of their museum experiences to other aspects outside of the museum than nonviewers.[8] Cognitively, these visitors were not simply regurgitating the information contained in the theaters; they were also relating the experience to an entire web of previous experiences and understandings, which, in the view of MHS researchers, was clear evidence of the provocation Tilden described.

THE ALLURE OF THE HYPERREAL

People have been trying to approximate some experiential and immersive equivalent of reality for centuries. The Romans enjoyed spectacular reenactments of the naval battles of the Punic Wars in their arenas. Panorama shows were popular attractions, anchoring shopping galleries starting at the turn of the nineteenth century.[9] A visitor to Paris World's Exposition in 1900 could witness variously simulated experiences such as a balloon ride over the city, a trip across Russia on the Trans-Siberian Railroad—complete with dining cars, smoking cars and a ladies salon—and the Mareorama, an ocean voyage by steamship.[10] Starting in the 1930s, a visitor to Chicago's Museum of Science and Industry could take the plunge down an exquisitely realized coal mine. Building off the world's fair model, theme parks, as pioneered by Walt Disney, have mounted increasingly complex shows, many of them combining theatrical robotics or animatronics with the more traditional amusement park ride. In the last decade, these theme park developments have resembled an arms race as each new ride tries to gain an advantage over the last astonishing, heart-stopping spectacle. Museums can learn from the multifaceted use of media in theme parks, just as theme parks have borrowed many ideas from museums.[11] Theme park rides, synchronized light shows and street parades with costumed actors and sophisticated audio tracks all have theater show control technology—i.e., electronically controlled systems behind the scenes that operate all of the elements of the show—at their foundation. Electronic technologies with quick response times and rugged durability are important in this environment, and can be useful in the museum.

A common thread tying all of these shows together is the use of state-of-the-art stagecraft. To varying degrees they all rely on powerful immersion techniques that make audiences feel that they are physical participants in the show. The best shows have strong narrative arcs that propel them forward. Perhaps even more important is a reliance on an audience's own desire to willingly suspend disbelief, to exercise the imagination in the vicarious experience of a simulated reality, an experience of what writer Umberto Eco has dubbed "hyperreality."[12] This apparently innate human desire explains better than anything else the enduring popularity of immersive theater.

The advances in automated, computer-based show control systems developed for theater and, to a growing degree, the theme park industry, have led to an entire generation of museum spectacles. Museums, always more strapped for resources than theme parks, and certainly more earnestly pedagogical, have experimented with some of the same technologies, albeit, at smaller scales and

budgets. Museum studies professor Marjorie Schwarzer, chair of the department of museum studies at John F. Kennedy University in California, credits Taizo Miake of the Ontario Science Center with coining the term "object theater" in the 1970s.[13] Object theater, broadly defined, means any museum-based automated theatrical presentation involving sets, lighting and audio cues. Add to this definition today's possibilities of projected or monitor-based media, in-seat or motion-based simulation (MBS), motion elements (sometimes called "show-motion"), animatronics or other special effects and a variety of user interfaces (tangible, voice or motion-activated, Radio Frequency Identification [RFID] chip, etc.)—all of which can be used in combination with live mediation by museum staff—and the museum with command of these resources has quite a varied palette of storytelling techniques to work from. The term object theater is deceptive, however, because museum professionals may misconstrue it with a tendency to put the collections object at the highest priority, even to the detriment of the public's museum experience. For that reason the term "story theater" may be more accurate since, at the end of the day, the quality of the story content is ultimately more decisive than any object or theatrical trick of the trade.

MULTIMEDIA STORY THEATER

But what is story theater? The exhibits team at MHS first asked this question as it looked at immersive media possibilities for the opening of the Minnesota History Center Museum in 1992. The team was influenced by object theater productions from two very different museums: "The Universe" at Science North in Sudbury, Ontario, and "Tetsuo's Room" at the Boston Children's Museum. "The Universe" was a pioneering use of story theater developed by Taizo Miake, Rob Gagne, David Lickley and Paul Martin for Science North's exhibitions program. This black box theater showed how multichannel sound, lighting, a captivating and enveloping setting and video projection could be woven into a story that creates a powerful, emotional experience for the museum visitor. The story theater opens with a child singing, "Twinkle, Twinkle, Little Star" as disparate elements are lighted. A 3-foot-wide petri dish full of white sand (the narrator explains how each grain represents one star in the Milky Way), a globe and planetary models that create a sense of scale and wonder about our solar system, a lunar rock collected by the Apollo program and other astronomy-related artifacts are highlighted in sequence. A projection of the marvelous Charles and Ray Eames' film "Powers of 10" allows viewers to grasp the sheer size of our universe. This production demonstrated the potential for museums to use

visual metaphors in theatrical, emotional experiences that audiences remember. This blend of exhibition design, theater techniques and filmed documentary storytelling paved the way for many story theaters to come.

At the Boston Children's Museum, story theater was developed for a different purpose: to interpret a distinct culture. In 1990, "Tetsuo's Room" allowed visitors in the "Teen Tokyo" exhibition to playfully peer through a transparent wall into a Japanese teenager's bedroom as it came to "life." In this way, the bedroom became a metaphorical window into the child's world. As the show unfolded, an English–speaking girl's voice asked questions about Tetsuo's interests, family concerns and daily routines, as the voices of Tetsuo and his family and friends answered. These questions were illustrated as the abandoned, quiet room gradually became animated through a series of life vignettes. Theater lighting highlighted various details of the room and sound design was blended with television clips to add more context to the story of Tetsuo's life. In the process Tetsuo's toys and video game controls moved on cue and, in one vignette, a room light swayed during a simulated earthquake, an innovative early use of computer-controlled show–motion effects. By the end of the show, the audience could feel as though they had become acquainted with Tetsuo through a fun and memorable museum experience.

These influential story theaters pointed the way for MHS to create more than a dozen immersive projects for its statewide network of museums and historic sites over the past 15 years. The first was "Home Place Minnesota," where, in an enclosed 50-seat theater, visitors experience an evocation of the universal longing for home. First-person accounts from diaries, poetry (including that of Garrison Keillor), memoirs and novels highlight memories of Minnesota's land and communities, evoking a range of feelings from celebration and nostalgia to isolation and despair. The stories are presented with music in surround sound and illustrated with hide-and-reveal techniques that incorporate photographs projected onto object settings and scrims and lighted theatrical set pieces, some revealed on large turntables. Everything is synchronized by a computerized show control system. More than 750,000 museum-goers have seen this 15-minute presentation, and as mentioned earlier, audience research showed that seeing "Home Place" heightens visitors' overall museum experience.

In 2003, MHS debuted the "Flour Tower" at Mill City Museum in Minneapolis. An immersive 8-story elevator ride, the "Flour Tower" chronicles the stories of men and women who worked in a Minneapolis flourmill, as the entire audience

Figure 1. At the Mill City Museum's "Flour Tower," visitors from the third floor of the elevator ride can immerse themselves in the sounds and sights of men loading a boxcar with bags of flour amidst the factory's moving machinery. © 2007 Minnesota Historical Society.

moves up and down between a vertically stacked series of dramatized settings (Fig. 1). Even though the show vividly recreates some of the dangers of flour milling, the social nature of seeing a story in a safe museum environment—similar to being emotionally caught up in a film at a comfortable movie theater— transforms it into a shared and meaningful experience with friends and family members.

The recent use of the story theater has not been limited to MHS. Science North and the Science Museum of Minnesota produce story theater shows, both for their in-house exhibitions programs and for museum clients across North America. They collaborated on "Brain Magic" at the Science Museum of Minnesota, where visitors are challenged with optical illusions created through the use of sound, moving set pieces, lighting, video effects and even a spray of water. The audience is led through the story by a "magician" narrator, projected life-sized onto the set.

At the Texas State History Museum in Austin, a story theater called "The Star of Destiny" was created by a firm with roots in theme park show design. The show is narrated by a video projection of an actor playing Sam Houston. Visitors literally

feel the story of the Lone Star State as air jets and motors incorporated into the seats are cued to the show. The same firm designed exhibits for the Abraham Lincoln Presidential Library and Museum in Springfield, Ill., including "Lincoln's Eyes" and "Ghosts of the Library," an elaborate hybrid of story theater combined with live acting. In this show, the live actor magically appears and disappears through imaginative use of the theatrical "Pepper's Ghost" technique.[14]

At the Australian War Memorial in Canberra, another innovative show, "Striking by Night," recreates a nighttime bombing run on Germany during World War II. The exhibit uses sound and lighting to dramatize the engines, searchlights, machine gun fire and flak, incorporating a number of full-scale aircraft to a high degree of chilling realism. The show is narrated by actual radio transmissions recorded in-flight during the war. Similarly, at the D-Day Museum in New Orleans, a story theater called "The Decision to Go" conjures the conversations between General Eisenhower and his staff that led to the decision to invade Normandy by using projections and lighting cues on theatrical settings. All of these productions share the common qualities of story immersion, but they tend to put the visitor into a relatively passive viewing position outside of the story action.

INTERACTIVE AND IMMERSIVE

Museum-goers typically navigate or "graze" through the gallery environment in social groups, moving, often very randomly, from feature to feature. This behavior is unlike that of solitary Web-browsers who interface with a glowing screen or theater patrons seated passively in a darkened space. Based on this realization, MHS began to look for exhibition media that are as intuitive and as interactive as possible. Media seamlessly integrated into the exhibit environment represents a relatively new opportunity that has yet to be fully explored and exploited. This strategy can create an experience unique to the museum visit that the visitor cannot find at home, and which takes as a departure point the visitor's natural proclivities to discover exhibit content at a leisurely and self-directed pace.

In light of this grazing behavior, MHS worked to enhance the immersive experience by erasing the line between viewer and story theater, allowing viewers to step figuratively through the theater proscenium and onto the stage of the drama itself. Starting with the 2002 "Get to the Basement!" tornado show, the museum placed visitors inside the story theater setting, immersing them in the historical experience of surviving a 1965 tornado that battered Fridley, Minn. As visitors "take safety" in a recreated basement environment of a tornado-shattered house, the upper floors of the home seem to be ripped away

(Fig. 2). Audio recordings of storm survivors form the narrative spine of the story, recounting the events leading up to, during and after the storm. Meanwhile, visitors experience theatrical simulations of the disastrous sequence of events as they are being described. The experience is largely conveyed through the sound design and a very limited view through a small basement window, leaving visitors to imagine the rest.

In the 2005 exhibition, "Open House: If These Walls Could Talk," MHS further blurred the line between setting and story by turning everyday objects in the rooms of a recreated home into interfaces for learning about the people who lived there over the past 118 years. In one example, touching a silver dollar on a 1960s era bedroom dresser activates a first-person audio story of how a family saved spare silver dollars to pay for vacations. Home movies of the family's vacations simultaneously appear in the dresser mirror. This use of material gathered from people who lived in the home lends immediacy and authenticity to a contextualized dramatization, and creates a surprising and delightful discovery for visitors.

Tangible interfaces allow visitors to interact with electronic media throughout the museum gallery. By using industrial sensors—such as RFID readers and motion detectors—MHS turned "Open House" and its touchable objects into an exploratory experience. This approach turns exhibit media into objects of

Figure 2. The Minnesota History Center's "Get to the Basement!" features a large spinning fabric tornado and the exterior of a storm-damaged home. © *2007 Minnesota Historical Society.*

discovery rather than a passive viewing activity; it allows museums to encourage a visitor's curiosity in a way that goes beyond traditional video screens and button pushing. Touch sensors allow visitors to activate storytelling media in a way that feels natural, warm and integrated into the environment.

Museum audiences, accustomed to and influenced by what they see in contemporary art exhibitions and hands-on museums, are more open to and aware of media as a storytelling device in museums than they might have been even a decade ago. Visitors have proven eager to explore the cues embedded in the exhibit and enjoy being rewarded for this process of discovery.

STORY THEATERS: A PRODUCT OF TEAMWORK

The exhibit teams that created the story theaters at MHS attest to the cross-disciplinary teamwork needed to set up these types of shows. Immersive productions are among the most collaborative areas of exhibition development and design. A varied cast of staffers responsible for content development and research, multimedia production, 3-D exhibit, lighting and graphic design, fabrication and prototyping is needed for their production. Outside vendors can include camera and sound technicians, music composers, video graphics experts, show motion consultants, acoustic engineers and computer programmers. Teams expand over each project, from the few needed to guide the early development phase to the larger team that becomes necessary as more specialized production skills are required. Prototyping ideas is crucial in developing immersive shows—demonstrations are created quickly with settings sketched in three dimensions out of cardboard or foam board made into full-scale models built in an off-site mockup space or on the exhibit floor. Vignettes and samples of the show should be tested as quickly as possible. If needed, quick-and-dirty "scratch" tracks can be recorded by staff as stand-ins for professional voice talent in order to try out spoken material before costly recording sessions are scheduled. Oral history interviews also can be used in roughly edited form, and visuals can be tested as rough-cuts in mockup settings. Prototypes can be quickly refined or eliminated according to audience testing results. In this way, the process is collaborative, iterative, constantly changing and self-correcting. A good story theater team draws upon diverse backgrounds and varied training in technical theater, multimedia production, artist installations and exhibition content and design development, lending a wide palette of skills and options to create each show.

CONCLUSION

The convergence of theater, artist installations, theme parks, live staging, filmed documentaries and factory automation is melding media in museum exhibitions into a new amalgam of exciting and memorable visitor experiences. Used in ways that heighten the qualities that museums already enjoy as "real" destinations, new media have afforded innovations that can make meatspace—physical spaces and places—just as powerful an arena for experimentation as the virtual sphere. Still, the technology itself is no guarantee of success. Having a good story to tell and telling it well are the ultimate requirements of any story theater venture. This necessity, more even than money, is the most critical dimension of the medium. Stories that reach the essence of the human experience and can be dramatized in such ways that visitors feel a close sense of connection to the story physically, emotionally and cognitively have the most impact and leave the most durable impression. For visitors, this is fundamentally an act of the imagination. Great story theater leaves something to the imagination while being imaginative in conception and realization. The fresh bloom of available show technologies are opening ample new avenues for creating innovative museum-based storytelling experiences that reward exploration and discovery.

NOTES

1. The American Association of Museums (AAM) cites a 1999 study by Lake, Snell and Perry that measures U.S. museum attendance (including zoos, nature centers and botanical gardens) at 865 million per year [see www.aam-us.org/aboutmuseums/abc.cfm#visitors, accessed July 31, 2007]. The International Association of Amusement Parks and Attractions (IAAPA) counts 335 million visitors to theme and amusement parks for 2005. According to league statistics, the four top-drawing professional team sports in the U.S. and Canada—baseball, football, basketball and hockey—combined drew just under 136 million spectators in the 2005–2006 season. All other professional team sports combine for 56 million additional spectators. The American Gaming Association measures 319 million visitors to casinos in 2004.

2. Michael Kimmelman, "Museums in a Quandary: Where Are the Ideals?" *New York Times* (August 26, 2001); John Falk and Lynn Dierking, *Learning in Museums* (Lanham, Md.: AltaMira, 2000), 91–112.

3. Marianna Adams, Jessica Luke and Theano Moussouri, "Interactivity: Moving Beyond Terminology," *Curator* 47, no. 2 (April 2004).

4. Roy Rozenzweig and David Thelen, *The Presence of the Past: Popular Uses of History in American Life* (New York: Columbia University Press, 2000), 184.

5. Robert Kaplan, "A Historian for Our Time" *The Atlantic Monthly* 299, no. 5 (January/February 2007); 78–84.

6. Freeman Tilden, *Interpreting Our Heritage* (Chapel Hill: University of North Carolina Press, 1957), 32–39.

7. Antonio Damasio, *The Feeling of What Happens: Body and Emotion in the Making of Consciousness* (San Diego, New York, London: Harcourt, 1999); and Joseph LeDoux, *The Emotional Brain: The Mysterious Underpinnings of Emotional Life* (New York: Simon and Schuster, 1996).

8. J. M. Litwak and A. Cutting, General Audience Survey of the Minnesota History Center, 1994. The report noted that viewers of the "Home Place Minnesota" show were more likely to find their experience at the history center interesting, welcoming and enjoyable. Participants in this study who found the visit more interesting also reported finding emotional or personal connections at a higher rate than others, suggesting a correlation between viewing the show, emotional engagement and interest level. A survey by the same authors in 1996 discovered that viewers of the show also spent a significantly longer amount of time at the History Center than nonviewers. In a 1993 study specifically surveying "Home Place" viewers, 87 percent reported that "thoughts and feelings in this show sounded familiar to me," 81 percent reported that "this show is about feelings and emotions about places," and 74 percent reported that "this show helped me remember things, events or people in my own past." In a 2002 study by Martha Bolinger of the "Weather Permitting" exhibition also at the History Center, Bolinger reported that watchers of the "Get to the Basement!" show "were the virtual inverse of non-watchers" in terms of the complexity of their responses to exhibit subject matter. Likewise, in a 2004 summative evaluation by Jeff Hayward, virtually all (97 percent) of visitors to the Minnesota Historical Society's Mill City Museum recognized the danger of flour milling, an interpretive point made only in the museum's "Flour Tower" show. Ninety-two percent of respondents rated the show "great" or "good."

9. Stephan Oetermann, *The Panorama: History of a Mass Medium* (New York: Zone Books, 1997).

10. Leonard de Vries, *Victorian Inventions* (New York, St. Louis, San Francisco: McGraw Hill, 1971).

11. According to the Henry Ford website, Disneyland was inspired in part by several visits Walt Disney made to the Henry Ford Museum and Greenfield Village in Dearborn, Mich. Disney's imagineers would later design the automated theatrical ride for the Ford Rotunda at the 1964 World's Fair in New York City, www.hfmvg.org/press/pressrelease/disney.asp.

12. Umberto Eco, *Travels in Hyperreality* (San Diego, New York, London: Harcourt Brace, 1967).

13. Marjorie Schwarzer, *Riches, Rivals and Radicals: 100 Years of Museums in America* (Washington, D.C.: American Association of Museums, 2006), 163.

14. Pepper's Ghost is an illusionary technique used in theater and in some magic tricks, in which a plate glass and special lighting techniques can make objects seem to appear or disappear or make one object seem to morph into another.

Can Museums Allow Online Users to Become Participants?

Matthew MacArthur

Blogs. Wikis. Mashups. Folksonomies. Social networks. Open source, open content and user-generated content. Once buzzwords, these tools and concepts are hallmarks of today's changing Internet landscape. We knew something important was happening when the social networking site MySpace surpassed search powerhouse Google as the most popular website. This milestone was symbolic of a shift in emphasis from the Internet as a collection of pages to the Internet as connections between people. *Time* magazine, in making "You" (the amateur bloggers, profilers, mashup artists and other online users-cum-contributors) Person of the Year for 2006, calls it a "revolution."[1]

Those with a stake in the creation and distribution of cultural content—media conglomerates, news organizations, technology companies—are taking the revolution seriously, employing a variety of offensive and defensive strategies in an effort to ensure their survival. Museums, libraries and archives, though lacking the same urgency, also have the sense that recent events could influence relationships with, and expectations of, their audiences. The cultural establishment remains deeply ambivalent about what writer Steven Johnson termed "this permanent amateur hour"—unsure whether to celebrate its "power to the people authenticity" or mourn "the end of quality and professionalism."[2]

This latest phase in the brief history of the Internet has come to be known as "Web 2.0," a term as ubiquitous as it is vague. Web 2.0 embraces a variety of concepts, some having to do with specific technologies and new ways of

thinking about the architecture of the Web. But more than that, it is a "social phenomenon embracing an approach to generating and distributing Web content itself, characterized by open communication, decentralization of authority, freedom to share and re-use."[3] In some ways, none of this is new. People have been posting homepages, conversing on bulletin boards and copying images and other media (legally or illegally) since the birth of the Web. The difference now is the scale at which it is happening and the cascading network effects enabled by a new generation of collaborative online applications. Ironically, the more bits of data that are added to these applications, the more useful they become as organizers and filters of Web content. Where once we were reliant on proprietary searches and directories to find information, now we can access and add to an unprecedented body of "collective intelligence" built by millions of users one tag, one link and one entry at a time.[4]

WEB 2.0 AND MUSEUMS

Of the various tools and concepts encompassed by Web 2.0, a few stand out as having particular relevance for museums. One such tool is folksonomy, the application of user-supplied subject terms—known as "tags"—to describe everything from webpages to works of art.[5] Proponents of folksonomy argue that allowing users to describe online content in terms that make sense to them, rather than relying solely on organizing principles imposed by others, will make that content more retrievable, useful and meaningful to the audience. Its most enthusiastic supporters add a countercultural flavor to the debate, as voiced by technology commentator David Weinberger: "Folksonomies stick it to The Man. . . . Even when the experts do a good job—as they usually do, because they're experts—it is still an implicit statement that someone else's way of thinking is better than yours."[6] Naturally, the "experts," trained in systematic descriptive methods that have been honed and developed over centuries, have a different opinion. In their view, folksonomy opens the door to idiosyncratic, inconsistent, irrelevant or simply incorrect subject terms, undermining the usefulness of any index that is created.[7] A collaborative research project, known as steve, has set out to study the potential of folksonomy for art collections in hopes that it will increase public access to works of art and improve the experience by encouraging personalization and multiple points of view.[8]

Using the Web to build relationships with and among users is another area in which museums have been experimenting for years. Web 2.0 tools give museums additional opportunities to build online communities, both on their own websites and on third-party sites. Many museums are experimenting

with weblogs, chats, social networking and other outreach tools. Because most successful social networks emerge in an organic, collaborative process, museums have found that it takes more than just a token institutional commitment to create a lively online community.[9] While a few attempts have been successful, others are either underutilized or unsustainable for a variety of reasons.

Wikis take the concept of user involvement a step further by allowing users to actually contribute to or edit content on a website. The most famous example is Wikipedia, the community-edited online encyclopedia with nearly eight million entries as of this writing.[10] Reaction to Wikipedia is mixed; some argue that its model of open and anonymous authorship, together with well-publicized instances of deliberate falsification, prevent it from being trustworthy as an authority. Even so, its breadth of material, up-to-the-minute responsiveness and sheer audacity as an enterprise continue to attract users and stimulate ongoing debate.[11] Wikis like it have been used for a number of other collaborative ventures, from community portals to scholarly research.

RELATIONSHIPS OF TRUST

At the heart of any discussion about museums and Web 2.0 lies the issue of authority. According to a 2001 American Association of Museums (AAM) survey on public trust of various sources of information, "museums are the most trusted source of information, ahead of books and television news." Respondents particularly valued museums as providers of "independent and objective information."[12] How is that trust affected if users are allowed to have a greater voice on our websites and even in our galleries? What is the proper relationship between professional experts and amateur enthusiasts? Traditionally, museum curators have been seen as "stewards of cultural heritage," providing not only primary research about material objects, but in recent times being expected to transmit a "clear and faithful understanding" of their meaning to museum visitors.[13] Some, even within museums, criticize this model as unnecessarily exclusive. According to one group of authors writing about science museums, learning is more likely when museums work with visitors to develop an approach that "has realistic overlap with the audience's behavior, attitude and expectations."[14] To do this we must allow visitors to be active participants from the beginning of the interpretive process, not just passive recipients at the end of it.

In 1997, when AAM published the seminal *Wired Museum*, a debate was raging about the impact of public access to high-quality digital images of collection objects. Would visitors no longer feel the need to visit museums? Would original

artifacts lose their "aura"? Would the role of curators be usurped if visitors could closely examine objects and sort them in various ways?[15] Today those concerns seem quaint, like the prediction that videotapes would lead to the demise of movie theaters. But museums and others are more worried than ever about how online digital content could be appropriated for questionable purposes in an era when savvy Internet users routinely mix and match images, music, videos and even databases to create everything from political spoofs to dynamic maps of UFO sightings. While some content owners recoil and sue for copyright protection, others allow or even promote the creative re-use of their content— witness how George Lucas, the creator of *Star Wars*, has cultivated a whole new generation of fans by allowing and in some cases encouraging amateur spinoffs that have appeared online in recent years.[16] *Wired Museum* contributor and informatics professor Howard Besser certainly hit the nail on the head when he predicted (with some regret) that the public would come to "view culture less as something to consume and more as something to interact with."[17]

The reaction of museums to the freewheeling Web 2.0 atmosphere is no different than that of most other content providers. On its face it appears to be an unprecedented opportunity to show that museums are serious about community involvement and ensure that we remain relevant to our audiences; yet the idea of deliberately diluting our intellectual content with substantive input from users—allowing their material to appear in connection with our trusted "brand"—makes us extremely uncomfortable. Law professor James Boyle of Duke University's Center for the Study of the Public Domain has theorized about why intellectual property owners feel threatened at the prospect of user participation. According to Boyle, content owners have historically had a tendency to be blind to "the opportunities that commons-based production . . . the non-property, less control, open access side of things tends to offer," while overvaluing tight control of ownership rights, rules and even methods of distribution. As a possible explanation he suggests that our instincts, laws and institutions were formed to protect physical property—a role still crucial to most museums. Digital assets, while similar in some ways to physical assets, have their own distinct qualities and should be offered up with a greater awareness of the balance between protection on the one hand and a lessening of control on the other.[18]

Leading thinkers about museums and Web 2.0 have identified institutional bias of the sort described by Boyle as the greatest obstacle to the adoption of a more user-centered approach. To combat this bias, some have seized on the notion of "radical trust," which suggests the need for a more intimate, equal relationship

between museums and constituents. The term is credited to librarian and blogger Darlene Fichter, who suggests that emergent systems—those built collaboratively by end users, without high levels of top-down structure or governance—can be successful only if established institutions trust their constituents to be not only users and customers but participants and co-creators.[19] Fichter emphasizes that inherent to any emergent system is the expectation—and, to a certain extent, tolerance—of some level of abuse, with mechanisms in place to prevent or correct it. Blogger Seb Chan of the Powerhouse Museum, in Sydney, Australia, picked up on this point: "Most 'systems' of trust in Web 2.0 applications are specifically constructed to encourage and protect, through safeguards and small but not insignificant 'barriers to participation'—what is being described as 'trust'."[20] With the exercise of appropriate caution, it is possible to be inclusive without being reckless.

BENEFITS OF PARTICIPATORY LEARNING

Much could be said about the benefits of museums allowing a loyal community of supporters to extend our knowledge and help contextualize our collections. More important in terms of our educational mission is the effect that user participation can have on the audience as learners. As informal learning online is treated elsewhere in this volume, let us briefly consider a few key principles of museum learning that, in each case, can be addressed by the thoughtful application of Web 2.0 methods:

- Visitors do not typically view museums as classrooms for in-depth learning so much as smorgasbords of content with which to construct their own meaning and associations based on individual interests and background.[21] Museums should not discount this mode of learning "out of fear of being unable to control the results. . . . Such action (or inaction) ignores the human realities of how meaning is constructed and how museums currently are used by the public to support personal growth and development."[22]

- Museums play a crucial role in this dialogue with visitors by offering arrangements of objects, thoughtful interpretation and a unique setting for learning that work together to help visitors make meaning out of the world and understand their place in it.[23]

- Museums present one version of "truth," but objects can tell many stories and hold multiple potentially valid meanings. Visitors may be well served when museums facilitate informed discussion incorporating multiple points of view.[24]

- "Minds-on" interactivity is even better than "hands-on" when it comes to learning. Museums should offer opportunities to solve problems, pursue inquiries and other "activities that require attention, time and engagement."[25] All museum learners would benefit from methods employed at children's museums, where young visitors are given a high degree of autonomy and control over the learning experience, with frequent opportunities to act as facilitators.[26]

- Social interaction with family or group members, and even among unrelated visitors, is a crucial part of museum learning. Group learning is not only effective but economical, as group members distribute information and come together to share results. Museums can serve groups of learners by designing experiences for multiple users, fostering social interaction and placing motivated novices alongside knowledgeable mentors.[27]

- Successful museum learning is about making connections—between the new (and young) and the old, between the familiar and the unfamiliar, between experiences inside museums and life in the wider world.[28]

THE MECHANICS OF ONLINE COMMUNITIES

While we know quite a bit about visitor behavior inside museums, less is known about the virtual audience. Do users want a more participatory environment on our websites? A survey conducted in 2007 by the National Museum of Natural History, which asked users to rate potential features of a new Web portal on oceans, sheds some light. More than 800 responses broke out roughly into three tiers: 80–85 percent felt that "fun facts" and interaction with experts was important; 43–54 percent felt strongly in favor of the ability to customize or contribute content or see other users' recommendations; only 23 percent felt that discussion boards were important. Web 2.0 skeptics might conclude from these results that indeed users value expert opinion more than they want their own voices to be heard. Proponents might respond that over time, thousands of potential users who do want to play a more substantial role could add tremendous value to an important scientific site. The truth is undoubtedly somewhere in the middle—confirmed by trends seen in general studies of museum patrons—that visitors benefit from access to the interpretation of experts and the ability to participate in a substantial way in the learning experience.

Developers of Web 2.0 applications have come to understand that even if relatively few "power" users are making full use of the tools of participation, the benefits can extend to all members of an online community. Blogger and Internet

entrepreneur Ross Mayfield has given this phenomenon a name: the Power Law of Participation. Mayfield draws a scale with, at one end, large numbers of users who are reading, marking favorites, tagging or leaving comments—low-threshold activities that can be described as "collective intelligence." As the level of engagement increases the number of users drops, with "collaborative intelligence" activities such as refactoring, moderating and collaborating being performed by a few at the high end of the scale. According to Mayfield, it is these higher-order activities that form the core of successful online communities, but "[the] point isn't just the difference between these forms of group intelligence—but actually how they co-exist in the best communities." He cites the classic example of Wikipedia, where "500 people, or 0.5 percent of users, account for 50 percent of the edits."[29]

Another key concept when contemplating the chaos that could ensue from inviting user participation is differentiation of access. Some museums have experimented successfully with allowing select groups of outside contributors to, for example, add descriptive tags to works of art, help with object research or collaborate on exhibits. As Jennifer Trant of Archives and Museum Informatics points out, part of trusting our audience is knowing who our contributors are and assigning levels of access. "Trust is built on identity; identity requires identification. . . . Assessments of trust require a history of an individual's actions—linking their trace with a distinct identity. Individuals build trust by behaving appropriately, over time."[30]

CONCLUSION

As of this writing, museums have talked about online user participation a great deal but concrete examples with measurable results are only just emerging. An example from the physical realm, however, demonstrates what is possible when museums adopt visitor-centric learning objectives and interpretive processes. In 2005, the Los Angeles County Natural History Museum invited six local artists to create original works using museum collections in an exhibition titled "Conversations: Collections, Artists, Curators." The goal of the exhibition was to "help make visitors more open to the many ways and means of learning, including the use of the imagination." Moreover, the museum acknowledged that "part of the learning process might not necessarily lead directly to an appreciation of some new scientific fact, but it can serve as an important initial first step or stage in stimulating an interest in something new."[31]

Although the exhibition was highly popular with a broad audience, it is especially worth noting the positive reactions of both the artists and the museum staff to the unusual collaborative process. Said one exhibition curator, "As the artists made selections for their installations, our curators came to see the collections and our scholarly pursuits from fresh perspectives. The installations include items that we might have never placed on public view and juxtapose things that we would probably not have thought to put together."[32] One of the artists, expressing his pleasure at being invited to participate, said, "This exhibition gives me a chance to use the collections I loved as a child and the Native American material that has so informed my life to help celebrate the museum's magical potential."[33]

In similar fashion, Web 2.0 tools promise to enable many forms of what the Los Angeles County Natural History Museum calls "the countless potential dialogues between the museum and its public."[34] While this requires museums to deliberately lessen their control as to how their objects will be used, discussed and contextualized, the rewards are only beginning to be imagined. Deeper levels of trust and collaboration with users could not only improve learning and increase audience engagement, but also enhance knowledge and stimulate creativity across the board. Taking the long view, it is apparent that the Internet as a medium of communication is still in a young, experimental stage. But many think that it has the potential to rival the advent of the printing press in its ability to radically alter the transmission of culture, methods of scholarship and even relationships of power. It seems clear that in order to secure a role for museums in the twenty-first century, the current Internet phenomenon—some say, revolution—must be taken seriously.

NOTES

1. Lev Grossman, "*Time's* Person of the Year: You," *Time* (December 25, 2006): 40.

2. Steven Johnson, "It's All About Us," *Time* (December 25, 2006): 80.

3. *Wikipedia*, s.v. "Web 2.0," http://en.wikipedia.org/wiki/Web_2.0 (accessed December 21, 2006).

4. See Tim O'Reilly, "What Is Web 2.0: Design Patterns and Business Models for the Next Generation of Software," O'Reilly Media, Inc., www.oreillynet.com/lpt/a/6228.

5. For a fuller discussion see *Wikipedia*, s.v. "Folksonomy," http://en.wikipedia.org/wiki/Folksonomy (accessed June 21, 2007).

6. David Weinberger, "Folksonomy as Symbol," Berkman Center for Internet and Society at Harvard Law School, http://cyber.law.harvard.edu/home/home?wid=10&func=viewSubmission&sid=2541.

7. Elaine Peterson, "Beneath the Metadata: Some Philosophical Problems with Folksonomy," *D-Lib Magazine*, November 2006, www.dlib.org/dlib/november06/peterson/11peterson.html.

8. See the steve homepage, www.steve.museum.

9. *Wikipedia*, s.v. "Social Software," http://en.wikipedia.org/wiki/Social_software (accessed December 21, 2006).

10. *Wikipedia*, s.v. "Wikipedia," http://en.wikipedia.org/wiki/Wikipedia (accessed January 17, 2007).

11. Cindy Long, "Getting WIKI With It," *NEA Today* (October 2006): 40.

12. Cited in Elizabeth Merritt, "Root of All Evil? The Ethics of Doing Business with For-Profit Entities," *Museum News* 85, no. 4 (July/August 2006): 31.

13. Maxwell L. Anderson, "Introduction," in *The Wired Museum*, ed. Katherine Jones-Garmil (Washington, D.C.: American Association of Museums, 1997), 16.

14. Stephen Bitgood, Beverly Serrell and Don Thompson, "The Impact of Informal Education on Visitors to Museums," in *Informal Science Learning: What the Research Says About Television, Science Museums, and Community-Based Projects*, ed. Valerie Crane (Dedham, Mass.: Research Communications, 1994), 67.

15. See Anderson, "Introduction," 19; and Howard Besser, "The Transformation of the Museum and the Way It's Perceived" in *Wired Museum*, 153.

16. See Wikipedia, s.v. "Star Wars," http://en.wikipedia.org/wiki/Star_Wars (accessed August 9, 2007).

17. Besser, "Transformation," 121.

18. James Boyle, "Reinventing the Gatekeeper" (keynote address, "Beyond Broadcast: Reinventing Public Media in a Participatory Culture," Harvard University, May 12, 2006), www.beyondbroadcast.net/blog/?p=100.

19. Darlene Fichter, "Web 2.0, Library 2.0 and Radical Trust: A First Take," weblog, April 2, 2006, http://library2.usask.ca/~fichter/blog_on_the_side/2006/04/web-2.html.

20. Seb Chan, "Radical Trust and Web 2.0," weblog, August 31, 2006, www.powerhousemuseum.com/dmsblog/index.php/2006/08/31/radical-trust-web-20.

21. John H. Falk, "An Identity-Centered Approach to Understanding Museum Learning," *Curator* 49, no. 2 (2006): 161; and George E. Hein, *Learning in the Museum* (London: Routledge, 1998), 147.

22. Falk, "Museum Learning," 161.

23. Jay Rounds, "Doing Identity Work in Museums," *Curator* 49, no. 2 (2006): 139; and Daniel Spock, "The Puzzle of Museum Educational Practice: A Comment on Rounds and Falk" *Curator* 49, no. 2 (2006): 176.

24. Hein, *Learning in the Museum*, 151; and Spock, "Museum Educational Practice," 178.

25. Hein, *Learning in the Museum*, 143–144.

26. John H. Falk and Lynn D. Dierking, *Learning from Museums: Visitor Experiences and the Making of Meaning* (Walnut Creek, Calif.: AltaMira Press, 2000), 187.

27. Falk and Dierking, Learning from Museums, 194–195; Hein, *Learning in the Museum,* 146; and Rounds, "Identity Work," 142–143.

28. Falk and Dierking, Learning from Museums, 200; and Hein, *Learning in the Museum,* 153.

29. Ross Mayfield, "Power Law of Participation," weblog, April 27, 2006, http://ross.typepad.com/blog/2006/04/power_law_of_pa.html.

30. Jennifer Trant, "Trust, Audience and Community: Museums, Libraries and Identity," weblog, September 1, 2006, http://conference.archimuse.com/node/106.

31. Natural History Museum of Los Angeles County, *See | Hear: Museums and Imagination* (Los Angeles: Natural History Museum of Los Angeles County, 2006), 13.

32. Ibid., 19.

33. Ibid., 32.

34. Ibid., 19.

Why the Internet Matters:
A Museum Educator's Perspective

Deborah Seid Howes

MUSEUMS AND THE INTERNET: FRIENDS OR FOE

Most museums encountered the Internet in the second half of the 1990s when little more than its potential for instant, inexpensive and widespread information dispersal was understood. At first glance, the Internet appeared antithetical to the core of museum identity; museums are about the real while the Internet is about the virtual: how could they possibly work together? Much creative thinking about the opportunities presented in this electronic network was stymied by this seemingly fundamental disagreement. Now that museums are beginning to recognize online experience as an important amplification of their educational visions, the challenge is how to transform a perceived foe into a fast friend.

Figure 1. What do museums and the Internet have in common?

A good first step in creating friendship is to discover commonalities among entities. In the Venn diagram (Fig. 1), the shared area between museums and the Internet contains the terms "information" and "visitors." Although the manner in which information is presented in the virtual and the real environments is different, the content tends to be similar: wall labels, collection databases, press releases, teacher packets, calendars, floor plans, scholarly essays, reproductions, even merchandise catalogs are established at your local museum's URL. As museum visitors and staff are becoming increasingly Web savvy, museums are transitioning to electronic methods of information distribution such as e-newsletters, portable document format (PDF) downloads and podcasts, thereby reaching a larger audience faster as well as lowering print production and postal mailing costs.

Likewise, visitors, whether virtual or real, can do many similar things in a gallery as they can in Web space, such as learn, teach, socialize, participate, shop, plan, research and/or have fun. Museums have just begun to connect common museum visitor behaviors with typical Web ones. For example, some museums have enhanced audio tours with bookmarking capabilities in which a list of consulted objects is sent to the visitor's e-mail address after a museum visit.[1] This e-mail list is linked to additional information on the museum's website and becomes part of the visitor's personal museum history, which deepens and broadens with each visit to the museum or its website.

The resulting relationship between museums and the Web is dynamic and complementary. In the twenty-first century, museums need the worldwide exposure of the Internet to promote their collections and expertise and to bring virtual visitors to their physical doors. The Internet, having no knowledge of its own, needs museums' expertise to satisfy visitors' expectations for validated, well-organized content. Consequently, the Internet grows in intellectual value as museums' online contributions increase.

This partnership can flourish because the Internet and museums share a fundamental goal—providing the public with easy access to information—and because their differences (e.g., real versus virtual spaces, validated versus anonymous content) complement one another. The Internet cannot contain real works of (physical) art or actual scientific specimens but can support high-resolution representations of them, as well as provide cultural or scientific context for subjects that are sometimes not possible to physically incorporate in a real exhibition. The Internet makes no claim of authoritative content but supports a plurality of information and relies on others—museums, visitors, etc.—to make sense of it all. The more

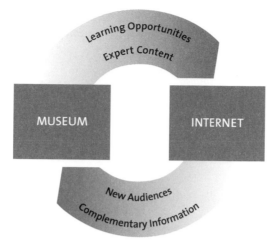

Figure 2. Museums and the Internet have a dynamic and complementary relationship.

museums contribute to the Internet in varying ways, the more Internet users will recognize museums as reliable sources of useful online information.

FROM THE INFORMATION AGE TO THE CONCEPTUAL AGE

For several decades proponents of traditional and progressive educational theories have argued whether developing memory, computation and analytic skills is more important than fostering creative, emotional and design abilities in students.[2] Essentially, the debate follows the division of labor between the left and right side of the human brain. The left hemisphere ingests large numbers of facts, analyzes them and creates efficient work systems, such as computer programs and factory processes that produce measurable results. The information age has been driven in large part by left-brained thinking and dependent upon standardized formulas to measure the promise and worth of its citizens. The brain's right hemisphere is its creative and emotional side: it makes meaning out of facts through design, narrative, play and other synthetic actions that elude quantitative measurement. Many educational theorists believe that the information age has been eclipsed— in part because of today's prevalence of information networks that can replicate much left-brain thinking—and that we are now entering the conceptual age in which right-brained skills will be paramount for success.[3]

Museums were born out of an Enlightenment attempt to understand the world by saving, naming and displaying its strange and wonderful elements in some kind of rational order. This premise fits nicely into the goals of the information age, as museums continued to serve as effective accumulators and valuators of historical,

cultural, scientific, aesthetic and other types of facts. Born out of the information age, the Internet is now the largest body of information known to man with the greatest breadth of topics delivered in the fastest way. In many ways, the Internet and museums are both products of left-brain attempts to understand, clarify and disseminate the facts of our world.

Recently, however, the Internet has been developing the right side of its brain. Of course, Web visitors will continue Googling for facts, but they are increasingly looking for personal expression, membership in social groups, learning opportunities and meaning-making. In essence, they are looking to feed the right side of their brain. Museums, in addition to their long-standing missions to keep the facts straight, have always appealed to the right side of visitors' brains. Museum exhibitions exemplify how creative minds weave facts into compelling stories: they allow us to empathize with animals, understand the importance of historic figures and model scientific and artistic processes, as well as provide opportunities for personal expression. As public institutions, museums are sustained by social membership and their missions are well balanced (hemispherically speaking) in their equal dedication to fact preservation and context explication.

On the virtual campus, however, the right side of the brain has not been well exercised by museums. Overall, museum websites are filled with facts and images, but have few opportunities for active, creative engagement. The following visitor activities are only a few examples of ways that museums can foster right-brain activities online.

Searching for Rich Information

Looking for information on the Web is often a tedious and inexact process in which individual searches yield hundreds of results to be judged. Connecting a museum's entire collection database of facts to the Internet is not as helpful as one might expect—those records only satisfy the most basic question ("Does the museum own any Vincent van Gogh paintings?") or research work ("Does the museum own the last drawing van Gogh created in Avignon?"). They mean nothing to the majority of searchers who wants to understand the meaning behind the facts ("Who was van Gogh? How did he make his paintings? Why did he cut off part of his ear?")

The same holds true for permanent collection galleries in which the object labels contain only name, rank and serial number information; other than

identifying the object, these facts do not serve the typical visitor well. In order to truly interest a visitor in understanding the meaning behind the facts, museums offer focused experiences in the form of special exhibitions, audio guides, group tours, kiosks or printed guides. Whereas most of the aforementioned exist for a short time in a limited space, content on the Web can live forever. Publishing contextual information about a collection in well-organized and predictable ways on the Web (e.g., a timeline of van Gogh's life, an essay on his painting style, biographical information based on his letters) not only supports a Web visitor's ability to make meaning from facts but, with correct tagging practice, it also raises the chances that more museum content will be found by all users via search engines. In other words, if a museum continually produces useful, inclusive information on the Web, it will continually bring new online visitors to its doors.[4] Conversely, if a museum does not create significant useful content on the Web, it ceases to exist for a great many that rely on search results to guide their research and planning.

Learning in Groups

Some visitors come to museums to learn with others in informal, drop-in gallery tours or formal classes for which they might make reservations and/or pay fees to attend. The Web also provides informal and formal methods of group learning. Dropping in on a live chat or contributing to the threaded discussion of an e-mail forum gives users an instant sense of the latest news on a topic and, possibly, access to a participating expert. Enrolling in a distance-learning class is a more structured experience: a teacher can set up a syllabus, assign readings and homework, facilitate discussions (which can be synchronous or asynchronous) and even administer exams.

Many museums already serve visitors beyond their walls, either by traveling to their communities with PowerPoint presentations at the ready, or by using twentieth-century technologies like telephones and video to exchange information over a long distance. Although these techniques continue to be effective, the great advantage of the Internet-based or -enhanced classroom environment is twofold: it utilizes a mixture of communication media—audio, video, e-mail, chat, threaded discussions and webpages filled with text and images—and the consultation of these materials can occur before, during and/or after class sessions. As a result, unlike most museum group learning, which occurs in a fixed place at a fixed time, group learning on the Internet can occur anytime, anywhere there is a computer and an Internet connection. The multiple ways in which students and teachers

communicate in an online classroom environment also lead many to feel that they have more opportunities to socialize with their fellow students than they would in a traditional classroom setting, as well as more sustained access to the teacher and the study materials.

Social Interaction

Since many visitors come to a museum for unstructured social activity, museums typically create spaces and opportunities for friends and strangers to talk, eat, rest, read, shop and more. Long, wide benches and Friday night jazz in the galleries both contribute to the hospitality of a museum. The growing popularity of social-networking sites on the Web means that users are also seeking social interactions online. These sites offer a number of opportunities for visitors to learn about and interact with each other, as well as to feel a part of a special group. Museums are only beginning to understand how their websites can be more accommodating to this kind of social interaction, especially as it pertains to membership. Fostering social activities in an online space is a new challenge for museum program staff but could be well informed by some old museum tricks: inventing group tasks such as collection-based treasure hunts, sparking discussion on current events or inviting Web visitors to create and share content. What would be the digital equivalent of wine and cheese?

Visitor-generated Content

Although no visitor expects to write a label or create an exhibition while visiting a museum, Web visitors increasingly expect to make content contributions to websites that go far beyond registering personal preferences. Currently, opportunities to generate Web content exist for every age and type of visitor. Children can enter virtual worlds to create and decorate fantasy houses, characters and wardrobes for their own delight and that of others. Many teenagers publish a variety of Web content daily on social networking websites and add their thoughts to group blogs. There are many media management websites that facilitate the sharing of copyright-free digital images, videos and sound, allowing amateur as well as professional artists to exhibit their art directly to the public for comment and use. Wikis provide easy-to-use publication tools that allow anyone, expert or not, to contribute to various knowledge-bases.

Much of the above Internet activity—which is steadily growing in popularity— can be seen as antithetical to the concept and foundation of museums. Museums were created to make sense and order in a world full of curious items and

inexplicable phenomena. They supported generations of experts to train in the connoisseurship of objects, details of history, annals of science and anthropology of the world. What role can museums play on the Internet if Web visitors are increasingly interested in the personal thoughts, images and sounds of individuals who are largely unknown and whose content is unedited and unauthorized?

The truth is that Web visitors and museum visitors are the same people. The desire to express or understand oneself is just as strong a motivator to visit a museum or a website as the urge to know more about the outside world. And how do savvy museum educators lead a group tour when personal misinformation volunteered from visitors is overshadowing authoritative content? They connect a visitor's personal observations to a wider truth that everyone in the group can appreciate and scholarship can support. Likewise, museums can welcome visitors' Web content in a format for steering towards a productive path of inquiry supported by institutional knowledge. The most valuable kind of information museums can provide to a conceptual age audience is the modeling of expert thought. The explanation of how something is known from a collection and analysis of facts will help your Web and museum audiences to edit their own content and bolster their expert thinking. The interaction can be as controlled as a "Dear Abby" column or as individualized as contributions to a folksonomic database, or as open as a blog, depending on the educational goals and temperament of the institution.

Serendipity

There is one final visitor expectation that cannot be overemphasized in this discussion of visitor behavior and yet is often overlooked: the joy of serendipitous discovery. Visitors come to a museum or a website with a purpose—to see an exhibition, research a topic, participate in an event—yet inevitably discover something new and unexpected: an answer to a long-standing question; images recalling family history; a conclusion they made on their own. Whatever the outcome, visitors know that each time they go to their favorite museum or a great website, they will be surprised with a new discovery. Although it is impossible to plan for specific serendipitous discoveries, museums know that surprise regularly occurs in their galleries. Internet activities that include surprising experiences, whether based in past visitor behavior ("people who like this book also bought this book . . . "), anticipated by Web authors ("webquest of the week") or randomly generated ("collection object of the day") are all well received by the Web public and can easily be better integrated into museum websites.

MUSEUMS AS LEADERS IN THE INTERNET'S FUTURE

Museums are uniquely poised to develop both sides of the brain: They are filled with authoritative facts and are good at making meaning of them and helping others to do the same. Yet too few museum staff members have understood how the Internet can support these left-brained activities in an online environment. Museums that have made significant contributions in this area rarely present their achievements within an educational framework that others, especially nontechnical staff, could learn and adapt. As a result of this and other factors, much pioneering museum work on the Internet does not translate into models for others to follow. The following three ideas for developing an educational strategy for Internet content are all easy to implement.

1. Bringing Educators to the Internet Leadership Table

For museums to support more and varied kinds of Internet visitor behavior, it is essential to include the leadership of educators. Through their teaching and publications, educators understand the many ways visitors make meaning in informal learning environments, and continually observe how serendipitous discovery and social engagement are essential learning motivators. The historic role of educators as audience advocates is even more important in a virtual space where opportunities to observe and measure visitor behavior are very limited.

Once educators explore and experiment in the virtual informal learning environment as well as witness behavior among anonymous Web visitors, they can and will think differently about planning educational experiences for all visitor types.

2. Using Existing Internet Tools

One reason more museums have not been at the forefront of computer-based activity design heretofore is that creating well-designed content required expert knowledge in computer processes and a fair amount of funding. Happily, the advent of free, easy-to-use Web-based production tools means that this is no longer the case. As of this writing, Google alone allows users to translate English words into 22 languages; design their own webpages or make a 3-D model; download maps and graphics into handheld devices; and participate in as well as make their own chat rooms, blogs, threaded discussions, sharable calendars, picture albums and collaborative work spaces—all free to anyone who can access the Internet.[5]

Becoming familiar with these and the myriad of other free content-generating tools will inspire creative educational applications for both online and in-museum visitors. For example, some educators are already using groupware to organize and support teacher workshops: Attendees "meet" each other and have access

to a selection of online reading materials before they show up for class at the museum. Using groupware, students can participate in online discussions with the instructor before, during and after the in-person event at the museum. The goal is to make the in-museum component as rich and productive as possible with educators that are already familiar with their students and students who have already familiarized themselves with the material.[6]

An effective Internet presence not only requires a museum to have its own website with a stimulating range of information and activities but also a proactive association with popular Web destinations in the relevant field of interest. Wiki-based encyclopedias, audio and video distribution portals and social networking sites should contain museum-generated, stimulating and timely content associated with museum URLs. A concerted effort by a museum to keep this externally placed information fresh and lively will be rewarded not only with increased visitor traffic back to the museum's homepage but also a positive view of the museum as a valued contributor to the Internet world of shared knowledge. Moreover, using someone else's website to publish your content means you are conserving the museum's resources to achieve your educational goals.

Another prime location for an "off campus" museum presence is the growing number of richly immersive and highly scalable virtual world sites such as Second Life.[7] Here Web visitors assume identities (that may or may not relate to those in real life) that live in a three-dimensional, real-time world built by community members. Real-life institutions, including museums, are creating "storefronts" in these environments as a way to increase their visibility in both worlds. Universities erect campuses in virtual worlds where social activities are organized, instruction takes place and students hang out.[8] Similarly, museums could make better use of the virtual world tools to organize educational activities parallel or in supplement to real-life ones. Imagine a virtual archaeological site built according to early twentieth-century scholars' measurements and memoirs, in which museum time-travelers could witness reenactments of historic archaeological activities and then conduct excavations guided by current ethical standards. Creating these rich, immersive educational online experiences no longer requires exorbitant funds or advanced computer expertise. Prefabricated spaces can be rented and inhabited quite easily in the education-minded areas of some virtual worlds or custom spaces could be constructed by computer-savvy virtual world volunteers. Developing communities of online museum volunteers is a new and promising area of museum outreach that can also create new possibilities for group learning.

3. Connecting the Virtual with Real Experiences

Although the thrust of this chapter is about what museums can do in the Internet world, a good Internet strategy must also include the real world. As visitors increasingly use the Web to plan their actual visits, museum floor plans, the nomenclature of museum spaces and the schedule of events and exhibitions all need to be identically described in both places. This has inspired some museums to rethink their workflows so that the production of content can be streamlined and repackaged for simultaneous virtual and real information displays, as well as downloading into mobile devices and other future applications.

Further, all new museum construction plans should include provisions for high-speed data connectivity and clean, robust electricity throughout the public as well as staff-only spaces. Pioneering experiments and evaluations done in the 1990s by a variety of museums including the San Francisco Museum of Modern Art and the Minneapolis Institute of the Arts demonstrated that visitors expect to find rich, Web-like information about the collection somewhere in the physical museum space as well as on their home computers.[9] Many museums, large and small, that rebuilt their galleries and/or educational spaces since 2000 now regularly include dedicated areas for computer terminals alongside books, films, staff members and other resources that information-seeking visitors consult at their leisure.[10] Even if the museum has no immediate plans for such dedicated spaces, planning for the information infrastructure in the form of wires and conduit during new construction means that the museum will be equipped to bring an Internet presence into the museum space with greater ease in the future.

Like our university brethren, museum professionals are rethinking the future of museum education classes. Distance learning, however executed, is now a common instructional alternative and visitors expect Web courses on museum-related topics as well as Web versions of programming that are museum-based.[11] As video and audio capture equipment continues to get cheaper, better and smaller, and high-speed wireless communication has become more pervasive, museums are better able to capture real-time events for wider use and seamlessly mix physical with virtual educational activities. A live Web conference among museum visitors on different continents could take place in a gallery of Rembrandt paintings; the technology intrusion could be no more than a few laptops equipped with built-in webcams and a palm-size video camera, as long as the behind-the-scenes technical and physical infrastructure is in place.

CONCLUSION

The Internet matters to museums because the information and educational needs of the world are changing in the twenty-first century. Just as the building of railroads in the mid-nineteenth century changed perceptions of space and time, we are now experiencing nothing less than the shrinking of Earth as we communicate instantly and seamlessly across the globe.[12] The nature of this communication is expanding from prepared monologue to include spontaneous dialogue reflecting the culture, education and personal background of global visitors. Providing not only the validation of facts but also the extended context and expert thinking in which these facts operate is essential for museums to preserve their credibility and relevance in this noisy exchange. The context of learning is also changing: increasing numbers of students of all ages are reaching out beyond the classroom to find stimulating educational experiences online. The Internet is an ideal platform for achieving all of these educational goals while also enabling visitors to experience the joy of learning in a self-directed environment—like they do in a museum.

Most museums today recognize the Internet's important capacity to help them achieve strategic goals such as boosting attendance, expanding audiences and improving pubic education. But the "how" is only barely understood. Museums must broaden their institutional focus beyond an organization rooted in an exclusive place in real time to a ubiquitous source of around-the-clock educational experiences. This evolution requires time and effort for museum staff teams to reimagine how the breadth of museum content—including its collection, publications, conservation work, scholarship, programs and archives—can effectively participate in this communication partnership spanning the real and the virtual. Once reimagined, museums as a group will play an influential role in a wider spectrum of educational efforts and thereby command greater credibility among conceptual age information consumers, wherever they might be.

NOTES

1. The Peabody Essex Museum in Salem, Mass., was one of the first museums to incorporate a bookmarking practice with their audio tour. See www.pem.org.

2. The most influential of the progressive theorists in the U.S. was John Dewey, who argued for the primacy of the learning experience. See for example, John Dewy, *Experience and Education* (New York: Macmillan, 1938). His legacy is continued today by many academic leaders such as Howard Gardner who has defined a variety of ways people acquire information and advocates for teachers to provide a "multiple intelligence" approach to their teaching;

see Howard Gardner, *The Development and Education of the Mind: The Selected Works of Howard Gardner* (London: Routledge, 2006). A museum version of this topic is well developed in Lisa Roberts, *Knowledge to Narrative* (Washington, D.C.: Smithsonian Institution Press, 1997).

3. For an easy-to-read version of this conceptual age theory, see Daniel Pink, *A Whole New Mind: Moving from the Information Age to the Conceptual Age* (New York: Penguin Group, 2005).

4. The Timeline of Art History, published in 2006 on the Metropolitan Museum of Art's website, www.metmuseum.org/toah, experienced dramatic growth from 10,000 to 20,000 visitors per day. Most of these new visitors were drawn from popular search engines, not from the Met's website pages.

5. In fact, this paper was composed and revised using a Web-based editing tool that allowed me and the editors in Washington, D.C., and Anchorage, Alaska, to work on it simultaneously.

6. Educational institutions including museums recently have begun to collaborate in making free content–generation tools including multimedia presentation software such as Pachyderm (www.pachyderm.org), educational environments such as Epsilen (www.epsilen.com) and social tagging such as steve (www.steve.museum).

7. For a full description of the educational implication of virtual worlds, see *The Horizon Report 2007 Edition,* published by the New Media Consortium in collaboration with Edu-Cause Learning Initiative, Austin, 2007, www.nmc.org/horizon. For an example of a virtual world, download Second Life at www.secondlife.com.

8. See Christine LaGorio, "Pepperdine in a Treehouse: Cyberclass in Second Life is the Ultimate in Distance Learning," *New York Times* (January 7, 2007) Education Life sec., pp. 22–23.

9. See results of a 2004 study, "IMLS What Clicks? Report," at the Minneapolis Institute of Arts, www.artsmia.org/index.php?section_id=80.

10. See, for example, new education-oriented spaces at the Tate Modern, London; the De Young Museum, San Francisco; and the University of Texas Blanton Art Museum, Austin.

11. For example, the Metropolitan Museum receives regular inquiries (usually via e-mail) from visitors asking for either a Web-based course or a webstream of a museum program they recently missed.

12. For an interesting discussion of how technology changed perceptions in mid-eighteenth-century, see Wolfgang Schivelbusch, *The Railway Journey* (Berkeley: University of California Press, 1977).

Real-time Learning, Outreach and Collaboration

Jonathan Finkelstein

While the public perception of museums might center first on the inanimate objects they house or the pasts they preserve, at the heart of the museum experience are the real-time activities of living human beings. Whether they are leading tours, answering questions, conducting gallery talks, sharing firsthand knowledge, telling stories, performing, reaching out to the community, facilitating workshops, researching artifacts or collaborating with other institutions—people are what breathe the life into every aspect of the museum mission. To take the museum onto the Web and focus exclusively on objects and collections, therefore, ignores a great component of the museum experience, the part brought to life through real-time interaction with museum professionals and the experts and storytellers they embrace.

Real-time communication has been a function of the Internet since it was created, and the World Wide Web, especially with the most recent innovations in Web based technology, has made real-time online communication a part of daily life for millions worldwide. With instant messengers, Internet phone calls, online chats, virtual classrooms, Web meetings, webcasts and multi-user virtual worlds, today's connected population spends a growing percentage of their waking hours communicating in real-time online with people far and near. Individuals, schools, companies, associations and other organizations are finding and adapting their rhythms live online, and the world is ready for museums that do the same.

There are many ways in which museums can make their human assets accessible to people outside the museum's physical exhibit halls, seminar rooms and

information desks in a manner that is both meaningful and practical. In this chapter, I explore the potential for online, real-time contact across museum functions in support of the institution's mission. For museums considering their overall contact strategy with the patrons they serve—and trying to leverage their Web presence in more dynamic ways—this will hopefully spark a sense of the rapidly evolving possibilities.

ABOUT REAL-TIME VENUES

Before jumping headlong into a discussion of how real-time tools can be employed in museum settings, it is useful first to take a brief look at the spectrum of virtual venues that enable this kind of instantaneous communication. With innovation moving at a rapid pace, attempting to classify real-time, or "synchronous," online venues is very much like shooting a moving target.[1] Nonetheless, a common set of attributes define the field.

One of the most basic real-time functions is the ability for two or more people online at the same time to send and receive text-based messages. This functionality, often called "chat," is the core communication component of instant messenger (IM), virtual reference and chat room tools. For many adults, use of IM is rapidly overtaking their use of e-mail as the chief means to communicate online—and for many younger Internet users, it already has.[2] Among the reasons for its popularity is the ability of IM tools to detect and display "presence"—a sense as to whether someone is available to communicate at a given time—and the ease with which one can get just-in-time answers from peers, experts or colleagues while multitasking on other activities. It is these attributes that make text-based messaging ideal for online helpdesks, virtual information booths and live online reference, a service area growing in popularity among libraries. It is important to mention that instant messaging is not just a social activity; it has rapidly become a communication tool that is critical to businesses and other organizations' missions.

Rapidly improving bandwidth, combined with the proliferation of free and low-cost applications and a higher performance level for even the lowest common denominator of consumer hardware, has made reliable use of the Internet for real-time audio and video conversations a common online activity. The technology for receiving and transmitting voice over the Web is not new, but technology innovations and a higher comfort level among users to do more with their computers has quickly brought this mode of technology-mediated human interaction to millions worldwide. No longer is the ability to broadcast limited to

those with access to expensive or bulky equipment, professional technicians and high-end studios. Just as the introduction of the mouse-driven word processor application in the 1980s made every house into a printing house, so has the convergence of new audio and video technology turned every personal computer and mobile device into a personal, interactive television or radio station.

Online audio and video capabilities are integral parts of most virtual classroom and Web-based meeting venues used for learning and collaboration among groups. Although the traditional, one-way transmission of audio or video to a passive audience that defined the earliest days of live webcasting is still quite common, it is giving way in many settings to more opportunities for audience members to be true participants, interacting with facilitators and with each other.

Real-time text, audio and video are complemented by a variety of other convergent features that can differ in their availability from one virtual venue to the next. Capacity to control the showing of slides, images, webpages and documents to multiple people connected to a given real-time online setting is key to transforming spaces for casual exchanges into true teaching, meeting and presentation environments. Add more interactive features, such as shared remote control of one person's desktop application, the ability to draw and annotate images together on the same virtual whiteboard or to divide larger groups on the fly into smaller break-out rooms for concurrent discussion, and your real-time venue becomes a true collaborative and learning environment.

The great potential of real-time platforms is the capacity to foster meaningful dialogue and sharing among two or two thousand people at the same time, regardless of their location. Yet for many, the most expedient organizational use of synchronous tools over the years has been to bring the standard lecture online. A pure broadcasting model for carrying the museum's offerings beyond its walls does not require much new thinking. Museums know a lot about what makes a good audio or video production. Interactive, online real-time venues, however, hold great promise for how we engage our visitors and learners in a true conversation. Before even considering the technology used, the two key elements of successful real-time activities are: (1) the appropriateness of the decision to do something live in the first place, in light of countless alternatives, and (2) the quality of the time spent together, which often falls into the hands of the person who convened or is facilitating the online gathering. Not coincidentally, these are the same benchmarks that define a well-conceived, live, offline event.

While I do not envision a world in which all museum-based communication happens live online, I do hope for one in which the merits of real-time exchanges are treated as a viable and important option to engage patrons, tell stories and share knowledge in ways that are best suited for shared, real-time presence.

IT'S THE RIGHT TIME FOR REAL TIME

The time is right for museums to play a leading role in producing and facilitating compelling live online activities and offerings. Collectively, museums have generated some of the highest-quality, media-rich content on the Web. A glance at the projects recognized annually by the American Association of Museums' Media and Technology Committee MUSE Awards illustrates museums' growing comfort and skill in translating in-person production expertise into immersive online experiences.[3] It is a natural next step to bring the museum's human-centered activities online in the same high-quality manner.

Museums are also notoriously challenged for space. Current exhibitions typically only showcase a fraction of an institution's total collection. And gathering spaces for live events are rarely of the size or in the supply that each museum would desire. Real-time virtual venues not only offer opportunities to bring virtually countless people together at the same time, they can also bring a sense of place and a feeling of proximity to participants. Whether a virtual seminar room is used to host a real-time online gallery talk, or a three-dimensional, virtual museum annex in a multi-user environment serves as home to a guided tour, museum professionals can spread their wings wider when not restrained by square footage.

New projects at nonprofit institutions often require new fundraising efforts, sponsors and long lead times. Fortunately, there are a growing number of free or low-cost ways for museums to bring activities live online and emerging online techniques for getting greater mileage out of the work done to produce physical events. Real-time online programs can also be crafted as revenue-generating opportunities by assessing participants an appropriate fee or linking online events to sponsor support that generate new and sustainable sources of income for the institution.

The benefits of collaboration among multiple museums on common projects and the decentralization and telecommuting of team members working to mount exhibits makes real-time online meetings a natural venue for museums to consider. An exhibition manager at a small museum, for example, can employ and meet with a graphic designer in another state online to review and mark

up panel compositions in real-time on a digital whiteboard, speeding up the production process and bringing skills to the local team that might not otherwise have been readily available.

Connecting with audiences for whom the museum is not accessible, due either to distance, physical disability or other logistical concerns, opens up a new avenue for museums as well. Making live museum programs available to students in other states and countries and giving homebound patrons access to museum staff—no matter where their homes may be—delivers on the true promise of a presence online.

One of the most compelling reasons that the time is ripe for museums to explore their "human side" in real-time online is that new audiences are already expecting it. Young learners are coming of age in a connected world, in which three-dimensional environments, Internet phone calls and real-time image sharing are routine. Roughly half of all teens today make daily visits to social networking sites online, more than 80 percent play games online and many consider e-mail old-fashioned compared to instant messaging.[4] As Deborah Schwartz advises, "It should be anticipated that youth programs that exploit new technologies will hold an increasingly important position in our museums."[5]

EDUCATION AND SCHOOL PROGRAMS

Education in a Web-connected era knows no boundaries. A docent able to impart an appreciation for history while interacting with people at a museum could just as deftly spark understanding by answering questions during a virtual tour for visitors thousands of miles away. Colleges, universities, training departments and a growing number of museums have been discovering virtual classrooms as a way to harness the give-and-take that is the hallmark of successful in-person learning moments.

The New York Transit Museum, which is physically located in a decommissioned subway station in downtown Brooklyn, uses a virtual classroom to extend the reach of museum educators from their underground location to classrooms in and beyond New York City. In one example, students in Boston, Philadelphia and upstate New York, not able to readily make the long trip to Brooklyn to learn about urban transportation, logged in at the same time to learn more about a temporary exhibition at the museum that featured a rare collection of subway car advertisements. Meeting the students online was a museum educator, curator and a guest expert, a pioneer in the field of public relations and advertising who

had consulted on the exhibit. The experience allowed all sites to see and hear one another from their respective desktop computers, show each other slides and images and mark up the same screen together, all at the same time.

Prior to the real-time event, the students were invited to independently study the museum's on-demand, online resources on the topic. They logged into the virtual classroom ready to ask follow-up questions of the museum's team. In addition to a lively question-and-answer period, the live online session included a discussion in which students compared aspects of public transportation in their respective regions. The give-and-take concluded with remote teams of students leading a short series of presentations based on their own research. The authenticity of the museum audience and subject experts, who provided feedback and encouragement, motivated the students to conduct quality research and stimulated their interest in the subject beyond the virtual classroom session.

The same museum also extends its use of the real-time online environment to provide special sessions exclusively for teachers. These intimate sessions with museum education staff help prepare educators for upcoming field trips with their classes, provide a live tour of the museum's growing online resources and foster conversation on how best to utilize these resources in classroom lessons. Such sessions are not only an important channel of communication for teachers, but also a meaningful way for museum staff to better appreciate the needs of and build stronger relationships with the populations they serve.

PUBLIC PROGRAMS AND HANDS-ON ACTIVITIES

Numerous museums, such as the Whitney Museum of American Art in New York, and Tate Modern in London, broadcast one-way, live online video and audio feeds of certain events taking place at the museum. Some institutions go a step further in making the events more interactive. The Exploratorium in San Francisco produces dedicated broadcasts for an online audience, during which participants submit text-based questions for the hosts or guest experts to answer in real time.[6] An increasing number of museums and cultural institutions also offer ongoing live feeds from their grounds or facilities. The Monterey Bay Aquarium, for example, transmits 12 hours of live video per day from multiple fixed camera locations, offering online observers a selection of views of the local ecosystem.

At nearby California State University at Monterey Bay, the ROVing Otter project allows remotely located students to control an undersea exploration vehicle in real-time from their classrooms using only a Web browser.[7] And students enrolled

in the distance education program at North Island College in Vancouver have control from anywhere they have Web access of a telescope pointed up at the dark night skies over Tatla Lake. Learners use their Web browser to position the telescope and then snap, save and analyze images of the stars and planets.[8] This kind of Web-mediated, remote, real-time control of physical apparatus and objects suggests an exciting future for hands-on exhibitions and activities created by museums.

EXHIBIT PLANNING AND MUSEUM COLLABORATION

Fostering relationships with patrons in meaningful ways via the Internet is but one part of the promise of today's online communication options. Real-time online tools also make it easier for museum professionals to collaborate with one another and with a broad range of institutions. Technology has made partnerships and projects possible that would have been too expensive or logistically impossible not too long ago. For many museums, collaboration is not just welcome, it is necessary.

The Smithsonian Institution's National Museum of Natural History has created a collaborative multi-institutional network to produce the Ocean Portal, part of the Smithsonian Ocean Initiative.[9] The initiative is designed to enhance ocean literacy worldwide. For this large-scale project, the Smithsonian partnered with the National Oceanic and Atmospheric Administration and created a collaborative, diverse network including institutions such as Woods Hole Oceanographic Institution, SCRIPPS Institution of Oceanography, the Monterey Bay Aquarium and Research Institute, LearningTimes, the American Association for the Advancement of Science and the United States Navy.

A collaboration of this scope would be untenable without affordable and efficient ways to bring key team members together. Frequent air travel for so many players is not practical. The cornerstone of the Ocean Portal communication strategy is an online community featuring a real-time virtual meeting room. Every few weeks, project stakeholders log into the conference room to share progress updates and discuss project ideas and directions. Using Voice-over-Internet Protocol (VoIP), application sharing and shared Web browsing tools, they look at related resources together, collaborate on project plans and documents and brainstorm new ideas. All online meetings are automatically recorded and posted to the online community to document the history of the project and serve as a resource for team members not present at the live gathering.

PROFESSIONAL DEVELOPMENT

Real-time platforms play an important role not only in staying connected to colleagues but also in staying connected to the museum profession. In rapidly changing times, knowing the latest approaches in the field is crucial, whether they pertain to collection management, school programs, leadership or technology. Some of the highest quality professional development comes in the form of networking with peers at face-to-face conferences. Only a relatively small percentage of museum staff, however, is afforded the opportunity to travel to regional or national conferences in a given year. For example, in 2007, at the American Association of Museum's largest annual gathering to date, more than 6,400 people made the trip to Chicago out of a total of 17,000 individual members and 3,000 museum members.[10]

One group that has recognized the opportunity for more frequent and more affordable professional development is the New Media Consortium (NMC), a not-for-profit organization of hundreds of leading colleges, universities and museums dedicated to the exploration and use of new media and technologies. The NMC hosts two or three online conferences each year on targeted themes, such as visual literacy, online gaming and the convergence of Web culture and video.[11] Following a call for presentations, hundreds of professionals meet online over a two- to three-day period to interact with one another in live online workshops, panel presentations and keynotes and to network behind the scenes via instant messaging. In the absence of travel costs for participants and staff and the high overhead of a physical convention center, online attendees enjoy easy and inexpensive access to their peers and the latest thinking in the field. The multiday and live nature of these online events creates a frenzy of activity around each topic, with an emphasis on dialogue and collaboration. Not having even left their desks, participants can immediately apply their learning and instantaneously tap into their new network of peers and partners in the field.

Online courses also can play a role in the professional development of a museum professional today. Museum-Ed, an organization dedicated to providing museum educators opportunities to exchange ideas, conducts a series of live online virtual classroom sessions that focus on learning theory for museum professionals.[12] The sessions are facilitated, but characterized by informal and collegial discussions, brainstorming and conversations about how to adapt each concept to what is going on in the education department at each participating museum. An intimate learning experience unfolds with only an inexpensive headset, microphone and

Web browser. Ongoing professional development and networking is no longer captive to small budgets and infrequent gatherings in distant cities.

MULTI-USER VIRTUAL MUSEUM SPACES

Museums have been exploring the potential of computer-generated, three-dimensional representations of gallery spaces for some time. Until recently, however, these forays have largely centered on an individual conducting a solitary virtual walk-through of a museum-crafted space. Today, multi-user virtual environments allow millions of users to navigate the same virtual spaces at the same time and in the company of others over the Web. This opens the door for museums to offer new types of immersive experiences. A museum can offer human-guided, online tours of recreations of exhibition areas, or render a new three-dimensional "dream wing" with no physical counterpart and open the space up for public programs not possible in their cramped quarters.

The United States Holocaust Memorial Museum, recognizing the need to share information about a genocide crisis in the Darfur region of Sudan, has moved its call for action to an increasingly popular three-dimensional, multi-user online community: Second Life. During a scheduled panel presentation sponsored by the museum, avatars, or virtual representations of each speaker, took to the three-dimensional stage to plead their case via a live audio stream.[13] Visually "seated" in the audience were the avatars of those in the online community who were present for the event. Unlike a straightforward webcast of a museum-based program, participants saw human-looking representations of each peer who was "there" with them. They could chat with one another, share ideas or simply enjoy the presence of others interested in the same topic. This notion of "shared presence" is common to most successful live online activities because it taps into a human need to be social and connect with others in a meaningful way.

CONCLUSION

For some time, a museum website was seen merely as a digital brochure, a tool to convey informational details about museum visits, hours and exhibits. More recently, museum websites have advanced to connect visitors more interactively with collections that better respond to each visitor's needs. But museums are not just repositories for objects; they are gathering places for people. The next step in the evolution of a museum's Web presence is to make the human activities that define a museum's programs, services and expertise accessible to a wider audience online. As such, museums will increasingly make a human presence online part

of their institution's strategic, communications and outreach planning. The future looks exciting for museums willing to recognize the value of connecting their professionals online in real-time—in a very human manner—with the audiences they serve and with each other.

NOTES

1. Jonathan Finkelstein, *Learning in Real Time: Synchronous Teaching and Learning Online* (San Francisco, Calif.: Jossey-Bass, 2006).

2. Eulynn Shiu, and Amanda Lenhart. "How Americans Use Instant Messaging," Pew Internet and American Life Project (September 1, 2004), www.pewinternet.org/pdfs/PIP_Instantmessage_Report.pdf.

3. See www.mediaandtechnology.org/muse.

4. Amanda Lenhart and Mary Madden, "Social Networking Websites and Teens: An Overview," Pew Internet and American Life Project (January 7, 2007), www.pewinternet.org/pdfs/PIP_SNS_Data_Memo_Jan_2007.pdf; Amanda Lenhart, Mary Madden and Paul Hitlin, "Teens and Technology: Youth Are Leading the Transition to a Fully Wired and Mobile Nation," Pew Internet and American Life Project (July 27, 2005), www.pewinternet.org/pdfs/PIP_Teens_Tech_July2005web.pdf.

5. Deborah Schwartz, "Dude, Where's My Museum? Inviting Teens to Transform Museums," *Museum News* 84, no. 5 (September/October 2005).

6. See www.exploratorium.edu/webcasts.

7. See http://science.csumb.edu/ro.

8. See http://142.25.208.57/tloo/index.htm.

9. See http://ocean.si.edu/getinvolved.

10. See AAM's website for museum statistics and Joelle Seligson, "At Record Breaking Annual Meeting, Museums Matter," *Aviso* (June 2007), www.aam-us.org.

11. See www.nmc.org/events.

12. See www.museum-ed.org.

13. See United States Holocaust Memorial Museum, "Crisis in Darfur, Live from Second Life," (January 9, 2007), www.ushmm.org/conscience/analysis/details.php?content=2007-01-09.

Museums Connecting with Teens Online

Allegra Burnette and Victoria Lichtendorf

Teens matter to museums, and museums strive to matter to this complex and evolving audience through innovative and genuine outreach. Both onsite and online, museums offer teens opportunities to learn about special topics, careers and interactivity that challenge their skills and creativity. Likewise, teens, parents and teachers have learned to look to cultural institutions for after-school, weekend and summer programming that include hands-on classes, advisory councils, internships, youth-to-youth mentorship and training in museum career skills. In recent years the number of museum teen programs now supported by technology has increased significantly. Communication and digital technologies such as computers, cell phones and iPods are an integral part of many teens' lives and are playing a more critical role in museum outreach. In addition to providing access to museum resources via the Internet, audio guides, cell phones and kiosks, museums are also training teens to use technology through hands-on workshops focused on video production, website design, podcasting and more.

In this chapter we consider how museums use online technology to support programming and promote connections with teens. We interviewed several colleagues engaged in various forms of programming explicitly or implicitly developed for teens and reflected on our own experience creating a teen site for the Museum of Modern Art (MoMA), New York. Our findings reveal a range of approaches such as blogging, documenting and archiving of teen programs and podcasting—opportunities museums have to utilize technology to engage a teen audience.

DEFINING A TEEN AUDIENCE

Museums differ when it comes to defining a "teen" or "youth" audience. Belonging to a broad demographic encompassing 13-year-old adolescents to 19-year-old young adults, teens experience tremendous shifts in their development that affect their emerging sense of identity. Sensitive to these issues, the Tate Modern's Raw Canvas program seeks to reach 16- to 23-year-olds, with older members acting as mentors to younger members both in the museum and online.[1] On an institutional level, the Ontario Science Centre (OSC) has focused on reaching young visitors aged 14 to 24—a period of critical life choices. The New York Historical Society, on the other hand, has found a more reachable audience in the "tween" category of 11- to 13-year-olds due to state and city school curricula. Furthermore, as we discovered when creating a name and identity for MoMA's teen site, Red Studio, teens themselves often offer contradictory opinions about how they would like to be identified both as individuals and collectively.[2] Given the complexities presented by this audience, producing relevant, meaningful content can seem prohibitive. Taking on this challenge is critical, however, and can be tremendously beneficial for all involved.

Apart from being future visitors, teens can contribute challenging and thoughtful voices to a larger dialogue about the significance of museums and their collections. As Rosanna Flouty, teen programs manager at the Institute of Contemporary Art, Boston, comments: "Teens are unafraid to push boundaries and take risks, and yet are at a place where they are still seeking places to identify themselves. Museums become a safe place to create risk-taking experiences." When looking at and discussing modern and contemporary art, teens' diverse opinions and their courage to express them can fuel sophisticated debate and dialogue. "Artists and teens have an immediate connection," notes Kathy Halbreich, former director of the Walker Art Center, in a report from the Wallace Foundation, "because they are both actively engaged in asking questions about life and culture and in overturning the status quo." Teens, Halbreich believes, are a critical audience that can help contribute to a museum's larger goals for outreach and visitorship. "Most teens don't see museums as places they can call their own, but I believe that they are the ones who should get the most out of what we do....We're bucking the notion that cultural institutions are elite, and we've seen how deeply our programs can touch the community. Opening doors and windows in one respect makes it easier to become diverse in others."[3]

TEENS ARE SOCIAL

Onsite, after-school programs are successful in part because they offer an alternative space in which teens can socialize. United by a common interest and

a safe space, demographically diverse teens often find themselves interacting with an unlikely group of peers. Students who participate in after-school programs also benefit from improved self-confidence, positive social behavior and interaction, positive feelings toward learning and improved school grades and achievement test scores.[4] As Deborah Schwartz, president of the Brooklyn Historical Society, has observed, "Museums hold the promise of learning, but in an informal and flexible way that is less reminiscent of school and more connected to real life. This flexibility is enormously powerful to adolescents who want answers to their own questions (not the questions as formulated by others)."[5]

Teens' interest in engaging with one another in museum programming reflects their inherently social nature, a phenomenon clearly manifested in their use of the Web. In 2001, while conducting focus groups and surveys of teens for Red Studio, we found that bulletin board posting sites such as Cosmo Girl and Bolt were especially popular. With the advent of MySpace and Facebook, the lure of social sites for teens has been brought to the forefront. It seems the brands and offerings may change, but teens' social needs do not. According to the Pew Internet Project, 55 percent of today's teens with Internet access use social networking sites and 55 percent have created online profiles. The report reveals how teen social networking cuts across race, ethnicity and class—although not necessarily gender, as girls are more active than their male peers.[6]

How can teens' adept use of online social networks align with their interest in social engagement within museums? As the following examples illustrate, museums have developed ways to integrate online communication networks into educational programming and exhibition design as a means for reaching a broader community.

COMMUNICATION NETWORKS

The Walker Art Center has been a pioneer in the arena of blogging on museum sites, developing blogs on multiple topics including Hot Art Injection, the Walker's teen exhibition series featuring call-in audio and the voices of teen artists. The Walker also has a website developed in part by its teen council (Walker Art Center Teen Arts Council or WACTAC), which in its current form serves primarily as an archive of teen programs and information about upcoming events. Recently, however, the Walker has been utilizing nonpublicized blogs to support onsite teen workshops and classes. As Christi Atkinson, assistant director of teen programs, observed: "Museums can't compete with commercial sites, so we focus on the community of teens that we work with—a community of people interested in

a certain idea." The blogs include curricula and multimedia projects and serve as a place for teachers and teens alike to submit audio comments. The teens gain a sense of ownership and involvement, and, because of the blogs' internal focus, can express themselves unfettered by issues such as copyright and moderation—two issues with which museums often grapple. As Witt Siasoco, program manager for teen programs, points out, the Walker can then focus on capturing teens' voices, inspirations and observations rather than having to monitor the use of nonlicensed material.

Two science centers have created online bulletin boards and blogs as part of a larger initiative to make science salient and meaningful to a broader audience. While neither is solely directed at teens, they serve as models for engaging this audience. Science Buzz, an exhibition, kiosk and Web-based initiative at the Science Center in Minneapolis, offers a model for online community exchange.[7] As organizers Bryan Kennedy and Liza Pryor point out, the success of Science Buzz is due in part to the fact that it focuses on current topics and is frequently updated. By posing questions such as "Should companies be allowed to patent human genes?" and "Science and politics—should they mix?" Science Buzz educators and scientists help model a broader view of science. Such immediately relevant content may provide an added draw for teens. Some of the most popular discussions have come from stories that teens started, although they often need to be encouraged to write the stories in the first place. "Teens have preconceptions about what they think is appropriate or what the museum 'wants,' which are not accurate," says Kennedy, "so we need to work with them to get them beyond that."

Similar to Science Buzz in its goal of fostering user-driven content, the online initiative at the Ontario Science Centre, RedShift Now, offers a mix of online and onsite opportunities for engagement.[8] Launched in 2005, the site was intentionally developed with a URL and identity separate from the main OSC site—the thinking being that RedShift Now would be more successful as an online space free of preconceptions associated with a science institution. With RSS (Really Simple Syndication) feeds of science news, postings, scientists' field diaries and activities such as stop-motion animations, Kevin von Appen, associate director of daily experience operations at the Ontario Science Centre, sees RedShift Now as "creating an online collaborative social space where people can do, see and experience things that make it more likely that they will understand innovation or acquire the skills to analyze and engage." But he also warns of the needs of an active and successful online social space. Commercial community sites have a large infrastructure supporting and guiding interactions, an infrastructure that

museums cannot replicate. "Don't assume that blogs are going to take care of themselves—they require the care and feeding of that community," he advises. Part of a larger initiative to engage a broader community in meaningful ways, RedShift Now is designed with teens in mind but is not explicit in its approach. "Teens have an attraction to authenticity. They don't want to be told what is interesting or be pandered to. Make it interesting and authentic, and they'll find it and tell their friends. Make it clear it's not for parents or little kids by developing content with youth in mind but not necessarily for youth."

DEVELOPING TEEN WEBSITES

Unlike the two prior examples, when it came to launching a youth-oriented site at MoMA, we decided to market it as "a site for teens." Inspired by heated debate and discussion about the definition and value of art in our after-school programs, ideas for a teen website were first generated in 2000. A project team comprised of staff from the education and digital media departments began exploring these ideas with various teen groups including MoMA's Teen Advisory Group, high school interns and a focus group. We also conducted an onsite survey for teens visiting the museum. This research, especially the surveys, confirmed our expectations about how teens consider art, but we were surprised by some of the results concerning online usage. While it was hard for teens to imagine what the site would look like, they overwhelmingly wanted it to look elegant and, specifically, not flashy. Polls were important to them, but so was a resource for researching deeply layered information. They wanted to be able to ask artists questions, and they wanted supporting information from museum experts. They wanted to make their mark on the museum, but much like von Appen's observation, they also very much wanted the authority or authenticity that the context of the museum provided.

Following the initial launch of Red Studio, a series of evaluations and user testing resulted in a redesign of the umbrella site and a rethinking of our approach. Based on an evaluator's observations of teens using the site, we learned that we needed to do a better job of framing and introducing artists through text and images. Even if their peers developed the questions and conducted the interviews, why, asked the testers, should teens feel compelled to watch and explore them? Features such as polls, on the other hand, were an immediate and intuitive magnet that offered instantaneous response.

The resulting redesign and content centered on a variety of choices, which were made more clearly available on the homepage. MoMA's approach to a site for

teens makes the results of teen programming in the museum (teen-led artist interviews and podcasts) available to others, while also offering related activities that can be done online (ReMix, a collage activity; Chance Words, a Dada poem; and youDesign, a design competition). A moderated posting board and polls allow teens to express their opinions, adding a community input component to the site. Similar to RedShift Now, because we were trying to create a space for teens, we were initially wary of making curricular or teacher-specific references on the site. We have, however, been rethinking this notion—contest participation and anecdotal information has made it obvious that teachers motivate teens to visit the site. One response to this finding is "In the Making," a feature archiving MoMA's intensive, hands-on summer program by the same name. Do-it-yourself activities drawn from the summer curricula provide models for hands-on projects for home or the classroom.

Does Red Studio succeed in reaching teens? Significant traffic increases indicate the redesigned site has more appeal than the initial iteration, but we often do not know for sure if it is teens who are using the site. Although contests require proof of age, no other registration is required because an added layer might deter teens. This raises the question: Is the site's success measured by whether or not its primary visitors are teens? As our colleagues in other institutions have observed, the topics tackled by teens are applicable to a broader community—teens lack the fear to ask difficult questions about the relevancy and meaning of art in museums, and their inquisitive courage provides a good model for adults. Museum community and teen sites can therefore also provide teachers with alternative ways of engaging students in difficult topics and vitalizing subjects ranging from history to art to science. In discussing the larger vision of OSC's RedShift Now, von Appen notes his goal to create innovative people, not to market for increased attendance. Individual museums and cultural centers may define their own terms for a particular project's success, but the landscape of working with teens online has changed so much in recent years that the possible long-term effect of connecting teens and museums will be under evaluation for some time to come.

WHAT'S NEXT?

When thinking about commercial online social networks, the question museums should be asking is not how they can compete for a teen audience, but rather how they can capitalize on the infrastructure provided by commercial sites to deliver content. Examples abound of museums entering this realm—from teen-created podcasts posted on iTunes to YouTube videos; the New York Historical Society is even considering creating profiles for historic figures as a way of dusting off

history and making it more relevant and youth-friendly. In addition, museum sites can offer a public record of their onsite programs for teens through descriptions, images and information about the teens involved. Museums can host online community forums for specific classes and groups, accessible internally or publicly. None of these approaches is offered up as the preferred solution, and certainly the approaches will continue to change form as technology itself changes. And while teens today have greatly improved access to technology at home and in schools, museums, libraries and other cultural and community centers, it is worth noting that issues related to access through digital media persist.

A genuine commitment to this audience, regardless of the approach, is the critical starting point for technology-based outreach projects. From the examples we have seen, the key to success appears to be an openness to experimentation. As Flouty suggests, "Take more risks! I now know that we can never predict how teens will connect to a museum program—whether it's through the art and artists, the process of learning, the content of the course, the technology itself or just from having a place to exist for a few hours that is safe." Such experimentation is best coupled with a thoughtful wariness of superfluous bells and whistles, familiarity and enthusiasm for the content, self-reflection and assessment and sensitivity to the needs of the teen communities. Just as museums need to remain open to learning from and integrating new technologies, they also need to continue to engage and learn from their teen audience.

NOTES

1. Raw Canvas, www.tate.org.uk/modern/eventseducation/rawcanvas.

2. Red Studio, http://redstudio.moma.org.

3. The Wallace Foundation, "A Place of Their Own: Teens Make Programs Come Alive at the Walker Art Center," www.wallacefoundation.org/WF/KnowledgeCenter/Knowledge-Topics/ArtsParticipation/WalkerArtCenter.htm.

4. Joseph A. Durlack and Roger P. Weissberg, *The Impact of Afterschool Programs that Promote Personal and Social Skills* (Chicago: Collaborative for Academic, Social, and Emotional Learning, 2007): 4; also available online at: www.casel.org/downloads/ASP-Full.pdf.

5. Deborah F. Schwartz, "Dude, Where's My Museum? Inviting Teens to Transform Museums" *Museum News* 84, no. 5 (September/October, 2005), 40.

6. Amanda Lenhart and Mary Madden, "Social Networking Websites and Teens: An Overview," Pew Internet and American Life Project, www.pewinternet.org/pdfs/PIP_SNS_Data_Memo_Jan_2007.pdf.

7. Science Buzz, www.smm.org/buzz.

8. RedShift Now, www.redshiftnow.ca.

The Name of the Game:
Museums and Digital Learning Games

Susan E. Edwards and David T. Schaller

Many museums are entering the world of digital games in an effort to reach young audiences. Over the past decade, museums across the United States and Canada have created many kinds of digital learning games developed and delivered through various channels. Staff members at some museums have been able to develop their own simple, casual games.[1] Other museums have hired media developers to build games tied to specific exhibitions or collections areas.[2] A few have partnered with the commercial game industry to put games about their content on gaming websites.[3] And some have even created distinct virtual arenas that include games for kids under their own domain.[4] Museums' investment in these digital learning game projects has exploded.

Within the museum world, however, skepticism persists about the term "game." It implies a frivolous diversion from serious educational objectives. Yet games are one of the oldest human activities, honed over millennia to be playful, engaging and motivating experiences.[5] With the advent of the personal computer, games gained a new, compelling format. Digital games have become a primary preoccupation for most young people and many adults, making it an exciting arena in which museums can develop new audiences. The Pew Internet and American Life Project reports that 75 percent of teens play digital games.[6] But it doesn't stop there. A 2006 study by the Entertainment Software Association reports that the average gamer is 33 years old, and that 25 percent of all gamers are over 50.[7] Clearly, games are a way of life for many people today, and not just because they're fun. In recent years, games have gained attention for their potential as powerful learning experiences.[8]

LEARNING FROM GAMES

It would be hard to deny that games require thinking, so why has it taken so long for the idea to take hold that games facilitate learning? Perhaps because games seem like an inefficient way to transfer information, and transfer has long been education's primary goal. Why go to the effort of designing a game when a few paragraphs of straightforward text should do the job? For some learning objectives, words will do the job quite nicely: *Van Gogh pioneered Expressionist art. There are one million species of insects. George Washington was the first president of the United States.* Trivia games employ this familiar model of information transfer, but they are an exception in the burgeoning field of learning games, which draws on a broad array of research emphasizing the value of problem-based, anchored instruction.[9] These, in turn, are based on the insight that all knowledge is contextual, rooted in the particulars of experience.[10] Games are by definition experiential and often employ rich contexts for the player to explore.

For these reasons, educators in schools and universities are increasingly using commercial digital games in classroom teaching or exploring the potential of custom-designed learning games, often in partnership with private industry.[11] Many museum professionals may feel apprehensive about stepping into an arena dominated by behemoths like PlayStation, Xbox, Wii and Shockwave. Museums cannot compete against glossy, high-budget console games like Grand Theft Auto—but the goals of that industry are not ours. Games can be effective tools for achieving museums' educational and promotional goals and for building new audiences at the same time. In this chapter, we discuss key questions to consider when creating digital learning games or when deciding whether to enter this arena at all.

Digital games can be expensive and time-consuming to make, but there is a wide spectrum of existing game models that can help. Museums can build games in-house, hire a developer or partner with for-profit companies to reach these audiences. Just like any new initiative your institution may undertake, it is a matter of weighing the benefits against the costs. There are many potential benefits to making games. The first step is to define your goals and decide if a digital learning game can help you accomplish them.

BENEFITS FOR MUSEUMS

At the simplest level of benefits, games can promote general awareness of your institution. If the game delves into your institution's collection, it is inherently a promotional tool, informing audiences about the museum's scope and content.[12]

In addition, games can expose your collection to audiences who would not likely browse through them otherwise. A game can provide new ways for existing audiences to explore your collections and perhaps expose them to aspects of your institution they would not have discovered on their own. In the Allentown Art Museum's Renaissance Connection "Be a Patron" role-play game, visitors can commission an artwork, selecting the subject, media and artist before they see the final product—a portrait from the museum's collection. As one teen said afterwards, "In an art museum you'd just walk right by that painting. But since I commissioned it, it's more interesting and meaningful."[13]

In addition to increasing awareness about your institution, targeted games can also achieve specific pedagogical goals. An art game that requires users to compare differences between paintings reinforces visual analysis skills. A natural history simulation game that models ecosystem interactions can teach players about biological competition and population dynamics. Games can have real-world impacts by educating audiences about the consequences of their own actions.[14] Games can even have social dimensions that benefit museums by fostering positive attitudes about museums and creating fun destinations for meaningful learning. Further, educational theorist James Paul Gee argues that video games provide important "identity work" by giving players an opportunity to imagine themselves in different social or professional roles.[15] If we provide opportunities for young people to learn the skills used by art historians, biologists, geologists, historians, etc., we can encourage them to imagine themselves in those roles in their own real-world futures.

WHAT GOES INTO A LEARNING GAME?

So how do you make a game? You are probably already doing it. Educators in most cultural organizations already use traditional games and game-like activities to teach young visitors in their brick-and-mortar space. Taking these tools into the digital world is a logical next step. If we think of a game as a pedagogical structure onto which a worldview and subject domain is mapped, we can see that the real interest in a game is in the content. This is where museums excel. A fantasy role-play game about an elf on a quest for a magical sword can be reinvented as a game about colonial tradesman on a quest to find work as a journeyman.[16] The game's structure—and the technology behind it—stays the same; it is the content that defines the new game.[17] Understanding the structure of a particular game genre and how it guides the player's learning will help you choose the best approach for your content.

While it is the content of a game that makes it uniquely educational, other structural elements that help foster intrinsic motivation make games particularly valuable to museum educators. In the 1980s, cognitive psychologists Thomas Malone and Mark Lepper studied computer games for insights into intrinsic motivations for learning.[18] Their taxonomy describes four key attributes that we can apply to learning games:

> 1. *Challenge*—Players tackle a clear, fixed challenge that is relevant to them. Frequent feedback guides them towards success, clarifying both successes and failures and promoting feelings of competence.

> 2. *Curiosity*—Cognitive curiosity is triggered by discrepant events and other paradoxes arising from the game play. Sensory curiosity is triggered by multimedia elements.

> 3. *Control*—Players have meaningful control over their actions in the game, causing clear and powerful effects in the game universe. Contingency, choice and power are key elements of control.

> 4. *Fantasy*—The context of the game includes some degree of fantasy, which engages the emotional needs of learners while providing relevant metaphors or analogies.

These attributes distinguish games from other types of learning interactives and serve as guideposts for game developers.[19] A game lacking in challenge, perhaps for fear of discouraging the player, will fail to motivate most players. A game that provides the player with no meaningful control, such as a role-play game that has a single "correct" path, will cause both motivation and learning to flag. And a game without fantasy will appear dry and uninviting, lacking the emotional appeal to get players into the game.

Fortunately, museums have a long track record with these attributes, particularly curiosity and fantasy. Since the days of the cabinet of curiosity, these qualities have loomed large in the museum visitor's experience. Schaller recalls the elaborate games he played as a child in the exhibits of Chicago's Museum of Science and Industry. These museum visits meant entering the "magic circle"—a place where "a new reality is created, defined by the rules of the game and inhabited by its players."[20] In the same way, games are magic circles where players assume new identities, follow a specific set of rules and assign new meanings to familiar actions. Each activity depends on a suspension of disbelief and an element of

fantasy, making the magic circle a valuable arena for exploring a subject in an exciting and meaningful way.

The magic circle does not require expensive and immersive game worlds, of course. It exists in simple playground games. But digital technology allows museums to populate their games with rich content from their collections and programs, enticing the player into the magic circle and perhaps immersing him/her in the subject matter. Malone and Lepper call this immersion "intrinsic fantasy," in which "the skill being learned and the fantasy depend on each other."[21] For example, the role-play game Oregon Trail uses intrinsic fantasy in that the player's ability to navigate the trail depends on the individual's knowledge of the game's historical context.[22] The game of Hangman, on the other hand, uses extrinsic fantasy, as the gallows context is not connected to the player's ability to guess words correctly. Malone and Lepper believe that intrinsic fantasy is more motivating and pedagogically effective than extrinsic fantasy.[23]

For museums, intrinsic fantasy is an attractive approach for some subjects and learning goals. Role-play games like the Minnesota Zoo's WolfQuest require the player to learn about the life of a wolf and its wilderness environment in order to accomplish the goals set out by the game.[24] Simulations like SimCity let players experiment with a virtual world or system and teach basic concepts and relationships about the system.[25] But designing such a game is no trivial undertaking, as it requires synchronizing the subject matter, in-game goals and learning goals to ensure that players learn the intended content. Every game proffers a simplified model of some aspect of the real world, which raises the risk that some players will create their own meaning from the game's underlying assumptions. Sherry Turkle has made famous one child's misconception generated by SimCity: "Raising taxes always leads to riots."[26]

Games using extrinsic fantasy (which generally fall into the category of "casual games") have long been stalwart tools in museum education. These games—such as Memory, Hangman, crossword puzzles and word-finds—are economical since it is easy to retrofit familiar games with new content; no new gameplay design is required. When the game genre suits the learning goals, casual games are quite engaging and effective. They are easy to learn and provide a few minutes of entertainment with no long-term commitment. They also appeal to people who don't consider themselves "gamers"—in fact, casual games are the only kinds of computer games that many people, particularly adults, play.[27] The J. Paul Getty Museum's GettyGames, for example, give children practice with observation and

Figure 1. A collaboration between the Minnesota Zoo and eduweb, WolfQuest puts players in the role of a wild wolf (www.wolfquest.org, launching December 2007). The intrinsic fantasy of the wolf role-play synchronizes with the learning goals, motivating players to explore the virtual world and figure out how to overcome challenges. *© 2007, The Minnesota Zoo and eduweb.*

pattern-matching skills, which serves the Getty's goal to develop children's visual skills and familiarize them with specific artworks. These kinds of games may not offer the kind of immersive, contextual experience of a role-play or simulation game, but they can help achieve institutional goals such as exposing audiences to your collection.

Regardless of genre, all games require external scaffolding to reach their full potential as learning tools. This can help players connect gameplay to prior knowledge, correct misconceptions (e.g. raising taxes causes riots), encourage reflection and consolidate learning. Current educational theorists advise that people learn best from their peers in communities of learning.[28] In a digital learning game, this scaffolding can take shape in face-to-face conversation between the player and a teacher, parent, docent or friend; in online discussion forums with other players comparing strategies and sharing tips; and in off-line extension activities.

DELIVERING THE GAME

Once you build a game, the next step is attracting players. The obvious venues for a game are your institutional website or a kiosk in an exhibition space. But even if you have an extensive website, most visitors are probably not coming for game content. Online advertising can help drive traffic to the games, but other tactics may be more effective. Games designed for classroom use can be promoted through school districts, professional associations and websites for educators.[29] Reaching children and teenagers in their free time is more challenging but not impossible. Rather than expect a youth audience to come to them, the Getty Museum took their collection to that audience by partnering with Whyville, an online educational environment for kids ages 9–13. The Getty placed a virtual Getty Museum with two educational games in Whyville, which provides instructional scaffolding and links back to the Getty's online collections, driving more traffic (and hopefully interest) to the institution.[30]

Museums can even turn to commercial gaming sites to expose large audiences of both hardcore and casual gamers to their learning games. The Space Science Institute, for example, posted several of its MarsQuest games on popular Flash games sites, attracting large numbers of users for several weeks, until the games dropped out of sight as new games replaced them.[31]

Figure 2. GettyGames use familiar casual games to encourage close looking at works of art from the J. Paul Getty Museum (www.getty.edu/gettygames). *© J. Paul Getty Trust.*

MEASURING IMPACT

Learning games are no different than any other educational endeavor in that real learning does not happen instantly. Museum evaluator John Falk points out that "It may take days, weeks or months for the experience to be sufficiently integrated with prior knowledge for learning to be noticeable even to the learner himself, let alone measurable."[32] Evaluating such learning in a museum setting is difficult once the visitor leaves the building, but technology offers the following new methods when evaluating digital games:

1. *Server statistics* reveal how many people have played an online game, where they came from, how long they spent with the game and much more. While strictly quantitative, these data provide basic information about the game's popularity and usage.

2. *Online surveys* can profile users before or after they play the game, providing information about who is playing the game and what they like or dislike about it. (These surveys are less effective at plumbing learning.) Surveys can also be used to solicit volunteers for in-depth telephone interviews, which are suited for probing learning outcomes.

3. *Embedded data recording* in the game itself can track player actions and behavior, providing valuable glimpses of their experience. For example, tracking the error rate in an artwork memory game could reveal which images were most memorable. In a role-play game, tracking player choices would provide insight into players' responses to the game scenario and content. Such tracking can also be a powerful tool for usability testing, as it will show common player mistakes and attrition spots.

4. *Fostering an online community* can provide rich, qualitative data about players' responses to the game. Message boards, polls, blogs, chat, fan fiction and fan art—all of these are viable tools to encourage players to share their experiences with the game. These ancillary activities are not only fodder for evaluation, but will likely extend and deepen players' learning through discussion and reflection and build a community around your collection and content. Community sites are also ideal avenues for connecting the game world with the real world, pointing players toward extension activities that will continue and deepen their learning.

The goals for your project will help determine which evaluation tools to use. If the goal is to increase traffic to your website, server statistics will provide the necessary traffic data. Goals to teach learning concepts will require more qualitative tools, such as surveys, focus groups and community feedback.

CONCLUSION

Digital learning games offer museums new opportunities to engage youth and adult audiences in compelling and meaningful ways. Indeed, educators in most cultural organizations already use traditional games as a tool to teach young visitors in their galleries. Taking this pedagogical tool into the digital world is a logical next step.

Games can introduce players to your collections and related content, immerse them in context-rich virtual worlds and encourage them to acquire specific skills and knowledge. A good digital game is by definition a good teacher, for it must teach players how to play the game, what meaning to derive from the game world and what strategies can be employed to win. Digital learning games can take many forms, from simple, casual games that can provide a few minutes of entertainment, to complex role-play and simulation games that require hours of time to master. Each has unique advantages and appeals to distinct audiences, so museums must carefully conceptualize their goals in order to choose the appropriate game model. These goals will also help determine appropriate avenues for delivering the game to intended audiences and inform the choice of evaluation tools for measuring impact.

Whatever the form, games have much to offer informal learning organizations. Games create a sustained learning experience that challenges players, inspires curiosity and engages the imagination. And they are enormously popular with youth and young adults, rivaling movies and television. The audience is there. The tools are available.[33] The content is waiting. The next step is up to you.

NOTES

1. For example, see the Getty Museum's GettyGames, www.getty.edu/gettygames.

2. For example, see the Allentown Museum's Renaissance Connection, www.renaissance-connection.org.

3. For example, see Smithsonian American Museum's jigsaw puzzles on Shockwave.com, www.shockwave.com/gamelanding/americanartjigsaws.jsp, and a virtual Getty Museum on Whyville, www.whyville.net.

4. See the American Museum of Natural History's Ology website, http://ology.amnh.org/index.html.

5. Elliot M. Avedon and Brian Sutton-Smith, eds. *The Study of Games* (New York: John Wiley and Sons, 1971).

6. Lee Rainie, "Digital 'Natives' Invade the Workplace: Young People May Be Newcomers to the World of Work, But It's Their Bosses Who Are Immigrants into the Digital World," PEW Internet and American Life Project, September 28, 2006, http://pewresearch.org/obdeck/?ObDeckID=70.

7. Entertainment Software Association, "Essential Facts about the Computer and Video Game Industry: 2006 Sales, Demographics and Useage Data," Entertainment Software Association, www.theesa.com/archives/files/Essential%20Facts%202006.pdf.

8. For more on learning and video games, see James Paul Gee, *What Video Games Have to Teach Us about Literacy and Learning* (New York: Palgrave/St. Martin's, 2003); Steven Johnson, *Everything Bad Is Good for You: How Today's Pop Culture Is Actually Making Us Smarter* (New York: Riverhead Books, 2005); and Marc Prensky, *Digital Game-Based Learning* (McGraw Hill: New York, 2001).

9. Kurt Squire, "Videogames in Education," *International Journal of Intelligent Simulations and Gaming* 2, no.1 (2003): 4; 49–62.

10. John Bransford, Ann Brown and Rodney Cocking, eds. *How People Learn: Brain, Mind, Experience and School* (Washington, D.C.: National Academy Press, 1999), 42–44.

11. For example, Tool Factory, www.toolfactory.com, creates computer games for the classroom that teach math, language, social studies and special education skills for grades K–12. Students at Ohio State University created the first-person shooter game Dimenxian, www.dimenxian.com, with the challenge to "Learn math or die trying," and Johns Hopkins University spearheaded the adventure game Decartes' Cove, www.jhu.edu/cty/cde/cove/index.html, to teach math skills tied to content standards. Some of these university projects are even receiving grants from organizations like the National Science Foundation and Institute of Museum and Library Services to develop and study the educational impact of the games. Interest in educational gaming is also emerging within the private for-profit industry. For example, GXB interactive, www.gxbi.com, is a new company developing educational games for the Nintendo Game Boy platform.

12. For example, a user who learns what coral reef fish eat by playing the Monterey Bay Aquarium's game, Crunch, Nibble, Gulp, Bite, www.mbayaq.org/lc/kids_place/cngb/cngb.html, may see the actual fish, such as butterflyfish and parrotfish when they visit the aquarium.

13. David T. Schaller, Steven W. Allison-Bunnell, Anthony Chow, Paul Marty and Misook Heo, "To Flash or Not to Flash? Usability and User Engagement of HTML vs. Flash," in *Museums and the Web 2004: Selected Papers from an International Conference*, David Bearman and Jennifer Trant, eds. (Pittsburgh: Archives and Museum Informatics, 2004), www.eduweb.com/to_flash.html.

14. The Serious Games Initiative is leading the charge for creating games for public impact. Their website, www.seriousgames.org, posts their mission: "The Serious Games Initiative is focused on uses for games in exploring management and leadership challenges facing the public sector. Part of its overall charter is to help forge productive links between the electronic game industry and projects involving the use of games in education, training, health,

and public policy." The social issues branch of Serious Games is Games for Change, www.gamesforchange.org.

15. Gee, *Video Games*, 51–70.

16. "Betwixt Folly and Fate," a new game from Colonial Williamsburg, uses just this approach, www.history.org/teach.

17. When talking about games and learning, many argue that games are a new medium for storytelling alongside books, television and movies. For more on games, storytelling and literacy, see Gee, *Video Games*; Bill Wasik, "Grand Theft Education," *Harper's Magazine* (September 2006): 31–39; and Jenny Levine, *Gaming and Libraries: Intersections of Service, Library Technology Report* (Chicago: American Library Association, 2006).

18. Thomas W. Malone and Mark R. Lepper, "Making Learning Fun: A Taxonomy of Intrinsic Motivations for Learning," in *Aptitude, Learning and Instruction III: Cognitive and Affective Process Analyses*, Richard E. Snow and Marshall J. Farr, eds. (Hillsdale, N.J.: Erlbaum, 1987).

19. David T. Schaller, "What Makes a Learning Game?" Report from the Web Designs for Interactive Learning Conference, 2005, www.eduweb.com/schaller-games.pdf.

20. Katie Salen and Eric Zimmerman, *Rules of Play: Game Design Fundamentals* (Cambridge, Mass.: MIT Press, 2004).

21. Malone and Lepper, "Making Learning Fun."

22. The Oregon Trail is an early educational role-play computer game developed by a Minnesota history teacher, www.learningcompany.com. It became popular on Apple computers in the mid-1980s and was common on computers in public schools.

23. Some dispute this. See M. P. Jacob Habgood, Shaaron E. Ainsworth and Steve Benford, "Intrinsic Fantasy: Motivation and Affect in Educational Games Made by Children," paper presented at the AIED 2005 Workshop on Motivation and Affect in Educational Software, Amsterdam, July 2005, www.informatics.sussex.ac.uk/users/gr20/aied05/finalVersion/JHabgood.pdf.

24. See www.wolfquest.org.

25. See www.simcity.ea.com. Sasha A. Barab and Michael K. Thomas, Tyler Dodge, Markeda Newell, Kurt Squire, "Critical Design Ethnography: Designing for Change," *Anthropology and Education Quarterly* 35, no. 2 (2004): 254–268, http://inkido.indiana.edu/barab/publications2.html.

26. Sherry Turkle, "Seeing Through Computers: Education in a Culture of Simulation," *The American Prospect* 8, no. 31 (1997): 76–82, www.prospect.org/print/V8/31/turkles.html.

27. Entertainment Software Association, 2006.

28. John A. Falk and Lynn Dierking, *Learning from Museums: Visitor Experiences and the Making of Meaning* (Walnut Creek, Calif.: AltaMira Press, 2000).

29. For example, the Cleveland Museum of Art's game, Dig In, was designed for classroom use with students working collaboratively, as an extension to an academic unit on Egypt. The museum's distribution strategy includes using their internal resources to reach teachers di-

rectly through personal contacts with the museum's education staff and through their highly active Teacher Resource Center and Distance Learning programs. Holly Witchey, Cleveland Museum of Art, e-mail message to author, January 2007.

30. Users on Whyville can learn more through tutorials, chat, placing earned artworks in their houses and reading articles about the museum in the site's newspaper.

31. James Harold, Space Science Institute, www.spacescience.org/index.php, personal communication, January 2007. MarsQuest, www.marsquestonline.org, was posted on the Flash gaming site New Grounds, www.newgrounds.com/portal/view/183886. In another example, the Smithsonian's American Art Museum provided Shockwave.com with images from its collections to create jigsaw puzzles.

32. John A. Falk, "Museums as Institutions for Personal Learning," *Daedalus* 128, no.3 (1999): 259–279, www.findarticles.com/p/articles/mi_qa3671/is_199907/ai_n8828014.

33. There are many options available for developing games in-house, including popular commercial Web applications, open source software and low-cost game engines. Flash, www.flash.com, is widely used for casual and even more complex games, but it has very limited 3-D capabilities. For 3-D games, developers have several choices of dedicated game development application. Gamemaker, www.gamemaker.nl, developed by an IT professor for game design students, has a drag-and-drop interface that allows non-technical users to create games. Unity, www.unity3d.com, is a professional authoring tool with a powerful 3-D game engine and physics and animation capabilities. Torque, www.garagegames.com, offers a suite of applications for 2-D and 3-D game development for independent developers. See DevMaster, www.devmaster.net/engines, for more information and user reviews of these and other 3-D game development applications.

Analyzing Return on Investment: Process of Champions

Leonard Steinbach

> But now, at long last, the computer has entered the house of the
> Muse and—like the man who came to dinner—the guest is here
> to stay. It would behoove the host to know something about his
> visitor's care and feeding, and prepare himself for the changes in
> household that the newcomer's arrival are sure to bring.
> —*Everett Ellin*, Computers and the Humanities[1]

IN THE BEGINNING

There is no doubt that computer and telecommunications technologies in
museums—guests or golems—are here to stay and have the potential to insinuate
themselves into every aspect of their hosts. File them under programming,
outreach, productivity, potential or panacea: The uses for technology range from
digital photography and asset control to complex collections and exhibition
management systems to multifaceted Web resources, exhibition-based interactives,
security and building automation systems, distance learning, customer relationship
management (CRM—read: membership and development systems) and more.
These do not even include the networks, workstations and other foundation
supports that are generally taken for granted.

It has been 40 years since the first museum computer projects—rudimentary
databases—began to emerge, but most museums have only jumped onto the
bandwidth bandwagon during the past 15 years. Nonetheless, it can still feel
frustrating that with so many desirable ways of using technology and so few
resources to realize them, museums may rely too much on intuitive, personal,
parochial and even political reasons for deciding which technology-based

projects deserve to proceed and in what priority. Not that ideas born solely of insight, passion and seeming common sense should be dismissed out of hand (my favorite question of 1996, "Should an art museum show art on its website?" comes to mind). Rather, museums could benefit from a better process for evaluating, comparing and prioritizing technology-based projects more objectively.

This essay presents Return on Investment (ROI) analysis as an important means for deciding whether or not a specific project should go forward. "Return on Investment" can have different meanings depending on context. In a limited business and financial context, ROI might strictly refer to the amount of money returned over a period of time compared with the amount of money invested. But if this rationale causes curators and conservators to cringe, that's a perfectly reasonable reflex. Museums (and most nonprofit organizations) measure success in terms of fulfilling their missions, not on returning a profit. Therefore, mission-related return on investment is an important part of the equation.

In essence, ROI analysis asks the following questions:
- Are the efforts and costs associated with the lifetime of the proposed project worth its expected mission or financial benefit?
- How does the return on investment in one project compare with the return on investment of other proposed projects?
- Is the project plan as efficient and effective as it could be?

The answers may or may not always be clear. They may be highly quantifiable or mostly qualitative. The answers require a thoughtful combination of fact gathering, internal impact analysis, outcome valuation, risk assessment, review of alternative mechanisms for achieving the same goal and recognizing the ramifications of foregoing alternative opportunities. After all, there are only so many great projects that can be pursued at one time. There may also be times when urgent needs or short deadlines preclude lengthy analysis. The impending obsolescence or end of vendor support for an existing system may require the change. Externally imposed regulations, laws or professional standards or accreditation requirements may also eliminate any choice. For example, in 2001 the American Association of Museums' *Guidelines Concerning the Unlawful Appropriation of Objects During the Nazi Era* required museums to identify and make public via the Internet information that might "aid in the identification and discovery of unlawfully appropriated objects that may be in the custody of museums."[2] This was not a matter of "whether to," but of "how to." But even with the decision having been made, ROI analysis can also prove helpful in analyzing and comparing approaches toward a goal.

An ROI analysis process should be an informative exploration—not an onerous burden. The depth of analysis should be appropriate to the cost and impact of the project. Also, one doesn't have to agonize over finding the *optimal* analysis. Consider embracing the concept of "satisficing," usually defined as "the tendency to select the option that meets a given need or . . . seems to address most needs rather than the 'optimal' solution."[3] As applied to ROI for museums, satisficing means reaching decisions related to a project once there is enough information to assure confidence that a good decision is at hand. This will avoid a more optimal but superfluous analysis. A successful decision will result as long as care is taken in where to draw the line.

Perhaps the most important outcome of an ROI analysis is that beneficiaries and implementers, management, board and others will have a clear understanding of the assumptions about costs, benefits and risks on which a project decision is based. As a result, they may be more confident that the project recommendation has been reached thoughtfully and rationally. It also distributes responsibility for project success in the face of uncertainty and risk.

There are many innovative ways for museums to share and preserve our history and cultural heritage, the joy of art and beauty and the allure of scientific discovery in this digital age. But museums have limited resources; priorities must be set based on value to the institution. The principles of ROI analysis, which embrace both finance- and mission-based return, provide a framework for thinking about those values.

This chapter, like many of the essays in this book, can be considered a "think guide" for current and would-be champions of great projects in the museum field—a breakfast for champions, fortified with a winning blend of analytical tools and tactics.[4]

IF ONLY IT WERE THAT EASY

"A meaningful return on investment (ROI) analysis in information technology is a little like saying you want to live a healthier lifestyle," notes Anthony M. Cresswell in *Return on Investment in Information Technology: A Guide for Managers,* an excellent resource for those who want to understand ROI at greater depth.[5] "Like lifestyle changes . . . ROI is a collection of methods skills, tools, activities and ideas (which) can be combined and used in many different ways to assess the relative value of an investment over time." Therein lie several challenges.

Defining the Project

It is vital to articulate the project purpose clearly so that anyone, including finance staff, senior management, the board and others who do not live within the project's sphere, can easily understand its importance. One format that gets straight to the point has just two key components:

1. A statement of goal and scope, which includes an overarching goal for the project, as well as a list of objectives and constraints within which the project must be achieved (e.g., number of system users, budget, deadlines, bandwidth, etc.). It forms a "contract among colleagues," which, if fulfilled, should define success. It also draws a functional boundary such that "project creep," the tendency for projects to grow beyond original purpose and cost, can be quickly detected and contained.

2. The duration of the project for which costs and benefits will be measured. Often known as a system or project lifecycle, this should not extend beyond five years; beyond that, it is likely that new technology, aging equipment or the need to migrate its content may require additional investment. Extending the period is also likely to exaggerate project benefits.

This project definition initiates greater specification and analysis, during which much more information will develop and the project scope will be refined.

Identifying True Costs

The true cost of a project is the sum of funds expended plus the value of opportunity, benefit or income forfeited as a result of implementing that project. The cost should be estimated for the project's lifetime but generally for not more than five years. This analysis is often more complex than well meaning—or so project advocates would have one believe—but it need not be overwhelming. Typically, technology project costs are proposed in terms of software, hardware, installation and training costs—mostly one-time, direct costs. However, if it stops there, you might as well code name the project "Hindenburg," as its unanticipated and ancillary costs, impact on staff and operations and optimistic time frame may just send the project down in flames. Vendor proposals are often unreliable barometers of true cost; they can be notoriously optimistic and rarely adequately address internal collateral costs. Underestimating true total costs also can exaggerate net value and push a project toward inappropriate acceptance. Identification of true costs is even more important for smaller institutions that may not be able to compensate later for unanticipated costs and unrealized

dreams. A long-range cost forecast can also be of critical importance when a project results from one-time, start-up grant funding and the cost of long-term sustainability has not been accommodated. There are three types of cost that must be considered:

1. *Direct costs* are generally the first and most straightforward to be assessed. These should include everything expended for the proposed project. "Everything" includes all hardware, software, implementation services, data conversion, technical and usability testing, infrastructure accommodation, training, support, customization and anticipated recurring costs. Anticipated recurring costs over the project lifespan could include software and hardware licensing, dedicated telecommunication, maintenance costs, additional data storage and back-up media, data migration and future retraining or advanced training for staff (already existing required equipment and infrastructure need not be counted unless the project will require a replacement during its lifespan). Everything can also include field trips to other museums, consultant fees, focus groups, reference material, conferences, trade shows and workshops directly related to project design and product evaluation. Sometimes, especially for complex or costly projects, a prototype, pilot project or product try-outs can be very useful. It can help develop a proof of concept, determine efficacy, evaluate usability, explore alternative approaches, understand interdepartmental implications, assess public reaction or garner internal support. The simple rule of thumb for discerning whether a cost belongs to a project: *If not but for this project, you would not be spending those dollars,* then it is a direct cost.

2. *Indirect costs* can be subtler, including such items as staff training and retraining over time, contract legal review or administration and increased electrical and environmental costs associated with equipment. The impact of a project on various areas of the museum may also incur indirect costs. Consider a new mass e-mail system for promoting programs and events; the ongoing costs of graphics design and editorial review may become an indirect cost. Indirect costs are sometimes defined as a fixed percentage of costs arbitrarily allocated to cover facility and administrative overhead especially in government grants and contract projects. However, because these rates are developed over time across many different types of projects and operations, they may not be appropriate to a specific project's cost analysis.

3. *Opportunity costs* comprise the value that would be forgone by not pursuing a project or course of action. No institution has sufficient financial and human resources needed to achieve all the projects that are inherently reasonable. Sometimes two projects may be mutually exclusive, extinguishing one potential benefit; sometimes one project must be postponed in deference to another. Consider the following choices, remembering that benefits won and lost can be finance- or mission-related: A larger restaurant and store versus more exhibition space? Work on deferred building maintenance needs versus a blockbuster exhibit? An upgraded website versus new digital imaging equipment? A new membership or development system versus a collection management system?

Benefits

Benefits—whether related to finance or mission—drive projects and their champions. Typical benefits can be financial (revenue, cost avoidance), audience satisfaction, increased organization capacity, creation and sharing of knowledge, collection stewardship and public service (such as school and community outreach), among others. They can also include strategic competitive advantage in terms of leisure time alternatives, prestige or philanthropic support. Sometimes investment in technology is simply the cost of continuing to be a player in the field.

Many projects would never proceed without their champions, from curators demanding new ways to express and share their passion to business staff who seek financial stability and more efficient operations. Champions, however, can also be myopic, failing to focus on the broader potential or implications of their proposals. Identification of a broad range of potential beneficiaries and their needs can strengthen a project's value. Could the education division of a museum benefit from alternative versions of the gallery interactives requested by exhibition design staff? Could a digital asset management project garner more support if more departments could store and access their content?

Although project definition, costing, risk analysis and benefit assessment have been presented linearly, the process is really quite iterative and self-informing. The risk analysis phase may result in a cost increase. Benefit assessment may require modification of scope. Done correctly, ROI analysis should be productive and helpful and come to a close when there is sufficient information on hand to give invested parties confidence in a decision and its cost. The effort should feel well worth it.

Risk Factors

Risk factors associated with a project also can be finance- or mission-related. Thoughtful risk identification helps assure project success and a thorough understanding of real costs. For example, introduction or replacement of membership/development or collection management systems can entail very high risk related to the ability to raise money, nurture relationships or manage and steward collections.

A decision to deploy a specific technology at any point in time implies an assumption about the pace of technology change. Even tried and true technology may soon be rendered obsolete and a seeming leading edge may lead your museum off the edge of a cliff. Consider how cell phones have overtaken personal digital assistants (PDAs) or how iPods and cell phones in museums are supplanting traditional audio tours. The adage, "Standards must be a good thing—that's why there are so many of them to choose from," stands as true as ever. But how do you choose? What is the worst case if it is not broadly accepted? How might a museum's adoption of or failure to adopt industry standards affect both project cost and long-term viability?

There is risk borne of changing systems, not just initiating them. Risks in changing over a membership/development system, for example, may include the inability to target prospects because of data conversion flaws; campaign goals may slide because cutover misses a deadline. Only once these risks are clear can they be reduced to a more acceptable level. Only then can testing and data review be increased, parallel system operations extended and staff training accelerated. The implementation schedule can be adjusted away from end-of-year fundraising. Of course, risk reduction can also introduce new costs, which feed back into the equation. The big question is, "How much can you invest in reducing risk before the cost of risk avoidance overwhelms project benefits?"

There are also personality-based risks. How dependent is a project on one person's knowledge and skill? What would happen if that person left the organization or vendor? What is the fallback position?

Not pursuing a project can lead to risks as well. Deferred building maintenance can foreshadow an array of costly perils. Inadequate investment in digital imaging might risk the need for re-photographing objects later. Allowing an old website to languish in look, feel and functionality could convey a poor image to visitors, members, donors and the press, causing a cascade of subtle but profound consequences.

Finally, the most dangerous risk can be too much success. Consider the new website with access to images, audio, videos and rich teacher resources there for the download. Wow! The traffic to the site immediately soars! Can the server and bandwidth handle it or will poor performance become a source of user frustration and institutional embarrassment? Can the museum sustain demands for keeping it updated and responding to visitor queries? What is the worst-case scenario for the unintended consequences of best-case success?

PUTTING IT ALL IN CONTEXT

Although the ROI analysis process suggests a certain meritocracy, projects may survive or die based as much on a museum's internal ecology as on comparative merit. Therefore, it is important to understand the species that populate the project environment.

Financial Managers

Institutions differ in how they financially account for projects. A project's financial amortization time frame, whether based on capital expensing, operational expensing or both, may differ from the lifespan used in the ROI analysis. That is okay—they serve different purposes. Sometimes certain costs for research, site visits, demonstrations and early stage consultancies are not charged to a project but are expected to come from previously budgeted departmental operating funds. This approach, which penalizes departments for their due diligence, can be counter-productive and demoralizing. The more expensive or profound a project, the more these research efforts should be funded as part of the project. However, if a project does not proceed to completion (which may be a good thing), expense accounting may differ.

Projects can be financed directly (capital and/or operation budget), from special allocations such as endowment or from external funding such as grants, gifts or loans. Lease or loan financing can be used to finance projects in whole or in part but should primarily be considered where the ROI warrants it. For example, one major museum allowed its computer and network systems to languish so badly that it became mired in a firehouse mentality of maintenance, repair and upgrade along with staff complaints of outdated software with few needed features. This became a money sinkhole with an IT staff driven to distraction, frustration and resignation (from their jobs). A three-year lease purchase plan funded a total replacement of computers, network gear and cabling plant repairs. The expense totaled no more than they had already planned to spend annually but the museum reaped full benefits from day one.

Departmental charge-back is sometimes used (to varying success) to fund projects and control costs. In one case, departments jointly funded a new e-mail system— it was the only way they could afford it, and each thought the return was well worth it. In another case, a major system's needed upgrade was almost scuttled when a significant department and beneficiary could not free the funds.

As illustrated above, the museum's accounting rules can support or impede a project. IRS rules and general accounting principals can be more flexible than some finance departments let on. Also, I intentionally skirt ROI measurement math such as Net Present Value (NPV) and Internal Rate of Return (IRR) in this essay in order to focus on fundamental principals; finance staff can determine how these or other measurements should or should not be applied. The bottom line, though, is simple. Enlisting a finance department as an ally in developing an ROI analysis plan can help assure that the results are both useful and credible.

Information Technology Staff

Engaging the museum's IT expertise and perspective early in the ROI analysis process can help identify synergistic opportunities and avoid unexpected problems or unintended consequences. For example, the IT staff could help identify the network capacity ramifications of increased digital imaging or the cost implications of expanded bandwidth needed by increased website access. For one museum, the implementation of a digital asset management system coincided with the need to upgrade their security system from videotape analog to digital. As the common denominator of both systems, IT were recognized both the initial cost savings and long-term maintenance efficiency to be achieved by using the same image storage hardware.

Board Members or Committee

Involvement of an interested board member, or committee of the board, in highly visibile, strategic or costly projects, can help establish support, justify risk, secure outside resources and, as one museum director put it, "give everyone cover."

Opinion Leaders and Key Staff

As much as the intended benefits of a project can raise it to the top of the priority list, negative unintended consequences, detected late in the process, can abruptly abort it. Sharing project ideas and soliciting feedback from opinion leaders and key staff can provide an opportunity to modify a project, improve its perceived benefit and broaden its endorsement.

WHEN BAD ROI RESULTS HAPPEN TO GOOD PROJECTS

If the net return is not as compelling as had been hoped, perhaps one of the questions that defines the ROI analysis process should be revisited: "Is the project plan as efficient and effective as it could be?" Once cost, benefit and risk calculations have been verified, alternative, more creative means of executing the project should be explored. These can include the use of manufacturer-refurbished equipment, the outsourcing of certain services such as Web hosting or minimizing software user licenses. Consider whether there are project components such as software modules, customization, multimedia production elements or website features that do not add enough value to justify their cost. Would one or more "off the shelf" products satisfy most of what seem to be the unique needs requiring costly solutions?

If the primary benefit of a project is mission-based but the immediate financial return is minimal and it is beyond the museum's funding capacity, perhaps the project can be affordably phased in with funding for subsequent phases to be secured later. If there is confidence in long-term financial payback, a loan or lease/buy-back plan may be appropriate.

Finally, collaborations and partnerships have increasingly emerged as an effective way of achieving projects. Advanced, creative and highly visible uses of technology can attract manufacturers to become partners or provide discounts. Many museums and college digital media programs have discovered mutual benefits in working together on Web and multimedia projects.

SHH … (WHEN ROI IS RARELY UTTERED)

As noted earlier, Cresswell compared ROI analysis with a "lifestyle change." Ideally that lifestyle change should carry through all layers of operations, not just special projects. But even where this kind of thinking is embedded, there may be gaps in its application. Here are some activities that rarely get the ROI-al respect they deserve:

Professional Development

Many managers still consider conferences, symposia and workshops such as those sponsored by Museum Computer Network (MCN), American Association of Museums (AAM), Association of Science-Technology Centers (ASTC) and others to be junkets or perks. As waves of cultural and technological change shake and stir the museum world, these are exactly the cauldrons of new ideas,

shared knowledge, professional networking and increasingly vital collaborations that provide high returns on investment. How much is one great idea, new collaboration, newly discovered grant opportunity or innovative technique for generating new audiences worth?

Ongoing Staff Training

High-quality, ongoing staff training in systems and software use and the strategies they employ is still often vastly undervalued, viewed as a luxury, indiscriminately deferred or considered a budget throwaway. Yet stagnant or outdated skills can reduce staff satisfaction and deprive organizations of the opportunity to wring the most benefits from their existing investments. Even more troubling, these are the same staffs that are asked to help specify new systems.

Civic and Social Engagement

The emergence of Web 2.0—a shared social space characterized by wikis, YouTube, MySpace, weblogs and social tagging—presents museums with a new realm of investment decisions. Virtual museums with real world images already exist in the Second Life virtual world, museums and directors have blogs and website visitors are asked to enter into dialogue with museums and other visitors. AAM has long encouraged civic engagement, and the digital age both amplifies and helps meet that challenge.[6] Civic and social engagements in a digital age can also shield museums from past biases of space and social demographics and "allow museums to be as expansive as we can tolerate."[7] How can we measure the return on this type of investment? I'd say with a leap of faith and a good sense of self-preservation.

CONCLUSION

Museum professionals work in a very exciting world—a world of ideas, knowledge and public benefit. Museums are among the most trusted institutions in the country,[8] and museum staffs champion their passions as they seek the best ways to steward their collections, build bridges to their communities and continue to earn the public trust. The technology that seemed to "come to dinner" in 1969 has become a permanent guest. Computer, imaging and telecommunications technologies are today's great enablers of these laudable ambitions. As this digital age forces museums to choose among a myriad of extraordinary opportunities, the values and processes of a Return on Investment "lifestyle" can help us meet that challenge.

NOTES

1. Everett Ellin, "Museums and the Computer: An Appraisal of New Potentials," *Computers and the Humanities* 4, no. 1 (September 1969): 25–30.

2. American Association of Museums, *Guidelines Concerning the Unlawful Appropriation of Objects During the Nazi Era* (1999, amended 2001), www.aam-us.org/museumresources/ethics/nazi_guidelines.cfm

3. See http://en.wikipedia.org/wiki/Satisficing (accessed August 14, 2007).

4. Although the term "champion" generally conjures the image of an individual, the champion described here need not be a "lone ranger"; our champion can be a department, staff group, board committee or ad hoc community of interest who passionately promotes and pursues their ideal.

5. Anthony M. Cresswell, *Return on Investment In Information Technology: A Guide for Managers* (Albany, N.Y.: Center for Technology in Government, 2004), www.ctg.albany.edu/publications/guides/roi.

6. American Association of Museums, *Mastering Civic Engagement: A Challenge to Museums* (Washington, D.C.: American Association of Museums, 2002).

7. Leonard Steinbach, "Forum: Civic Engagement in a Digital Age" *Museum News* 82, no. 3 (May/June 2003): 27ff.

8. American Association of Museums, "Americans Identify a Source of Information They Can Really Trust," press release, May 7, 2001.

Technology's No Tea Party
for Small Museums

Angela T. Spinazze

How do 12,000 small museums in the United States incorporate information technologies into their physical spaces, museological practices and online environments? Which technologies are used? What are the obstacles to bringing them in? What benefits do small museums receive from the use of technology?

Over the course of the past 20 years, information technologies have become part of day-to-day operations in museums around the globe. In most small museums, however, the use of these technologies remains limited due to cost, staff and access constraints. Technology costs money and requires suitable expertise to engage, and gaining access to infrastructure can be difficult in both urban and rural communities.

When we talk about information technologies in the context of small museums, we are talking about more than simply a Web presence. All museums use technologies to keep the doors open, the lights on and maintain environmental conditions that are suitable for the display, storage and preservation of artifacts. It is easy to forget, however, the value of using information technology to communicate with constituents, solicit donations and keep audiences informed. The technologies given the most attention these days are those used to support online access to collections information. Many small museum websites, however, also serve as staff extensions by providing vital information such as visiting hours, directions and answers to frequently asked research questions.

In autumn 2005, in preparation for a session to be held at the American Association of Museums (AAM) annual meeting in Boston, a colleague and I

distributed a survey to ask some simple questions and start a dialogue about the use of technology in small museums. This chapter highlights the results of that survey, the respondents' comments and the insights shared by the panelists who brought the session to life.

SMALL MUSEUMS AND TECHNOLOGY: A CONVERSATION

The intent of the AAM session, "Technology's No Tea Party for Small Museums," in Boston in 2006 was to raise awareness of the technology needs of the roughly 12,000 small museums in the United States. Two of AAM's standing professional committees, the Small Museum Administrators' Committee (SMAC) and the Media and Technology Committee (M&T), supported the session. For the purpose of the discussion, SMAC defined a small museum as an institution with:

- a combined annual budget of $350,000 or less
- staff size of five or fewer
- one or more staff members with multiple roles in the museum (i.e., curator/ volunteer coordinator)

To help set the agenda for the discussion, the panel issued a survey asking museum professionals who work in small museums to describe technology use in their institutions. The survey consisted of ten questions aimed at identifying which technologies small museums used, the obstacles and benefits of those technologies and what technology needs lacked adequate solutions.

Informal in nature but written with clarity of purpose and the desire for measurable results, the survey was available on the M&T website for two months. Announcements and invitations to participate were posted to a variety of list-servs and a postcard mailed to all 350 members of SMAC.

Eighty-two museum professionals responded to the survey. All but seven respon-ses met the qualifying requirements defined above. We heard from curators, col-lection managers, directors, registrars and volunteers, among others. The largest number of responses, 29, came from directors/executive directors.

Here are some highlights of the survey results (complete survey results for questions 1 through 5 are available at the end of this essay):

- The top three technologies used in small museums are e-mail, word processing and the Internet. A tie for the fourth most used technology, interestingly, was between voicemail, digital scanner and digital camera.
- The most significant barrier to using information technology is financial support.

This was followed by a tie among the other three options offered: staffing, knowledge of technology and experience or comfort with technology.

- The most beneficial use of technology reported was to facilitate communication among colleagues and members. This response led by a considerable margin, followed by collections management and publications.
- Software needs without adequate solutions include kiosk applications, audio guides and website creation. Facilities management and membership/ development tools closely followed these three responses.

While the survey responses may not seem surprising—most modern-day museum work environments involve the use of word processing software, e-mail and the Internet—they do shed light on the information ecology of small museums. The idea of an information ecology, as described by researchers Bonnie Nardi and Vicki Oday, exists on a local level. In their words, it is "a system of people, practices, values, and technologies in a particular local environment."[1] It behaves much as a habitat does in biological ecology terms. An information ecology is characterized by locality; it reflects the relationships between technology, people and practice; it is complex and diverse; and it must evolve organically based on the needs of those inside. This environment offers an arena within which to reflect on the effects of our use of technology. It is within our local habitats, the authors posit, that we find the greatest ability and perhaps creativity to affect technological change. In turn, this shifts the focus toward people and away from machines.

The survey results reflect this very notion of people as the nexus. The responses support the idea that, within the small museum habitat, the information ecology is characterized by a community of professionals working with limited resources, guided by professional and ethical standards, engaging in object care, display and interpretation and incorporating technology as a means of assistance with daily administrative and communications activities. This ecology reflects "the stable participation of an interconnecting group of people and their tools and practices."[2]

Whereas museums of greater size are able to take basic information technologies for granted, fixing their attention beyond the day-to-day, small museums use their information tools as extensions of their limited staff, who spend more time communicating with colleagues, producing newsletters and scheduling volunteers. The information ecology that small museum professionals describe, along with the resounding reply that financial resources are the biggest barrier to acquiring information technology, makes a compelling case for focused investment in this group on the part of grant-making institutions.

BOSTON TEA PARTY

Four panelists at AAM's 2006 Annual Meeting discussed the four themes that emerged from the survey responses—planning, choices, funding, expansion—in relation to their direct work experience. The panelists included Lin Nelson-Mayson, executive director of the Goldstein Museum of Design at the University of Minnesota in St. Paul; Steve Ringle, registrar at the University of Maine Museum of Art, in Bangor; Cindy Bowden, director of the Robert C. Williams Paper Museum at the Institute of Paper Science and Technology at the Georgia Institute of Technology in Atlanta; and Joni Blackman, director of the Fenton History Center in Jamestown, N.Y. This heterogeneous group represented art, science and history institutions located in the midwest, south and northeastern regions of the country.

Each panelist presented his or her own experience working with information technologies in relation to one of the themes. Evident from the start, however, was that each of the themes is echoed in the others. Examples of the overlap of these themes are reflected in the experiential summaries described below.

Planning

> Information is a source of learning. But unless it is organized, processed and available to the right people in a format for decision making, it is a burden, not a benefit.
>
> —*C. William Pollard*

Lin Nelson-Mayson discussed planning for digitization, a process that was being explored as part of a larger university-led strategic planning process at the Goldstein Museum of Design. The museum has less than three full-time staff and a collection of approximately 23,000 objects, with an emphasis on textiles and costumes. The collections are used heavily by classes at the University of Minnesota, as well as by students at neighboring academic institutions. Hands-on activities with fragile textile and costume collections can be difficult and typically require expert handling and planned access.

At the time of our conversation, the university was in the process of an institution-wide reorganization. As part of that process, the museum was selected to become part of a major initiative: a new college of design. It is within this context that the museum began to analyze its level of technology and how a change in academic location and standing might affect its ability to provide a larger audience meaningful access to its collections.

Given the nature of the Goldstein's collections and the difficulties associated with providing access to them, digitization was a process worth exploring. So how does a museum begin strategic planning for digitization? Early discussions focused on the value, meaning and process of digitization and the museum's specific needs in terms of staff. Questions such as how would digitizing the collections enhance our ability to do our jobs better, make the collections more useable or affect staffing, were explored along with what digitizing the collections would require. How much will it cost? Who will do the work? What types of questions will students ask about the collection? How will they find what they are looking for once the digitized images are made available?

These questions and many more were to be discussed at the museum's planning retreat, a key element of the process. As she reflected on what digitization might actually mean for the museum, Nelson-Mayson underscored a second vital element in the planning process: the ability to foresee and plan for change.

It became clear that time spent up front would help ensure success. Without adequate planning, objectives would not be clearly articulated; the primary audience, the students, would not be adequately provided for; and the technology would not be meaningfully integrated into other museum activities. It is precisely because the Goldstein wants to enhance access to its collections and increase awareness of them beyond its traditional audiences that the museum takes planning so seriously, Nelson-Mayson said. _____

Choices

> The most interesting information comes from children, for they
> tell all they know and then stop. —*Mark Twain*

Steve Ringle reviewed a variety of factors that staff at small museums might consider when deciding whether to introduce, change or enhance facilities, programs or procedures that involve technology. He covered all areas of museum practice, from point-of-sale systems in gift shops to temperature and humidity control, collections management and security systems. Ringle drew from firsthand experiences working with many forms of technology to describe how difficult it can be for small museums to make decisions about technology purchases, integration and maintenance.

Any museum regardless of size or scope will benefit from the following list of considerations compiled and reviewed by Ringle. Taken together with the

planning advice shared by Nelson-Mayson, decisions about your institution's information ecology can develop gradually, in an informed fashion and with full participation by museum staff.

Cost. Does the museum have the money to acquire the technology? Can the museum get the funds to make the acquisition, upgrade, etc.? What effect will the expenditure have on other museum priorities?

Necessity. Is the new technology (system, software application, hardware) something that the museum must have? For example, if an existing critical system has failed, such as a security system, there may be no choice but to purchase a replacement. What if the file server has been hacked and a security breach has occurred? Internet security may not be high on the list of priorities for your institution but it may become one if something unexpected occurs.

Demand. Is there internal demand for the technology? Does the director or a staff member require it? Is someone on the board promoting it? Is the board expecting that it will be purchased, installed, etc.? Perhaps this technology is something staff have campaigned for, or the public has come to expect the museum to use this technology and it's now time to take on that challenge.

Scope. Does the museum have adequate staff, time, space and equipment to undertake the project? What hardware, software and other materials are required in order to complete it? Which of these does the museum already have access to, which must be purchased and how easy will it be to acquire them?

Complexity. Do you and your colleagues have the aptitude and skills necessary to accomplish the project? How easy or difficult will it be to accomplish? Is there a steep learning curve with regard to this technology? Will it take a long time to install the hardware or to master the software?

Maintenance. What are the long-term costs? Is this a one-time installation? Does it require staff expertise and training? Will all new staff require training to use it? What utilities must be paid for once the new system is up and running? Does this system require an outside consultant to maintain it? (An alarm system, for example.) Is there a staff person eager and enthusiastic to take on the project? If not, who will be responsible?

Image. Is the museum seen as innovative? Does your institution take a leadership role in the community? What image does the museum want to project? If

the museum develops or commissions a new technology, will it also make the technology available to other institutions?

Availability. Is the technology readily available and ready to use off-the-shelf? If the museum needs a one-of-a-kind or unique solution, how will that happen?

Maturity. Is the technology mature or in a development stage? Could it be "buggy"? Is there good online support? Are there user groups and/or forums in which to raise questions?

Transition. What happens if the new technology replaces an existing technology? Can the museum plan to gradually introduce the new system while phasing out the old system or does the changeover have to be all at once? What is the transition plan from the old system, policy and process to the new system, training, installation, deployment, practice and policy? What changes? What remains the same? How does the museum manage abandonment? Embrace the new?

Opportunity. Is the time right for this technology because of a special offer? Did the museum receive a hot tip on a good deal? Is there a benefactor ready to act? Is the timing right to submit a grant application?

Funding

> Everybody needs money. That's why they call it money.
> —*Danny Devito*, Heist

Cindy Bowden spoke about potential financial resources and underscored the importance of mission-focused use of technology. She emphasized the role that grants can play to provide much needed funding to support innovation. And she demonstrated how spending time up front to seek out funders with synergistic goals and objectives allows institutions to use technology with a purpose and keep the museum's mission front and center.

For example, Bowden recalled how an initial grant from the Museum Loan Network was leveraged to obtain a second grant in support of the same long-range goal: a collections survey, the development of the Robert C. Williams Paper Museum's first collections catalogue and ultimately participation in a nationwide community of museum lenders and borrowers. The museum used the one-year, $15,000 survey grant to survey the collections for objects that had potential to be contributed to the network's loan program. The grant covered the purchase of photography equipment including a digital camera, lights and backdrops to

produce digital images of the surveyed objects. In addition, the museum purchased software for object cataloguing and digital image collection and earmarked a key portion of the acquired funds to cover part of the salary for a registrar to conduct the survey. The results of this effort included the identification of five hundred artifacts as potential loan objects, all digitized and catalogued. Of these, one hundred objects and their associated records and images were contributed to the Museum Loan Network database, which enabled other institutions to borrow them and learn about the Robert C. Williams Paper Museum in the process.

Bowden emphasized that because of this single, focused effort, more institutions became aware of the museum not because they added digital images to their website but because their images were made available to other institutions through the Museum Loan Network's database. In addition, the museum leveraged its participation in this program to secure a second grant from a different organization that helped pay the salary of the registrar whose expertise was needed to complete the survey. This one loan started the museum on its way to being able to catalogue its collections, create digital images of them and participate in a much larger network of cultural organizations. This small, local, university-based museum is now a lender to institutions across the country.

Expansion

> They say time changes things, but you actually have to change
> them yourself. —*Andy Warhol*

When a museum decides to develop a website, museum staff have to consider what they want it to accomplish and how they will help it grow. Joni Blackman explored these questions in her talk about how to expand the use of a technology once it has already become part of professional practice in a small museum.

It may seem clichéd to ask what a museum website might accomplish, but the fact is all websites are not created equal. Knowing what your museum wants its site to do will keep a site development project on track. Blackman echoed Nelson-Mayson's call to spend time plannning and went a step further to suggest that working with an outside expert can help keep these discussions and the stated outcomes focused, taking into consideration both what can and must be done in the present as well as what the future may hold.

Blackman recommended articulating a set of accomplishments for the site along with a means to measure success. In addition, she asked many of the questions

found on Ringle's list such as scope, complexity, maintenance and cost. She emphasized consistency of style, method and structure to aid in maintenance, longevity and clarity of message.

CREATIVE COLLABORATIONS

The goal of the session in Boston was to raise awareness of the technology needs of small museums and talk about solving these needs. What models can lead the way? There are many creative ways that small museums have become tech-savvy and empowered without breaking the bank. The most visible small museums have become so through collaborations with larger organizations that minimize the barrier to entry and, in turn, provide a high return on investment.

Museums on the Move is one of several services provided by the East Lothian Museums Service (ELMS) in the United Kingdom.[3] Designed to help small museums connect with community organizations interested in displaying museum curated exhibitions in their spaces, Museums on the Move provides the necessary equipment—secure, museum-quality glass cases with two internal shelves; computers in lockable cases for digital display of digital photos; curated presentations, sound, etc.; projectors; folding, free-standing notice boards to display related original materials or facsimiles; and other accessories that might be useful depending upon need. Museums on the Move is a recent addition to other outreach services already offered by ELMS, but one that over the course of just a few years has helped several institutions in the region gain awareness through community involvement.

Collections Australia Network (CAN) (formerly Australian Museums and Galleries Online—AMOL), an online portal since 1997, included museums across Australia in a collaborative effort to provide online access to cultural heritage collections.[4] Through a set of tools and tutorials designed to make it easier to digitize collections and contribute high-quality content to accompany them, the CAN portal includes published exhibitions, news items and a searchable collections database. They recently agreed to participate in the Federated Open Search Project, which seeks to provide focused search capabilities across Australian institutional records contributed by archives, museums and libraries. The information and collections currently accessible through CAN include contributions from 80 organizations representing all Australian territories.

In Canada, a similar effort by the Canadian Heritage Information Network (CHIN) has been ongoing since the mid-1980s.[5] CHIN has produced online

guides to creating and managing digital content, a biannual review of collections management software applications and digital publishing opportunities such as the Community Memories project, for example. The network enables small museums across Canada to participate in online initiatives that would be formidable to accomplish on their own.

Closer to home, statewide initiatives such as North Carolina's Exploring Cultural Heritage Online (ECHO) promotes the use of technology to enhance collections access and provides guidance and training to those in need.[6] This project began with a focus solely on libraries. Over time, however, it has broadened its efforts and now encourages collaborations between libraries and partner cultural organizations. Grants for digitization are available, as are a host of online educational materials that address issues such as planning for digitization, preservation and online collections access. Small museums such as the Museum of American Pottery in Creedmoor, N.C., with a collection of 400 pots and an online presence of a single webpage, as well as the Arts Council of the Lower Cape Fear in Wilmington, N.C., which does not have a Web presence, are partners in ECHO initiatives.

If a museum with a minimal Web presence, a mission that has kept it going for 30 years and an awareness of opportunities around it can participate in a state-wide effort to build awareness of unique and important collections, then clearly small museums are more Web-savvy than we might want to give them credit for. Certainly, the respondents to our survey, along with the talented speakers at the session, backed this up. I would like to think that with a bit more support from local, state and national organizations, we might begin to understand better how small museums fit into the information ecology of the collective museum community.

CONCLUSION

There are very practical needs voiced through the responses to the survey. Barriers to technology use are based on financial, staff and expertise constraints. These are areas that the museum community itself can help address through professional partnerships, mentoring/tutoring programs, educational initiatives and efforts of inclusion. In addition, museum studies programs might begin to consider seriously the needs of small museums as a facet of their academic programs. The community as a whole benefits when young professionals come into the field with an awareness of where they are needed and with firsthand experience gained by working in these institutions.

Local, state, regional and national programs need to think beyond the Web when they develop programs about information technologies and small museums. While kiosks, audio guides and the Web were among the top three issues in need of solutions, membership and development, volunteer scheduling and facilities management were not far behind. These last three activities mentioned by respondents that are in need of smart technology solutions fall off the radar of most solution providers. Why not engage a savvy group of museum professionals—including designers, application developers and content providers—to develop and build an open source solution to something as basic as a scheduler so that small museums can manage one of their most basic revenue generators—the rental of their buildings' space to community groups for special events?

Small museums are more visible and the barriers to technology use begin to lessen when small museums are invited to participate in the larger cultural and museum communities. The return on investment can be significant for all involved. Regional museum associations might consider becoming service centers much like East Lothian Museum Service, which is part of a larger network of regional centers that develop programs specifically designed to meet the needs of local museums. What small museums need more than ever, though, is a more strategic place in the larger community so that their participation can further their institutional mission, as much as, if not more than, it furthers specific project goals and objectives.

This conversation concerns learning from small museums as much as understanding the unique characteristics of their information ecologies. We have learned that the ways in which small museums use technology is innovative and centered on people doing their jobs. Technology is more than a tool; it is an extension of the staff, it serves as a key component in the larger organizational mission and there is a healthy respect for the planning process because these museums have consistently realized great benefits from integrating technology into all facets of professional practice.

SURVEY RESULTS

Note: *Below are the survey results for questions 1–5. Results for questions 6–10 are not included here, as they asked for information specific to each respondent.*

Questions about how the organization currently uses technology

1. Which of the following information and communication technologies does your museum use? [Respondents were asked to check all that applied.]

69	E-mail
66	Word processing applications (MSWord)
65	Internet/website
64	Digital camera
64	Phone (voicemail)
64	Scanner
59	Digital image software (Photoshop)
58	Spreadsheet applications (Excel, Quick Books)
51	Collections management software
45	Database applications (Filemaker pro, MSAccess)
40	E-publishing applications (MSPublisher)
39	Network
37	Intranet/shared files and resources among staff
30	Membership/development software
28	Central server
8	Scheduling applications (facilities, people, exhibits)
5	Ticketing software

2. Rank these barriers to the use of information technology in your museum, beginning with the most significant barrier (1) to the least significant barrier (4).

42	Financial support
13	Staff
11	Knowledge of technology
7	Experience with technology

3. What is the most beneficial use of technology in your museum today?

64	Communications—ease of communication with colleagues, members, staff (e-mail, newsletters, etc.)
50	Collections management—keeping track of objects, artifacts, etc.
42	Publications—production/distribution of newsletters, catalogues, etc.
35	Administration—accounting and management activities, scheduling, etc.
33	PR/marketing—press announcements, invitations, etc.
28	Membership and development activities—gifts, planned giving, etc.
19	Education—teacher support, student visits, etc.
0	Events—planning, ticketing, etc.

4. What technology solutions does your organization need that it cannot find ready-made?

Do you have software for . . .

- 27 Kiosk applications
- 24 Audio guides
- 20 Website creation
- 19 Facilities management (room scheduling, work order control, etc.)
- 19 Membership/development
- 17 Volunteer scheduling
- 16 Inventory control/sales
- 15 E-Publishing (electronic newsletter, etc.)
- 9 Collections management
- 9 Group scheduling
- 8 Image processing/manipulation (Photoshop, etc.)
- 7 Ticketing
- 5 Desktop publishing
- 4 Advanced administration (database, financial, HR, etc.)
- 1 Basic administration (word processing, spreadsheets, etc.)

Do you have hardware for . . .

- 20 Kiosk applications
- 18 Audio guides
- 15 Security
- 10 Collections management
- 10 Network
- 10 Scanning
- 9 Inventory control/sales
- 8 Advanced administration
- 7 Basic administration
- 6 Ticketing
- 4 Desktop publishing

Questions about staffing

5a. Does your museum have an information technology specialist?

- 17 Yes
- 55 No

5b. If yes, then he/she is:

- 8 Full-time
- 3 On contract
- 2 Part-time
- 2 Job share
- 1 Board member
- 1 Volunteer

NOTES

1. Bonnie A. Nardi and Vicki O'Day, *Information Ecologies: Using Technology with Heart* (Cambridge, Mass.: MIT Press, 1999).

2. Ibid.

3. Museums on the Move is made possible through a grant from the Scottish Museums Council to the East Lothian Museums Service to help community groups curate their own exhibitions in unusual spaces. See www.eastlothianmuseums.org/content.

4. Sarah Kenderdine, "Inside the Meta-center: A Cabinet of Wonder," from Papers: Museums and the Web 1999, www.archimuse.com/mw99/papers/kenderdine/kenderdine.html.

5. The Canadian Heritage Information Network (CHIN) promotes the use of information technologies to aid in the development, presentation and preservation of Canadian cultural heritage since 1970. See www.chin.gc.ca.

6. North Carolina ECHO, Exploring Cultural Heritage Online is a portal to special collection materials found in North Carolina-based institutions such as libraries, archives, museums and historic sites. See www.ncecho.org.

Open Source, Open Access: New Models for Museums

Susan Chun, Michael Jenkins and Robert Stein

From their early days as public institutions, museums sought—through research, display and publication—to share their collections. Over time, museums' presentation of knowledge broadened to include professional practices and policies through publications, public lectures and education programs. The digital era presented museums with additional opportunities for sharing knowledge. Though museums have embraced some of these possibilities, such as outreach to a broader audience via the World Wide Web, other prospects are largely untapped. One such unrealized opportunity is museums' potential to share not just their collections and interpretation but also their software and software development methods, by building and adopting open source software and collaborating using open source models.

Open source software is software for which the code is made public—either under terms of a license agreement or through the copyright holder's decision to place the code in the public domain—allowing users to freely modify or adapt the software for their own needs. Its corollary, which in this paper is called "open access" software, exposes enough information about the code to allow users to take advantage of the software without requiring the developer to actually publish or relinquish control over the code. In rejecting proprietary software models, leaders of the open source movement also embraced collaborative, even public processes for specifying and developing software, which are here referred to as "open source methods." These methods, and the philosophy that they embody, represent a potentially invaluable new model for the museum community.

The open source software movement has been widely discussed and generally embraced in corporate, academic and personal computing settings.[1] For museums—organizations whose resources, both human and financial, may be limited—the promise of open source is especially compelling. In addition to creating efficiencies of cost, open source development activities can draw on well-established networks for institutional collaboration and offer an important professional development opportunity for museum professionals.

Nonetheless, actual adoption of open source software and methods has been relatively limited in the museum community. There are a number of possible explanations for the failure of museums to adopt open source models, including the lack of appropriately skilled staff, uncertainty about the benefits of collaborative development, a conviction that "competitive advantage" might be lost through the sharing of technology and apprehension about how to contract for services and products. Still, the potential of open source software—paired with open content licensing—to increase access to content, and the use of open source methods to energize discussion between colleagues about institutional processes warrant consideration of open source as a new philosophy for museums. In this essay, we propose models for initiating and participating in open source and open access projects, examine the pros and cons of these models with respect to museums and consider the philosophical implications of using open source methods to support institutional goals.

DEVELOPMENT MODELS FOR OPEN SOURCE AND OPEN ACCESS

Museums may hesitate to adopt open source methods, believing that the tools, processes or outcomes of open source development are incompatible with their established practices.[2] With a variety of ways to adapt open source methods to existing strategies, however, museums may find this process easier than expected.

Perhaps the best-known model for open source development utilizes a grassroots team of developers. Grassroots projects are those in which the primary stakeholders for the project's success are also the primary developers. Notable examples of grassroots development projects exist in the professional software development space, such as the Apache server and Mozilla's Firefox Web browser.[3] Adopting the methods of these successful projects for the museum community would mean that most or all of the software development work would fall to museum staff members. Ideally, such projects would also engage the museum user community, taking advantage of the shared vocabulary and needs of project participants to communicate about features and requirements.

Resulting grassroots projects for the museum community would have the potential to produce software tailored specifically to community and institutional needs. A serious drawback to this approach is that most museum professionals do not have backgrounds as professional software developers. Consequently, system architecture and design can suffer, and the resulting software has a tendency not to scale well beyond its initial deployment. Given that the ability to augment and expand open source software is a key motivation for participating in such collaborations, museums-only grassroots development carries some risk.

Recently some commercial software companies have been taking a different approach to open source software development that leverages its benefits while protecting the company's intellectual property, an approach that might well be termed "open access" software.[4] Open access software makes the features and methods of the underlying software public by exposing an application programming interface (API), the expression of a set of functions and syntax that developers may use to exploit the underlying software without having to directly include or modify it. Companies such as Google, Yahoo and Amazon have taken advantage of this method for exposing APIs, allowing developers to utilize their software without access to the actual source code.

For museums, open access development could allow tailored customizations to commercial-grade software, thereby leveraging the expertise and quality assurance processes of a commercial software company. Because many of the open access APIs allow developers to extend the functionality of already robust software, the cost of development can be much less than building wholly custom applications. This approach may be well suited to finite projects where ongoing growth and long-term sustainability are less important than delivering unique content and experiences to users. One such example of a popular open access application is the Google Maps API, which has been widely used in "mashups" to provide a geographic context for a wide variety of information. For example, HousingMaps.com, one of the very first Google Maps mashups, is designed to present houses for sale and rooms for rent across the country; it uses the Google Maps API to place these listings on an interactive map.[5] Museums have begun to exploit the tool set as well: an interesting example by the British Library presents documents from the collection in their geographic context, using information about location already in the catalogue (see Fig. 1).

Another outstanding demonstration of a small museum taking advantage of open access software produced by a commercial vendor is a website developed by

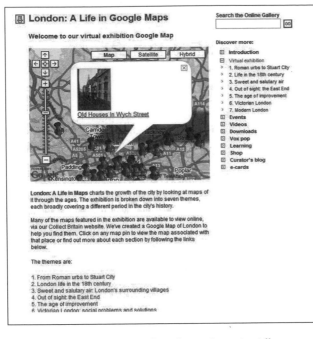

Figure 1. The British Library's "London: A Life in Google Maps," (www. bl.uk/onlinegallery/features/ londoninmaps/exhibition. html).

the Maxwell Museum of Anthropology in Albuquerque, N. Mex., to showcase the photographs of the American photographer John Collier Jr. (see Fig. 2). The museum takes advantage of a mashup with the photo-hosting site Flickr to publish hundreds of high-resolution images. The cost-conscious choices made by the website developers served to marshal project funds for additional site features as well as to expose the Collier photographs to Flickr's millions of daily users.[6]

The open access method is not without risks. As with proprietary software solutions, it may be impossible to customize underlying software. Likewise, changes to the API are not likely to be made if the vendor does not perceive a business opportunity. Finally, open access software is provided and supported by a company. If this company dissolves or significantly changes its strategic direction, support for the software on which an organization depends may be terminated. Open access and grassroots methods also bear the risk of a lack of long-term support for the software product.

The drawbacks associated with these first two models for open source development suggest a third method in which museums would pool the dollars they spend on commercial closed source development to instead fund open source customizations that can be shared and extended by a community of invested participants. In this model, museums would contract with software vendors to build open source software that meets any of a variety of institutional

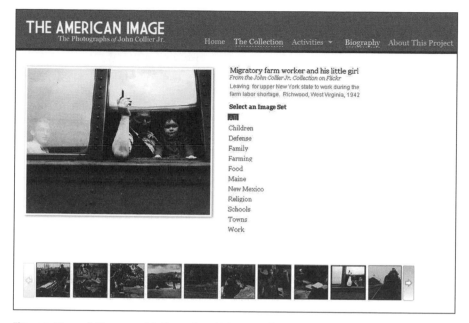

Figure 2. Maxwell Museum of Anthropology, University of New Mexico, "The American Image: The Photographs of John Collier Jr.," (http://americanimage.unm.edu).

or community needs. Contracting with outside software developers is not unique in the industry, but an important difference here is that museum staff would also share in the workload around project planning, development, testing and documentation, and that an explicit commitment would be sought from the vendor to release the source code under an open source license. In this way, some of the disadvantages cited in the previous two methods can be addressed. The museum (or museum collective) can contract for commercial-quality software that is specifically tailored to institutional needs, not settling for whatever the vendor decides to provide. If it is specified that the software is to be open source and is intended to be extended in the future, the developer can take this into account when crafting the software, allowing the project to tolerate extensions and features not initially envisioned.

CURRENT OPEN SOURCE PROJECTS

A few examples of successful open source projects exist in today's museum community. One such project is steve, a collaboration of art museums to design, build and share an open source software tool for collecting "tags" to describe museum objects.[7] The project was born out of a discussion at the Metropolitan Museum of Art (the Met) about approaches to gathering keywords that describe works in the museum's collection. The Met's staff recognized the need to collect terms that visitors might use to describe artwork—terms that curators

may not use in official documentation. These descriptive terms could include iconography, colors, emotions or themes, as well as words in other languages. Encouraged by promising proof-of-concept testing conducted on-site in 2004, Met staffers hypothesized that an online community of volunteers would willingly "tag" images of works of art.[8] A tool set for publishing images and collecting terms online was needed, however, to prove the hypothesis beyond proof-of-concept. In 2005, lacking available resources to build the tools, the Met turned to colleagues in the museum community and found a number of partners willing to collaborate in tool development and research. Project team members from more than a dozen organizations endorsed the philosophy of building open source software that would be shared and freely downloadable. The project philosophy also included an open collaboration model—the public documentation of specifications, discussions and products—as well as a commitment to making both research results and raw data public. By mid-2007, the project's participants had worked together to release the steve tagger software, to create a project website and to launch a research project funded by the Institute of Museum and Library Services. Most of the project team's organizations contributed institutional resources to specify, develop, test, deploy and document a functioning software tool, each contributing according to its staff's own strengths—demonstrating the possibility of effective collaboration by museums toward a common technology goal.

Two somewhat unexpected developments of the steve project may be worth noting. Early in the collaboration, it became clear to the project team that, although there was general agreement about the software specification and the research agenda, the partner institutions had a range of different motivations for participating. Some were attracted by the efficiencies of cost that would result from shared development work; others saw the project as a professional development forum, exposing technology staff from their organizations to others in the community. Furthermore, these institutions had very different ideas about the actual value of a tagging project for their users: some organizations were intent on using collected tags to facilitate access, while others were intrigued by the potential of tagging to engage visitors in a closer relationship with museum objects. Interestingly, the fact that the participants' incentives for joining may have varied has not affected the quality of the collaboration; it may, actually, have strengthened it by equipping contributors with a richer understanding of the work as well as additional motivations for success. A second unexpected development has been the exceptionally strong interest shown in the project by members of non-museum constituencies: academics, librarians, the press and

professionals from the private sector, including commercial software developers. Had the project been carried out using traditional closed source development methods by a vendor on contract to the Met, it seems unlikely that the work would have provoked such lively interest and useful feedback.

Another well-received open source project in the museum community, the Pachyderm multimedia authoring tool, began life as a project of one museum. The San Francisco Museum of Modern Art (SFMOMA) developed the tool set to produce its award-winning online publication, "Making Sense of Modern Art." SFMOMA later teamed with the New Media Consortium to extend the tool's functionality. Though not originally an open source project, Pachyderm's sponsors made a studied decision to develop using open source methods, gathering members of the community to help to specify a tool set that would be of value to the museum and academic community as a whole, with a goal— accomplished in 2006—of releasing the resulting software as open source.

INSTITUTIONAL JUSTIFICATION

While museums may consider open source solutions based on the quality or appropriateness of the software itself, some additional institutional considerations may be studied also as museums—and the museum community—weigh their policies on open source.

Museum-specific applications do not represent a lucrative vertical market for most software vendors. While the museum community has benefited from the work of a few notable software companies, the resources of these companies are necessarily limited due to the size of the market they serve. These companies must make decisions about the direction of their software and service offerings based on business opportunities that do not always align with broader community need. Improving a product's feature set to land the next big client often takes priority over more challenging tasks such as revisiting dated architectures to make applications integrate more easily with other systems. Working in a collaborative manner—developing open source solutions and releasing local customizations— museums and software vendors can reduce redundancy and harness the gained resources to create more open museum-specific applications.[9]

The most common argument for open source software development is that it is cheaper than purchasing proprietary solutions that require configuration and customization for local needs. With an open source solution, upfront costs are generally lower: no per seat licensing cost, no underlying operating system and

database licenses to buy. Beyond a lower initial price for the software, however, other related costs may be similar to those of proprietary alternatives. Retaining qualified technical staff, conducting ongoing training, maintaining the system and integrating with other systems will account for the largest cost in any technology project. While museums may find a financial argument for open source convincing, other rationales may be more compelling.

Developing successful content-related software requires the participation of professionals from the intended user group as well as technology professionals. As museums bring these sometimes unfamiliar groups together to work on open source projects, each participant has an opportunity for professional development. Nontechnical staff are exposed to the decision making and rule-based approach that is central to software development, and technical staff have the opportunity to learn more about the programs at the core of the museum's mission. With this learning, users can embrace the institutional change required to adopt new software, and the technology staff can develop a greater sense of personal investment in the museum. This approach also provides the ability to recoup some of the investment in standards work long done by collections information staff that is not easily implemented in off-the-shelf software offerings.

Beyond the business arguments for adopting open source development methods, museums can hope to use open source activities to their benefit in other ways. They may, upon closer evaluation, come to see open source philosophies as inherently compatible with museum culture, where successful exhibitions and programs are built around long-standing relationships centered on shared needs, established standards, knowledge exchange and strong personal and professional relationships. Leveraging such embedded institutional relationships beyond the exhibition and collection spheres and into that of technology may strengthen already vital bonds between organizations. Collaboration to build software and tools that promote art and culture may increase museums' effectiveness in attracting public attention in an already crowded online space, where cultural institutions are disadvantaged by budget constraints and a reluctance to earn income through advertisements.

In practice, building software that scales for use by many institutions instead of just one will certainly require additional advance planning, a tax on time and brainpower. The cost of this advance planning may well be offset by the advantage provided by tapping the collective wisdom: The reflection and deliberation that go into planning software that works for the community at large will likely

contribute to the production of more successful applications. To support this new way of developing software, museums will need to draw on their existing tools for institutional collaboration—the regular exchange of information between museum partners through visits and exchanges, the practice of shared standards development and expression and the vital role of museum organizations to foster and manage discussion. New tools and processes for managing collaborative work are likely to be required as well, and these tools may themselves be a useful product of future open source activity.

CONCLUSION

Museums may derive several kinds of benefits from participating in open source software projects, among them the creation of software specifically tailored to the needs of institutions and the museum community in a way that supports growth and ease of maintenance. Open source projects may also create efficiencies of cost for some small-scale projects and provide professional development opportunities for staff. This brief discussion of the potential for open source software, development and methods in the museum community raises the questions, "What next?" and, "How can an individual museum enter meaningfully into the open source environment?" Museums interested in exploring these benefits must take several steps. First, they will need to determine whether existing staff possess the skills required to evaluate the most appropriate ways of participating in open source projects: deciding which methods and models work best is likely to be determined by the resources, inclination, timetables and needs of the institution and the ability to make informed recommendations about when open source solutions will work is essential. Institutions must also examine, at a policy level, their commitment to open source activity, as those who see sharing knowledge as an extension of a core mission may be well served by endorsing open source software development or methods. Those institutions choosing to endorse open source should do so publicly, by openly expressing a policy that gives preference to vendors or museum collaborators who choose open source solutions—as the National Library of Australia did in its 2007 "IT Architecture Project Report," which proposed that the library "consider open source solutions where these are robust and functional. For functionality developed in-house, it is proposed that the library return intellectual property to the public domain."[10] Finally, museums that choose open source solutions for new projects should evaluate and publish their results, and—in the spirit of civic contribution and collective creativity that is the open source movement—add both the product of the work and the understanding gained in the process to the body of knowledge that is shared by the museum community.

NOTES

1. The precise use of the term is hotly debated in the software community, where some members use the term "open source software" interchangeably with the terms "free software" or "software libre." Others sharply contest the ethical, moral and philosophical imperatives implied by choosing the label "open source software" over "free software." It is not the intention of the authors to visit or vote in the open source–free software debate: these matters are treated with lucidity and passion by the leaders of the open source movement, especially Richard Stallman, in his collected essays with Lawrence Lessig and Joshua Gay, *Free Software, Free Society: Selected Essays of Richard M. Stallman* (Boston: Free Software Foundation, 2002); and Eric Raymond, *Cathedral and the Bazaar: Musings on Linux and Open Source by an Accidental Revolutionary* (San Francisco: O'Reilly Media, 2001). See also Michael Cusumano, et al., *Perspectives on Free and Open Source Software* (Cambridge, Mass.: MIT Press, 2005); Chris Dibona, et al., *Open Sources: Voices from the Open Source Revolution* (San Francisco: O'Reilly Media, 1999); and Steven Weber, *The Success of Open Source* (Cambridge, Mass.: Harvard University Press, 2004).

2. A common misunderstanding about open source software (or free software) is that it is *for free*. Richard Stallman and the GNU Project clarify the meaning and intent of free software developers by specifying that the intent of free software is "free as in 'free speech,' not as in 'free beer'." The project's definition of free software also includes the following rights: (1) You have the freedom to run the program, for any purpose; (2) You have the freedom to modify the program to suit your needs (access to the source code is essential to allow the exercise of this right); (3) You have the freedom to redistribute copies, either gratis or for a fee; (4) You have the freedom to distribute modified versions of the program, so that members of the community can benefit from your improvements (from The GNU Project. "Philosophy of the GNU Project." *The GNU Operating System*, www.gnu.org/philosophy/philosophy. html).

3. See Audris Mockus, Roy T. Fielding and James Herbsleb, "A Case Study of Open Source Software Development: The Apache Server," *Proceedings of the 22nd International Conference on Software Engineering* (Limerick, Ireland: International Conference on Software Engineering, 2000), 263–272; and Mitchell Baker, "The Mozilla Project and mozilla.org." *Mozilla Overview*, www.mozilla.org/editorials/mozilla-overview.html.

4. Yunwen Ye and Kouichi Kishida, "Toward an Understanding of the Motivation of Open Source Software Developers," *Proceedings of 2003 International Conference on Software Engineering* (Portland, Ore.: International Conference on Software Engineering, 2003), 419–429.

5. Google Inc, "The Google Maps API," www.google.com/apis/maps.

6. Maxwell Museum of Anthropology, University of New Mexico, "About This Project," *The American Image: The Photographs of John Collier Jr.*, http://americanimage.unm.edu/about.html.

7. See www.steve.museum.

8. Jennifer Trant, "Exploring the Potential for Social Tagging and Folksonomy in Art Museums: Proof of Concept," *New Review of Hypermedia and Multimedia* 12, no. 1 (June 2006): 83–105.

9. We are not suggesting that open source software should be used for all museum–specific applications. Our institutions have selected proprietary software solutions for many content-related applications, and in many cases are well served by these systems. The challenge for museums is to determine where and when open source development or solutions offer advantages over proprietary offerings.

10. National Library of Australia, "IT Architecture Project Report," (March 2007), www.nla.gov.au/dsp/documents/itag.pdf.

Reach More and Earn More: Connecting with Audiences Online

Nik Honeysett

Even though it is hard for us to imagine a world where one cannot buy or research anything on the Web, much of the museum community seems reluctant to fully embrace the Internet, either by not having a website, or by treating it as an afterthought. Some of the early museum Web pioneers established sites 10 to 12 years ago, but many museums still struggle with the simplest of technology requirements, let alone the luxury of a website. For an industry with severe budget constraints and the need to reach communities, communicate with the public and educate them about their collections, however, the Web is by far the most effective and economic way to do so. Further, museums lacking their own Web presence often suffer from misinformation about their institution posted by non-authorized organizations. If you care about the accuracy of online information about your institution, if you need to promote your institution and if your mission dictates that you educate the public, you should not only have your own website, but it should be core to your business strategic planning and operations. Like it or not, the Internet is becoming the primary way we research, do business, plan vacations and entertain ourselves and learn. It's also a powerful tool to increase revenue. More importantly, the youth of today—our future—are digital natives. To either remain or become relevant, any mid- to long-term strategic planning must include the Web as a primary mechanism to fulfill your mission.

MUSEUMS ON THE WEB

> Never be afraid to try something new. Remember, amateurs built
> the ark; professionals built the Titanic. —*Unknown*

Although the precise number of museum websites is unknown, a review of
the available statistics suggests that between one- and two-thirds of American
museums do not have websites.[1] A typical explanation of why a museum does
not have a website is that the cost of entry is prohibitive, particularly for small
museums. These costs are decreasing, however; as of January 2007, entry-level
websites can be hosted for less than $100 over two years.[2] The claim that technical
or design expertise is required is also now moot, given that these websites can be
template-based and built using Web-based construction wizards, no expensive
Web designer or programmer required. So aside from time, all that is needed is
an Internet connection with which to create and maintain a website.

Given this reasoning, it is curious that not every museum has a website. Likely
the perception still exists that building a website is expensive, time-consuming
and technically challenging. In this case, the benefits and argument for having a
website need to be more clearly defined within the museum community.

For-profit companies create websites to improve productivity—and in the
for-profit world, "productive" means "generates money." Corporations use the
Web as a means to that end. Take for example, this excerpt from a top Fortune
500 company's mission statement: "We must continuously achieve superior
financial and operating results while adhering to the highest standards of business
conduct."[3] In this regard, corporate websites are productive in the extreme. E-
commerce in the U.S. for 2006 totaled well over $100 billion and while U.S.
trade overall is slowing down, e-commerce has been increasing on average at 7
percent per quarter for the last two years.[4]

In contrast to the commercial world, consider what "productive" means for a
nonprofit museum. If museums teach us about the world we live in and our place
in it, then the definition of "productive" for a museum can be equally simple.
Core to a museum's mission is education and the dissemination of information
about its collection. The effectiveness and economy of the Internet as a vehicle
to do that is hard to beat. If greater productivity means more effective education
to a larger audience about museum collections, then using the Web should
be a priority for every museum. Although there are some superb examples of
museum websites, however, it would appear that a website is largely seen as an
afterthought by the majority. To illustrate, the Heritage Health Index report on

the state of America's collections found that 75 percent of the nation's collections are not available online.[5] Further, if you have a website, you must consider how much content you should develop primarily for it. That is, how much content do you need to present for online audiences who may never visit your institution? Is your website a vehicle for sharing content of the museum or a promotional tool to attract live visitors to your institution? If you track the number of visitors to your institution, do you also track the number of visitors to your website?

MUSEUM WEBSITE VISITS

A museum's strategic plan should recognize that having a website is fundamental to carrying out the institution's mission. The simple truth is that museum websites attract large online audiences, normally much larger than their physical counterpart. When I conducted a survey in December 2006 to support this essay and a conference panel, I received approximately 100 responses from predominantly U.S. museums.[6] The intention of the survey was to compare museums' physical and online visitor numbers as well as to compare figures for the people and budget assigned to Web activities. The information gained in the survey gives a sampling of what museums think of their websites from the perspective of the resources and budget they devote to it. The survey essentially asked four questions: (1) What is the average attendance at your institution? (2) How many visits does your website receive? (3) How many staff members contribute to your website? and (4) How much money do you spend on your website?

The survey instructions defined a visit to be a series of requests to a website by a single surfer at intervals no greater than a predetermined timeout of approximately 20 minutes. The survey found that physical visits to these 100 museums totaled 9 million per month; the corresponding online visits totaled nearly 18 million. For some institutions in the survey, the online audience was at least ten times the physical audience; it was less for only a few.

A closer look at the survey results highlights some interesting operational facts: 24 percent of respondents did not have any staff officially tasked with working on their website—a clear sign that the Web is not seen as a core aspect of these museums' business. This 24 percent, however, did budget for Web activities—a combined budget of $95,000—but half had no budget at all. Despite this underinvestment, online visits in this group totaled 300,000 visits per month. One of the most fascinating statistics from the survey is for the museums that claimed no official website staff or budget. This group, approximately 7 percent of the respondents, nonetheless reported an aggregate total of 100,000 website visits per month.[7]

So if this is the low end of the investment scale, what did the survey tell us about institutions at the other extreme? In terms of staffing, museums that had more than five people devoted full-time to Web activities accounted for 14 percent of those surveyed. Two of these institutions had no additional investment, but additional investment for the rest totaled almost $2.1 million per year and yielded 7.2 million visits per month. Estimating a dollar-figure equivalent for a full-time employee of $75,000, we can approximate a total cost of investment by these institutions of just under $10 million. According to the survey results, that investment yields 86 million online visits a year, translating to a cost per visit of 11 cents (versus the median expense of $23 per corporeal visitor reported in AAM's *2006 Museum Financial Information*[8]).

Having looked at the low and high ends of the investment scale, we must also weigh an average figure for investment against the number of online visits. Excluding the institutions that did not measure online visits, roughly 10 percent of the respondents, I calculated 17.7 million visits per month, or 213 million per year. The staffing costs and capital investment behind this totaled about $18.5 million and translates to 9 cents per visit.

> If you make a product good enough, even though you live in the depths of the forest the public will make a path to your door, says the philosopher. But if you want the public in sufficient numbers, you would better construct a highway.
> —*William Randolph Hearst*

In the case of the Web, an "information superhighway" has been constructed for you: All you have to do is build an off-ramp. The survey results suggest a strong chance that if you establish a website for your institution, you will receive at least as many online visits as physical ones. Twenty-eight percent of institutions in the survey are receiving at least one million visits to their website per year; 5 percent are receiving that number per month.

MUSEUMS AND E-COMMERCE

If these figures fail to demonstrate that there are compelling mission-related benefits to establishing a website, or compelling reasons to start thinking more about these virtual visitors, perhaps guarantees of revenue generation will do the trick. A 2005 survey carried out by Archives and Museum Informatics consultants David Bearman and Jennifer Trant on museum Web implementations received 59 respondents and found that just fewer than 50 percent of those museum websites had an e-commerce function.[9] The functions listed were museum shop,

publications, membership, exhibition/event tickets, rights and reproduction and charitable giving.

Like their websites, museums on the whole approach e-commerce in an offhand way. The Internet has established expectations about buying online and whether we like it or not, it is an environment that is driven by demand. Web surfers are often task-driven; they go to sites for specific purposes. If they want to purchase something, they go to a purchasing website like Amazon, eBay or TicketMaster. Alternatively, they go to a search engine where for-profit companies pay good money to ensure their products rank at the top based on keyword searching. Have you ever seen a museum-sponsored "buy" link on Google or Yahoo?

The success of the Amazon and eBay business models for e-commerce is largely based on what is known as the "long tail."[10] At one end of the spectrum are sales of the high-volume consumer products: top 100 CDs, MP3 players, plasma TVs, etc.; at the other end are the niche and esoteric consumer items that individually represent small sales, but collectively represent the majority of total sales. The latter is the "long tail," and its applicability for museums and e-commerce should not be underestimated. Its implementation and success is predicated on the portal notion—that there is a single point of access.

The holy grail of e-commerce sites is called "conversion"—the point at which a surfer starts to make a purchase.[11] The name is appropriate because it reflects the task-based nature of Web surfing, as well as that people are first and foremost researchers and need to be converted to buyers. Many museum websites would be much simpler to navigate if, rather than being categorized as museum professionals, educators, "the general public," etc., Web visitors were all regarded as researchers. Visitors to your website are looking for some type of information; it is extremely unlikely that they are on your website to buy something.

Consider the results of a 1999 survey by Jakob Nielsen of 1,780 Internet users who had purchased something on the Web:
- 5 percent of visitors expressed interest in buying something during their visit.
- 50 percent of these attempted to do so during the visit.
- 56 percent of the people who attempted to buy completed a purchase successfully.[12]

The result of combining these three numbers is a conversion rate of about 1 percent or one sale per hundred visits. But this assumes a fully integrated website, where all paths lead to the shopping cart—which is the norm for e-commerce

sites. If there is no connection between your museum's intellectual property or collection objects and the merchandise associated with them, if you are not trying to convert your researchers to buyers, you will be lucky to sell anything. The best way to sell merchandise is to have someone else do the conversion for you: Yahoo stores, Amazon and eBay are where the majority of buyers are and where your "long tail" products can find a home. Although partnering with these sites does not guarantee success and can involve a range of costs, these sites have established themselves as secure and safe ways to shop online and based on current revenue and adoption trends there is every reason to assume that this will continue.

ONLINE MEMBERSHIP AND DONATIONS

While there are obvious convenience and economic benefits to selling museum memberships online, these products are curious in that they are geographically limiting. They are a product that is intrinsically set to have limited sales. The benefits for becoming a member are almost exclusively geographically related: reduced entrance fee, preferential treatment for events at the institution and a discount in the store. You might receive e-mail updates, but that likely promotes the institution's events. This business model would be untenable in the for-profit world—can you imagine a software company that only sold its product within its city limits? Museums need to consider what products they have that are applicable to a national or international audience or what benefits memberships could have that would not be physically tied to their museum.

> Donors do not give to institutions. They invest in ideas and people
> in whom they believe. —G. T. Smith

Too many museum websites that accept online donations do so in an incredibly insulting way. There is rarely any promotion or marketing of the institution in order to convince someone to donate; there is often no indication of what value a donation will bring but just a pop-up list of dollar figures or an empty field with a "$" sign beside it as part of some other purchase. This presumption of entitlement on behalf of the institution is not the most effective way to generate donations. The business of online development and online donations is no different than in the physical world: it is time-consuming and hard work. The fact that people give in this way online probably has more to do with tax implications or some prior connection with the institution than anything else.

The physical equivalent of the way many museums accept online donations would be to host a party of potential donors and walk around with a bucket expecting

people to empty their wallets into it. Museums should look at the trends in online giving, particularly Howard Dean's use of the Internet for his 2004 presidential campaign.[13] The Dean strategy was to use the power of the Internet to generate awareness through viral marketing, user groups and list-servs and a large amount of cash from small donations. Which is more profitable: 100 donations of $1,000 or 100,000 donations of $1? Dean was successful because he (and his campaign team) understood how messages spread through the Internet. Rather than spam people for donations, Dean targeted his message at carriers—people who would spread the word on his behalf, such as sympathetic online groups and influential bloggers. The ease with which the message can be forwarded and discussed, the trusted source—whether friend or favorite blogger—who would send the message and above all the convenience of using a credit card or PayPal to donate resulted in a lucrative campaign.

Whether or not people will ever visit your institution, the more people that know about it, the better. In terms of fundraising, you can only get a certain number of people in a room; there is no such restriction on the Web.

NEW THINKING

> We cannot solve our problems with the same thinking we used when we created them.
> —*Albert Einstein*

There is an often-drawn parallel between the Internet and the automobile industry. When the automobile industry first started there was a vast number of companies making all manner of vehicles. As the industry developed, it consolidated to the point where we are now, of just a few large manufacturers. The same thing is happening to the Internet, where we are beginning to see enormous consolidation, focus and popularity of sites such as Google, Amazon, eBay, YouTube and MySpace.[14] It is crucial for museums to track these trends and understand what the impact is and how to benefit. These sites—where the public is searching, buying and socializing—are free tools and offer museums free exposure. Museums are here for the public good and the public is online.

One of the most important things to consider is our future audience and their expectations. Today's youth only know a digital and online world. They need to be engaged now, because it will be much harder to engage them in ten or twenty years' time. Investing in the Web now is a necessary long-term investment for the museum community for sustainability.

We are in a period of transition, in which many adults are still unfamiliar and uncomfortable with technology—particularly the Internet—and where kids know nothing else. Museums, even with their limited budgets and resources, need to address this transition to remain relevant.

The Web is also an environment where creative thinking can flourish. If you absolutely cannot afford a website, build a community on MySpace and maybe your MySpace community will help you finance a website. Start a free blog or a wiki. If you have merchandise, sell it on eBay—you do not need a website to sell online. Find other museums who are in the same situation as you and partner on a website to spread the cost. Above all, start to engage an online audience.

As a final thought, consider your mission, your intellectual property and forget your building. Now consider what it would mean for you to serve an online audience who will never visit your physical site but who may be just as loyal as those who do.

NOTES

This paper was adapted from a session at AAM's 2007 annual meeting in Chicago, entitled "Why Millions of Virtual Visitors Must Matter to Museums."

1. There appears to be no comprehensive data on the number of museums that have a website and no comprehensive online directory, so inferring a statistic is problematic. The American Association of Museums (AAM) estimates 17,500 museums in the United States (www.aam-us.org/aboutmuseums/abc.cfm [accesssed June 22, 2007]); the International Council of Museums (ICOM) lists 1,470 American museum websites, ICOM Virtual Library Museums Pages, (http://icom.museum/vlmp/ [accessed June 22, 2007]); Yahoo! Search Directory lists less than 500 entries in "Museums, Galleries, and Centers," (http://dir.yahoo.com/Arts/Museums__Galleries__and_Centers [accessed June 22, 2007]); and Google Directory lists just over 600 in "Art Museums," (www.google.com/Top/Reference/Museums/Arts_and_Entertainment/Art_Museums [accessed July 31, 2007]). One of the most comprehensive online lists appears to be musee.com, which claims a database of 37,000 museums worldwide, but returns just over 1,000 entries for American museums. Curiously, the largest list of U.S. museum websites is not to be found online, but rather in the annually printed *Official Museum Directory* (OMD), which lists just under 6,500 U. S. museum websites. This still does not give us a comprehensive statistic for museum websites, however, since the OMD only lists 9,500 museums. The best we can assume from these numbers is that 68 percent of museums have an online presence. But if the remaining 8,000 museums do not have a website, then we can estimate that only 37 percent of museums have a website.

2. As of January 2007, Web Hosting Inspector lists entry-level website packages for as little as $3.95/month which includes domain registration, http://webhostinginspector.com.

3. ExxonMobil, "About ExxonMobil—Guiding Principle," www.exxonmobil.com/corporate/about/about_operations.asp.

4. U.S. Census Bureau, "Quarterly Retail e-Commerce Sales—3rd Quarter 2006," November 17, 2006.

5. Heritage Preservation's Heritage, "Health Index Report," www.heritagepreservation. org/HHI/HHIsummary.pdf.

6. Nik Honeysett, "Museum Visits and Website Development Survey," December 2006, posted to SurveyMonkey.com in January 2007. By way of disclaimer, there is no guarantee that all respondents have an equal understanding or reporting of the notion of website visits and page views, even though they were defined in the survey. For example some Web metrics packages and webmasters may filter out Web robots, some may not. Not filtering would result in inflated statistics. The results give credence to what is a common understanding: that museums generally have larger online than physical visitors and do not devote resources and budget to the Web despite this fact, http://mediaandtechnology.org/survey. This is the most detailed survey available; the Institute of Museum and Library Services is working on a study of museum website visitors, to be released at an unknown date.

7. Museums in these groups measured their website traffic using both visits and page views. For the purposes of reporting a single visit statistic, a visit is assumed to be an average of three page views. This figure is derived from the data itself in that about one third of respondents entered their visit and page view numbers, the average page views per visit was 2.9.

8. Elizabeth E. Merritt, ed., *2006 Museum Financial Information* (Washington, D.C.: American Association of Museums, 2006).

9. David Bearman and Jennifer Trant, "Archives and Museum Informatics Survey of Museum Web Implementations," 2005, published online March 2006, http://archimuse.com/research/mwbenchmarks/report/mwbenchmarks2005.html.

10. Wikipedia, "The Long Tail," http://en.wikipedia.org/wiki/The_Long_Tail (accessed June 22, 2007).

11. Wikipedia, "Conversion (Marketing)," http://en.wikipedia.org/wiki/Conversion_ (marketing), (accessed June 22, 2007).

12. "Jakob Nielsen's Alertbox, February 7, 1999: Why People Shop on the Web," www. useit.com/alertbox/990207.html. Despite the date of this survey this conversion rate is still regarded as an accurate percentage of a website's ability to convert Web surfers into buyers.

13. Vinay Bhagat, "Lessons for Nonprofits from Howard Dean's Use of the Internet," *Convio* (September/October 2003), www.convio.com/site/News2?page=NewsArticle&id= 2600624&news_iv_ctrl=1201. See also Joseph Graf, "Donors and Fundraising in the 2004 Presidential Campaigns," *National Civic Review* 95:3 (2006), 35–41.

14. This list is consolidated even further by the acquisition of YouTube by Google in October 2006. Consolidation is inevitable because of the buying power of organizations such as Google, who have the capacity to buy out emerging and popular technologies. Furthermore, business models for Internet startups often include acquisition by a larger organization as a primary goal.

Promoting Social Change
Through Technology

Lawrence Swiader

What Can You Do? . . . Breathe. Love. Live. Create, Imagine, Dream. And Act. You must Act . . .

> —*Katie*, comment posted to the United States Holocaust Memorial Museum website, Jan. 17, 2007[1]

Museums have been agents of social change for a long time, using their collections and physical space to advocate for societal adjustments. In the last ten years, technology has opened new avenues for making a difference. Using delivery methods like the Web, museums can now be quicker to the punch and reach a much larger audience—and even assume the role of activists. Instead of waiting for the public to make intentional visits to their buildings or websites, museums have many new ways of pushing their messages in front of people just at the moment they may be ready to take action. As an extension of the museum's role as a learning center, many institutions are using technology to remind citizens of their role in a democracy, to be more inclusive via online communities and change the environment by being more "green." But while technology has great potential to address the challenges faced by museums in relation to access and audience development, can it really promote social change? Through timely initiatives and strategies for action, the United States Holocaust Memorial Museum (USHMM) and other institutions have been implementing technology for social change. These new initiatives have had an impact on audience development and have been met with overwhelmingly positive responses.

Social change should be thought of as an ongoing process from knowledge to action. Museums are already great holders of knowledge; one need only look at the mission statements of a few museums to see that there is at least the hope that visitors will take action in response. Examples include:

- The mission of the Computer History Museum is to preserve and present for posterity the artifacts and stories of the information age. As such, the Museum plays a unique role in the history of the computing revolution and its worldwide impact on the human experience.[2]

- The U.S. Navy Museum collects, preserves, displays and interprets historic naval artifacts and artwork to inform, educate and inspire naval personnel and the general public.[3]

- The Heritage Center Museum collects, preserves and interprets Lancaster County Pennsylvania's history and decorative arts through the permanent collection, annual exhibitions and educational programs.[4]

- The National Museum of American History dedicates its collections and scholarship to inspiring a broader understanding of our nation and its many peoples. We create learning opportunities, stimulate imaginations and present challenging ideas about our country's past.[5]

- The United States Holocaust Memorial Museum is America's national institution for the documentation, study and interpretation of Holocaust history, and serves as this country's memorial to the millions of people murdered during the Holocaust. The Museum's primary mission is to advance and disseminate knowledge about this unprecedented tragedy; to preserve the memory of those who suffered; and to encourage its visitors to reflect upon the moral and spiritual questions raised by the events of the Holocaust as well as their own responsibilities as citizens of a democracy.[6]

Changing attitudes and gaining knowledge are key ingredients to instigate action. Recognizing this makes adding technology to the equation easier. Walter Dick and Lou Carey, professors at the Universities of Florida State and South Florida, respectively, wrote a seminal book in 1978 that introduced a model, or a step-by-step way creating successful learning experiences. In their *Systematic Design of Instruction,* they suggest selecting the media or mode of delivery for instruction after establishing the learning objectives and strategy.[7] Knowing that we want to change attitudes and instigate action are our learning objectives. Selecting technology as a part of the instructional strategy often makes sense because of its power to change attitudes through simulation.

Another model, the Elaboration Likelihood Model,[8] underscores the value of simulation in changing attitudes. This model is based on the idea that there are two ways to change someone's attitude about a certain concept or object: the central route and the peripheral route. The central route refers to learning via careful and deliberate thinking. The thought process is active. The peripheral route, by contrast, involves being on the periphery of ideas. Someone is thinking enough to be aware of the situation but not thinking carefully enough to catch errors and inconsistencies.[9] The peripheral route can also be described as:

> Rather than examining issue-relevant arguments, people examine the message quickly or focus on simple cues to help them decide whether to accept the position advocated in the message. Factors that are peripheral to message arguments carry the day. These can include a communicator's physical appeal, glib speaking style or pleasant association between the message and music playing in the background. When processing peripherally, people invariably rely on simple decision-making rules or "heuristics." For example, an individual may invoke the heuristic that "experts are to be believed," and for this reason (and this reason only) accept the speaker's recommendation.[10]

This, of course, is an important concept in advertising. If a product is used by someone you respect, the chances are greater that you will have a good attitude toward that product.

This approach can be used effectively on a face-to-face basis, but one-to-one or one-to-few is an inefficient way to affect social change on a wider level. Enter technology in the design model once again. Technology is a well-recognized tool for teaching or reaching many people—especially people who are geographically dispersed. Web 2.0 methodologies, such as social networking sites, wikis, picture and video sharing and folksonomies, emphasize online collaboration among users and offer immense potential for museums to affect social change on a large scale. USHMM used these methods to reach many people through a number of projects related to the exhibition "Darfur/Darfur."

REACHING OUT TO MANY

In July 2004, the USHMM's Committee on Conscience declared a "Genocide Emergency" for Darfur, an embattled area in the western region of Sudan. Since then the museum has been working to educate policy makers and the American

public about the urgent need to take action to end the genocide. The museum has mounted a display on the emergency, held educational programming featuring members of Congress and Holocaust survivors and hosted two national conferences on the issue for student leaders. The museum also launched a weekly podcast series and blog, "Voices on Genocide Prevention," featuring leaders in government, media and advocacy addressing how citizens can get involved in genocide prevention efforts.

All of the museum's efforts around the Darfur genocide are certainly meant to increase knowledge, and more importantly, to change attitudes. The goal is twofold: (1) to have visitors to the museum walk away with facts about the genocide and (2) to change their outlook toward their role in a global society.

During Thanksgiving week 2006, the museum projected wall-sized images taken by leading photojournalists of the escalating crisis in Darfur from an exhibition called "Darfur/Darfur" onto its facade, marking the first time the national memorial's exterior was used to highlight contemporary genocide (Fig. 1). The program, "Darfur: Who Will Survive Today?" succeeded in its goal to draw attention to the continuing crisis. The press covered the event, which, through the use of technology to project the images onto the building, also reached hundreds of people who came to the museum and viewed the live

Figure 1. Installation view of "Our Walls Bear Witness—Darfur: Who Will Survive Today?" at the United States Holocaust Memorial Museum, Washington, D.C., November 2006. *Photo by Arnold Kramer. © U.S. Holocaust Memorial Museum.*

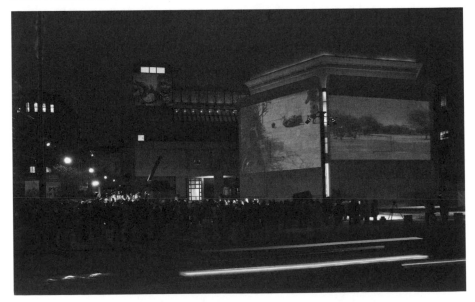

webcast, creating a large-scale communal experience—a "happening." After the event, people who attended the event—and even those who did not—blogged about it in Web 2.0 style.

Jim Johnson wrote in his blog, (Notes on) Politics, Theory and Photography:

> Although projections like this are not unprecedented—Krzysztof Wodiczko most famously has undertaken a number of them—this seems like a rather bold step for an institution such as the Holocaust Museum to take. Yet, while I applaud the USHMM for the novel approach it is adopting here (this is the first such projection it has undertaken), my question remains the same—what sorts of action are the images themselves meant to induce viewers to undertake?[11]

Leslie Thomas, a Chicago mother and architect who curated "Darfur/Darfur," the original photography exhibition on which the projections were based, said in a USHMM press release, "Once you see photos of a murdered three-year-old little boy whose face has been smashed or the body of a one-year-old girl who has been shot you cannot look honestly at your own children without doing something to stop this killing."[12] Her statement is in essence a response to Johnson's query.

To build on the success of the event, the museum decided to extend its reach by creating a "virtual" replica of the powerful, outdoor photography exhibition (Figs. 2 and 3). Actress and activist Mia Farrow discussed and answered questions about the worsening situation in Darfur and neighboring Chad at a live, virtual 3-D event in the online community Second Life.[13] The program, held on January 9, 2007, was open to the press and the public without charge. Farrow appeared as her avatar self along with the avatars of her son Ronan, who has served as a UNICEF Spokesperson for Youth in Sudan; Ron Haviv, one of the photographers in "Darfur/Darfur"; and John Heffernan, director of the Genocide Prevention Initiative for the USHMM's Committee on Conscience.

The virtual event in Second Life allowed visitors from around the world to experience the photography exhibit with its moving photos, as well as to view video of the outdoor installation at the museum over the period of a month. The people at the live event, full to capacity at more than 80 avatars (yes, there are limitations in cyberspace related to the capacities of the technology), heard Farrow, who had just returned from Chad following three earlier trips to Darfur, describe

Figures 2 and 3 (opposite). Two "frame grabs" from the USHMM's January 9, 2007, event in Second Life, showing Mia Farrow's avatar and the replica of the projections from November 2006. © *U.S. Holocaust Memorial Museum.*

the situation: "We're seeing atrocities of an indescribable kind . . . [with people] clustered under trees, dazed and terrified. The situation continues to deteriorate, and ending this human catastrophe will require the engagement of citizens from all walks of life. Activism begins with education, and I am proud to be working with the U.S. Holocaust Memorial Museum in calling attention to genocide unfolding on our watch." She returned to the region in February 2007.

During the event, Farrow explained that after discovering that some of her own money was invested in Sudan, she promptly saw to it that her money was divested. After the program, one attendee wrote in by e-mail:

> Great job today. At one point I looked at your map and saw 72 people connected. Heck, I even got our attorney to attend via his avatar.

> I actually learned a lot and am contacting our financial advisor regarding any investments we may have tied to Sudan. I have no desire to be connected to any of it and figure this is a good place to start.

> Thank you for doing this. You make the world a better place.

Figures 3. © U.S. Holocaust Memorial Museum.

Many other people blogged about the event. There were 9,140 citations on the Google search with the phrases: "Mia Farrow," "Second Life" and "Darfur" on January 31, 2007. Most important, the blogging and associated comments well outlived the live event. Also outliving the live event is an 11-minute "machinima" (a mash-up of the words "machine" and "cinema") of the event that can be viewed as a video clip on the museum's website, YouTube and other outlets for video clips on the Web.

Attendees writing letters to the editor of their newspapers, appearing at ensuing events, blogging and donating money are just a few indicators that change actually occurred. Real change is usually hard to accomplish and expensive to document, and most museums cannot undertake it—especially since change in attitude is usually the result of a (sometimes long) iterative process. Relying on indicators of change for signs of success is a sound way to learn whether your program made its intended impact.

INTERNAL STRUCTURE TO FACILITATE USE OF TECHNOLOGY FOR CHANGE

Museums can prepare themselves to make use of social technology by creating organizational structures that support it. From my experience, this starts with a strong Web/technology director. The director needs to be part geek, part curator and part politician. Most important, s/he needs to have some responsibilities for creating programs.

A critical partner for the director is an instructional designer, someone who applies the systematic process of learning to the planning of instructional materials (using technology and other tools) per the approach that Dick and Carey describe in their book. The instructional designer should be committed to a systems approach to education, which separates the selection of media from the project's objectives. This approach keeps staff members honest, as there is always a temptation to fall in love with a new technology or attractive media while forgetting what you are trying to achieve. The up-front needs assessment that is a part of the systems approach includes audience identification and is essential to being able to evaluate your results.

It is essential that project managers get things done on time and on budget and that communications personnel look for partners to help disseminate museum content and messages. Wikipedia, iTunes, GoogleAds and other sites (like the use of advertising on blogs) all have potential for providing just-in-time information and emphasizing a message. Messages carried by both media and word-of-mouth reinforcement are more likely to be accepted than suggestions carried by one of these alone.

Content creators that report to the director are also important. Videographers, designers and editors who work within the creative space of designing technology for change not only increase the quality of a project but also its speed and timeliness. And it is the element of timeliness that really creates the opportunity to instigate social change—one that technology is uniquely qualified to support—for one never knows when the moment will strike.

One such moment came in the summer of 2006 on the United States Holocaust Memorial Museum's website. We posted pictures and a story told by Brian Steidel, a former U.S. Marine who was a part of the African Union peacekeeping force, with the purpose of moving people toward action—toward caring. The museum

received many comments to its website in that period, including this one by someone who learned to understand their neighbor after seeing the exhibition:

> Back home in California a Sudanese family moved in from Egypt.
> They fled Sudan and went to Egypt hoping for a chance at peace.
> I now better understand their struggle.
> —*Ridge*, comment posted to USHMM website, Aug. 8, 2006[14]

NOTES

1. A visitor comment posted to the United States Holocaust Memorial Museum (USHMM)'s website in a discussion space about concrete actions that could help people in the Democratic Republic of Congo and prevent genocide from happening today. See www.ushmm.org/museum/exhibit/online/congojournal/comment/details.php?ProjectId=ROG &TopicExtId=ROG_together (accessed January 31, 2007).

2. See www.computerhistory.org/about.

3. See www.history.navy.mil/branches/org8-4.htm.

4. See www.culturalhistorymuseum.com/about/mission/default.asp.

5. See http://americanhistory.si.edu/about/mission.cfm.

6. See www.ushmm.org/museum/mission.

7. Walter Dick and Lou Cary, *The Systematic Design of Instruction,* 3rd ed. (New York: Harper Collins, 1990).

8. Richard E. Petty and John T. Cacioppo, "The Elaboration Likelihood Model of Persuasion," in *Advances in Experimental Social Psychology* 19, ed. L. Berkowitz (New York: Academic Press, 1986): 123–205.

9. See www.healthyinfluence.com/Primer/elm.htm (accessed February 2, 2007).

10. Richard M. Perlof, *The Dynamics of Persuasion* (Mahwah, N.J.: Lawrence Erlbaum Associates, 2003).

11. http://politicstheoryphotography.blogspot.com/2006/11/darfur-who-will-survive-today.html.

12. Comment made to USHMM employee, November 20, 2006.

13. See www.secondlife.com.

14. A visitor comment posted to the Holocaust Encyclopedia comments portion of the USHMM's website, www.ushmm.org/wlc/comments.php?lang=en (accessed January 31, 2007).

Stewardship for Digital Images: Preserving Your Assets, Preserving Your Investment

Günter Waibel

On March 29, 2006, a *New York Times* article claimed that "3 out of Every 4 Visitors to the Met Never Make It to the Front Door."[1] The impressive number of visitors in the *Times* story who did not come to the building experienced the Metropolitan Museum of Art (the Met) online, highlighting the increasing significance of a museum website for the overall museum enterprise. Surveys by the Institute of Museum and Library Services (IMLS) on technology and digitization reflect the growing importance of digital surrogacy in an upward surge of museums digitizing for access.[2] In 2001, only 6.1 percent of respondents identified better access to collections as their motivation.[3] In a 2004 survey, access to collections emerged as the primary reason for digitization by 56 percent.[4] The same report shows that 74.4 percent of respondents had digitized between one and five thousand images in the 12 months preceding the survey.[5]

In recent years, new workflows and technologies have lowered the cost of digitizing mass-produced materials. The Internet Archive, for example, has created scanning stations and processes that allow capture of bibliographic materials at 10 cents per page.[6] However, for capturing rare and sometimes unwieldy museum objects, efficiencies are harder to achieve. In 1998, Cornell University issued a press release announcing the Herbert F. Johnson Museum of Art's efforts to digitize its entire collection—budgeted at $680,000 for about 27,000 objects, the projected cost per capture amounts to about $25.[7] Almost ten years later, an informal poll of three photographers at major U.S. art museums confirms that this number represents the low end of average contemporary digitization costs. If anything, the cost of digitizing museum objects has increased over the last decade.

Assuming $25 per capture, a museum that digitizes 5,000 images a year will effectively spend $125,000 on digital surrogates. An investment of that magnitude requires proper justification or, to use an accounting term, an analysis of Return on Investment (see Leonard Steinbach's essay in this volume). To properly weigh both sides of the equation, the I(nvestment) consists both in the financial cost of capture as well as the less tangible cost of exposing the artwork to movement and light.[8] The R(eturn) consists of improved public access as well as increased productivity throughout the museum if desirable digital images are readily available to staff who need them. These benefits, however, are bought too dear if the digital file created becomes unusable over the mid-term. If digitizing collections becomes an activity similar to the popular conception of maintaining the paint coat on the Golden Gate Bridge (when you are done, you start over), offering digital collections may be much more expensive than most museums originally conceived.

From that perspective, digital preservation emerges as the quest to preserve both the digital file and the investment made. If the physical collections are the main building block of a brick-and-mortar museum experience, digitized museum objects are their equivalent in the online space. As museum staff increasingly value the impact digitized collections make on their audience, they are learning to value the digital surrogate itself as an asset worth tracking and maintaining. In this article, I describe key challenges in the stewardship of digital images from a museum perspective by examining management and preservation issues.

THE PRESENT: DIGITAL ASSET MANAGEMENT

The activity of digital asset management is already deeply ingrained in museums, even as the software systems to manage that activity are just starting to take hold. Enterprise-wide, museums generate staggering amounts of digital files. So far, individuals or departments have taken on the task of managing these files without museum-wide coordination. This ad hoc management of digital files results in redundant effort: different departments create and store the same file; finding a file in the separate impromptu storage fiefdoms becomes a time-consuming exercise. From this perspective, formalizing asset management by purchasing a software solution simply acknowledges that digital files support day-to-day operations more efficiently when organized in a dedicated database.

A digital asset management system (DAMS) streamlines the flow of information throughout the institution by giving an authenticated user access to the appropriate file in the desired file-format at the time of need. The acronym DAMS,

as well as the industrial-strength software packages offered to museums, come from the business world (primarily sectors such as advertising and marketing), where vendors promise significant return on investment because DAMS allows employees to spend more time working with files rather than searching for or recreating them. The definition of digital asset management varies widely, yet the following from Bitpite.com points the right way for my purposes: "The process of storing, retrieving and distributing digital assets (files), such as logos, photos, marketing collateral, documents and multimedia files in a centralized and systematically organized system, allowing for the quick and efficient . . . reuse of the digital files that are essential to all businesses."[9]

In the museum world, there has been a recent surge in DAMS implementations, for instance at the Dallas Museum of Art, the Metropolitan Museum of Art, New York, the Minneapolis Institute of Arts, the Brooklyn Museum and the San Francisco Museum of Modern Art. These institutions have installed industrial-strength systems, while many other museums of all stripes and colors are investigating or implementing.[10] As a first pass, many of these institutions have declared digital images of their permanent collection as the initial content target for their DAMS. Most of them expect to include a much wider variety of content and formats in the future.

As those who have tried will testify, implementing a DAMS is an extremely complex undertaking. Since vendors have had little experience in the nonprofit or museum sector to date, establishing clear communications with the provider of the system is just the first of many challenges. The short list below illustrates three select strategic issues, which repeatedly surface in the accounts of early implementers.

1. A Challenge to Museum Culture: A DAMS Is a Disruptive Technology
Digital images of permanent collection objects are pervasively used throughout the museum—those who create, edit and use them barely fall shy of the entire staff. A DAMS creates a structure within which all of this activity has to be funneled. As a result, the advent of a DAMS changes work behaviors, job descriptions and even organizational charts. It calls for new and revised policies and procedures at every level of the organization.[11]

2. A Challenge to Museum Practice: A DAMS Spotlights the Quality of
 Descriptions
At its core, a DAMS provides the ability to retrieve a desired digital file. While

the software establishes the framework for this activity, it requires appropriate descriptive metadata to execute successful searches. Implementation projects grapple with questions about upgrading existing descriptions both to improve access in-house as well as for an outside audience. For example, in a surprising turn of events, the implementation of their DAMS led the Met to investigate social tagging as a strategy to make their digital images more retrievable.[12]

3. A Challenge to Museum IT: DAMS in the Ecology of Systems
In museum implementations, the metadata for digital images of collection items usually comes from the Collections Management System (CMS). Both DAMS and CMS must interoperate so that available data is not re-keyed and updates to either system can be synchronized. The desire to couple descriptions and asset management in one system has led some institutions to investigate whether their CMS can provide certain asset management functions, as outlined in Dianne Nielsen's article, "In Pursuit of Efficiency: Traversing the Boundaries of a Collection Information System."[13] Museums must situate their DAMS in an institution-specific ecology of systems that executes the functions of collections, rights and reproduction, website content and workflow management. Determining the boundaries of each system, its specific functionality and its interaction with peer systems presents a major challenge.

THE FUTURE: DIGITAL PRESERVATION

Museum professionals also tend to associate a DAMS with digital preservation. In a survey, ClearStory (a DAMS vendor) conducted during the Museum Computer Network (MCN) conference 2005, 47 percent of respondents agreed that DAMS should conform to the digital preservation standard Open Archival Information System (OAIS).[14] ClearStory itself asserted that "a DAM solution can serve as a singular platform for digital image preservation, collections management, marketing communications, and exhibit innovations," placing digital preservation squarely in a DAMS' realm.[15] To explore the question "Is a DAMS the solution to digital preservation?" requires a closer look at the concept of digital preservation itself.

According to a report on the OAIS by the OCLC-RLG Working Group on Preservation Metadata,[16] digital preservation aims to ensure:
- Viability: the presence of an intact and readable bitstream
- Renderability: the capacity of humans/computers to view/process the bitstream
- Understandability: the capacity of intended users to interpret the rendered bitstream

Viability

When museum professionals first debated ensuring the longevity of digital data, the discussion often centered on questions of viability. Spurned on by news reports about degrading music CDs, such as "The CD Time Bomb," comparing the merits or lifespan of certain brands of CD-R's (Compact Disc-Recordable) became a popular topic on list-servs and during conferences, until the conversation shifted to concerns over the long-term availability of CD readers.[17] To channel the spirit of the conversation: "If you've got floppy discs sitting in your drawer, yet no drive in your CPU to access the data, you shouldn't be consoled that a CD-R manufacturer claims your data will be safe for the next 100 years." Just within that narrowly bounded conversation, the challenge of digital preservation reveals itself in layers of complexity.

A variety of strategies have been identified to address the issue of viability that surfaced during these early debates. "Media Migration," for example, addresses the issue of media obsolescence (e.g. the absence of readily available floppy disc readers) by moving files from an eclipsing media (floppy disc) to an established media (CD-ROM). The same term also refers to copying files from a degrading to an intact storage media to forestall media corruption (e.g. demagnetized tape). Coupled with a process that verifies that the information stored has not changed over time (such as a message digest[18]), media migration assures "bit-level preservation," the certainty that the digital file remains unaltered and readable from the storage media. If data from a Northeast Documentation Conservation Center (NEDCC) survey among cultural heritage institutions may serve as an indicator, only 11 percent of the respondents indicated that they did not perform any back-up at all, which leaves 89 percent with a rudimentary strategy in place to ensure viability.[19] A DAMS should be capable of supporting such a back-up strategy.

Renderability

Concerns over media obsolescence and media corruption, however, represent only the first and most superficial preservation issue. Imagine a scenario in which the storage media and the files on it are both intact and readable but cannot be accessed because the software to execute the code will not run on contemporary computer systems. Most people are familiar with this problem through their experience of trying to open text documents created by obsolescent word processing applications such as MicroPro International's WordStar on a contemporary computer.

Format migration and emulation ensure the renderability of a digital file. Format migration moves a file from an eclipsing into a contemporary format. For example, using a converter to save a word processing document created with Word for Windows 6.0 (1993) in the latest version of Microsoft Office Word 2007 can be considered format migration. Emulation, on the other hand, uses a contemporary computer system to mimic an obsolescent system and retains access to the original files in that manner.[20] For example, Apple's Rosetta technology allows applications written for PowerPC-based Macintosh computers to run on the latest Intel-based machines.[21] According to the 2004 IMLS survey, only 7.6 percent of museums had a policy in place that governs the conversion of digital files to next-generation formats and therefore could be considered making a significant gesture towards addressing renderability.[22]

Format migration for digital preservation necessitates that the underlying parameters of the transformation can be adjusted transparently to preserve the characteristics of the source file in the new format.[23] While any sophisticated DAMS will include the capability to reformat digital images on the fly to a different dimension or file format, this functionality is primarily geared toward creating throw-away derivatives optimized for the task at hand. A DAMS supporting the basic preservation strategy of format migration would have to allow an institution to specify different types of codec configurations to be used when transforming different batches of files.

Understandability

The next challenge to preservation deals with understandability, the time frame for the potential crisis putting access at risk has noticeably expanded. While viability may become an issue within years, and renderability within a decade, understandability tries to project the object to be preserved into a time when all contextual information we take for granted has been lost, and what has been preserved needs to speak for itself. A conservative time frame in which understandability could become an issue is one generation (usually measured as 20 to 25 years).

Understandability asks the question: Who is your audience, and how much context will it need to apprehend the archived information across time without the intervention of the information's producers? The OAIS proposes defining a designated community to answer this question. The particular knowledge base of the designated community determines what contextualizing materials need to be preserved to keep the document intellectually accessible. For example, if your

designated community consists of Java programmers, any archived Java code will be readily recognized and understood by that particular audience. If the designated community consists of programmers in general, documentation about Java needs to be archived as well to bolster the audience's knowledge base.[24]

With understandability, the list of preservation challenges clearly moves out of the realm of technology and into the realm of policy and documentation. Even with the preservation goals of viability and renderability, the more scrutiny they receive, the more technological issues retreat into the background and organizational issues arise. The technological challenges of format migration, while not insurmountable, will not be adequately addressed by staff lacking access to proper training. Media migration becomes meaningless if the institution housing the digital repository does not have the funds to implement the strategy. Mustering the institutional will to enact policy and fund the commitment to preservation emerges as a much bigger hurdle than the complexity of technological measures to prolong the life of digital materials. According to the 2004 IMLS survey, only 55.7 percent of museums had any kind of policy pertaining to digital preservation.[25]

The RLG-NARA *Audit Checklist for the Certification of Trusted Digital Repositories,* arguably the most succinct blueprint of the characteristics of a digital preservation repository to date, emphasizes the organizational infrastructure of policies, procedures and commitments, which crucially enables the successful application of technological solutions.[26] Our initial question, "Is a DAMS the solution to digital preservation?" needs to be rephrased as "Can a DAMS be the technological component of a comprehensive digital preservation strategy?" A cursory evaluation surfaces some doubt whether a DAMS meets the criteria outlined in the *Audit Checklist*. Some preliminary questions include:

- Can a vendor-based system be considered "well-supported [...] infrastructural software"? Who will support the system if the vendor goes out of business? Does the vendor have a "defined process for service continuity" stipulated by the *Audit Checklist* in case of an economic downturn?
- Could an institution running a vendor-based DAMS even answer all of the questions in the *Audit Checklist* or would some of the answers reside inside the impenetrable "black box" of the proprietary software?

Eventually, a thorough evaluation of a DAMS installation at a specific institution against the *Audit Checklist* will answer these questions. Since commercial DAMS are created with the intent to manage present-day digital files for use rather

than for posterity, a conservative view of their capability to preserve digital files according to established standards seems prudent. Rather than a silver bullet solution, the DAMS could be seen as a museum's first major point of engagement with the thorny issues of digital preservation. Beyond all other obvious benefits to museum operations, implementing a DAMS is a first step towards better stewardship of digital assets, which may develop into a full-blown institutional digital preservation strategy down the line.

MOVING INTO THE FUTURE—COLLABORATION

While reliable cost models for digital preservation are still very much under debate, there can be little doubt that digital preservation repositories that pass the test of a certification, as envisioned by the *Audit Checklist*, would stand out as a major expense even in the budgets of large museums.[27] At this juncture, the argument reaches a critical impasse. The introduction to this article asserted that digital preservation is necessary to capitalize on the significant investment in digitization, while now it appears that the price tag for fully fledged preservation very likely will be prohibitive for any single museum.

On the other hand, museums will have no choice but to engage on preservation issues. Beyond the narrow focus of this article on digitized collection objects, museums have a stake in preserving other types of born-digital information for which the easy way out of doing it over simply does not apply. For example, science museums have to manage large research datasets and digital field photography for the long-term, while contemporary art museums have started accessioning digital media artworks into their collections. Addressing the longevity of these and the many other born-digital assets central to a museum's mission can only be avoided at the risk of losing access to the data.

Ken Thibodeau, head of the National Archives' Electronic Records Archive, faces similar issues. He is charged with preserving all government documents of historical relevance, including 32 million e-mails from the Clinton administration. Thibodeau reportedly once shared his quest for a trusted digital repository with the head of a government research lab, who replied: "Your problem is so big, it's probably stupid to try and solve it."[28] The National Archives subsequently contracted with Lockheed Martin to develop a $308 million digital preservation repository.

To relate this sobering anecdote to the situation museums face—and move beyond the cost bind—the comment by the government researcher needs to be

augmented with only one word: "Your problem is so big, it's probably stupid to try and solve it alone." Digital preservation is neither a product nor a technology, but an infrastructure. While preservation policy needs to be carried locally, the people, technology and ultimately the summary cost of the trusted digital repository do not. A collaborative investment leveraging economies of scale most likely will be the only option for museum-sized institutions and budgets to attain access to digital preservation.

This model has already gained traction on university campuses. The Harvard University Library, for example, offers the services of its repository to any campus unit in need of digital preservation; among its customers are the Harvard University Art Museums, the Museum of Comparative Zoology and the Peabody Museum of Archaeology and Ethnology.[29] At $5 a gigabyte per year, Harvard's Digital Repository Service (DRS) performs bit-level preservation; an additional fee, to be negotiated at the time of need, covers file format migration. The California Digital Library (CDL) provides a similar service to the University of California system of campuses, which includes a significant number of museums.[30]

To maximize the returns on their sizeable investment, organizations that maintain digital repositories increasingly look for partnerships, creating an opportunity for institutions such as museums to benefit from their work. Beyond DAMS, the next step in stewardship for digital assets in museums is building relationships with other cultural heritage institutions and assessing their interest in jointly investing in a shared infrastructure for digital preservation.

NOTES

1. Carol Vogel, "3 Out of Every 4 Visitors to the Met Never Make It to the Front Door," *New York Times*, March 29, 2006, Section G.

2. Institute of Museum and Library Services, "Status of Technology and Digitization in the Nation's Museums and Libraries," public report, January 2006, www.imls.gov/resources/TechDig05/Technology%2BDigitization.pdf. This report contains data both from both the 2001 and 2004 survey; hereafter cited as "IMLS Digitization report." A separate publication containing data exclusively from the 2001 survey is also available: Institute of Museum and Library Services, "Status of Technology and Digitization in the Nation's Museums and Libraries 2002 Report," public report, May 10, 2002, www.imls.gov/resources/TechDig02/2002Report.pdf.

3. IMLS Digitization report, 37.

4. Ibid., 37

5. Ibid., 26

6. Heidi Benson, "A Man's Vision: World Library Online," *San Francisco Chronicle*, November 22, 2005, www.sfgate.com/cgi-bin/article.cgi?file=/c/a/2005/11/22/MNGQ0F-SCCT1.DTL.

7. Cornell University, "Cornell's Johnson Museum Launches $680,000 Effort to Put Permanent Collection on the World Wide Web," press release, January 27, 1998, www.news.cornell.edu/releases/Jan98/digital_museum.dg.html.

8. For an analysis of light exposure during direct digital captures, see Benjamin Blackwell, "Research on Technical Aspects of Photography Relevant to Museum and Artist Needs," N.d., www.benblackwell.com/BenWebM/serv.htm.

9. Bitpipe, Digital Asset Management page. N.d., www.bitpipe.com/tlist/Digital-Asset-Management.html.

10. All of these museums have presented on their progress in the session "Get the Picture: Experiences in Selecting and Implementing Digital Asset Management Systems in Museums" at the Museum Computer Network (MCN) 2006 annual conference in Pasadena, Calif. Museum Computer Network, "Get the Picture: Experiences in Selecting and Implementing Digital Asset Management Systems in Museums," N.d., www.mcn.edu/conference/mcn2006/SessionPapers/GetThePicture_DAM.pdf.

11. For a description of the impact a DAMS can have institution-wide, see Susan Chun and Michael Jenkins, "Why Digital Asset Management? A Case Study," *RLG DigiNews* 10, no. 1 (2006), www.rlg.org/en/page.php?Page_ID=20999.

12. Ibid.

13. Dianne Nielsen, "In Pursuit of Efficiency: Traversing the Boundaries of a Collection Information System," *RLG DigiNews* 10, no. 1 (2006), www.rlg.org/en/page.php?Page_ID=20999.

14. ClearStory, "Museum Digital Preservation Initiatives," whitepaper, N.d., www.clearstorysystems.com/pdfs/Whitepaper_museum_archiving.pdf (accessed February 9, 2007, pdf now discontinued). For an excellent introduction to the OAIS, see Brian Lavoie, "The Open Archival Information System Reference Model: Introductory Guide," *Digital Preservation Coalition Technology Watch Series Report*, January 2004, www.dpconline.org/docs/lavoie_OAIS.pdf.

15. ClearStory, "Museum Digital Preservation Initiatives."

16. The OCLC-RLG Working Group on Preservation Metadata, "Preservation Metadata and the OAIS Information Model: A Metadata Framework to Support the Preservation of Digital Objects," report, June 2002, 1, www.oclc.org/research/projects/pmwg/pm_framework.pdf.

17. Laura Evenson and James Sullivan, "The CD Time Bomb: Detractors Say Compact Discs are Deteriorating with Age," *San Francisco Chronicle*, January 14, 1999, www.sfgate.com/cgi-bin/article.cgi?file=/chronicle/archive/1999/01/14/DD86984.DTL. For an up-to-date analysis of life expectancy of various digital media, see Vivek Navale, "Predicting the Life Expectancy of Modern Tape and Optical Media," *RLG DigiNews* 9, no. 4 (2005), www.rlg.org/en/page.php?Page_ID=20744.

18. Created by algorithm, a message digest uniquely profiles a digital file. If the data within a file has changed, the same algorithm will produce a different message digest, alerting the user to the change.

19. Tom Clareson, "NEDCC Survey and Colloquium Explore Digitization and Digital Preservation Policies and Practices," *RLG DigiNews* 10, no. 1 (2006), www.rlg.org/en/page.php?Page_ID=20894.

20. In the cultural heritage community, the Koninklijke Bibliotheek (National Library of Netherlands) has chosen a combination of format migration and emulation as an approach to digital preservation. See Oltmans, Erik and Nanda Kol, "A Comparison Between Migration and Emulation in Terms of Costs," *RLG DigiNews* 9, no. 2 (2005), www.rlg.org/en/page.php?Page_ID=20571.

21. See Apple Inc., Rosetta, N.d., www.apple.com/rosetta.

22. IMLS Digitization report, 23.

23. To get an idea of what kinds of choices format migration might entail, see Stephen Abrams et al., "Harvard's Perspective on the Archive Ingest and Handling Test," *D-Lib Magazine* 11, no. 12 (2005), www.dlib.org/dlib/december05/abrams/12abrams.html.

24. I've adopted this example from Brian Lavoie, "Meeting the Challenges of Digital Preservation: The OAIS Reference Model," *OCLC Newsletter* 243 (January/February 2000), 26–30, http://digitalarchive.oclc.org/da/ViewObject.jsp?objid=0000001747.

25. IMLS Digitization report, 36.

26. RLG-NARA Task Force on Digital Repository Certification, "Audit Checklist for Certifying a Trusted Digital Repository—Draft for Public Comment," report, August 2005, www.rlg.org/en/pdfs/rlgnara-repositorieschecklist.pdf; hereafter cited in the text as *Audit Checklist*.

27. For an example of the ongoing debate, see Digital Preservation Coalition, Report for the DCC/DPC Workshop on Cost Models for preserving digital assets, N.d., www.dpconline.org/graphics/events/050726workshop.html.

28. Brad Reagan, "The Digital Ice Age," *Popular Mechanics*, December 2006, www.popularmechanics.com/technology/industry/4201645.html.

29. Harvard University Libraries, Overview: Digital Repository Service (DRS), N.d., http://hul.harvard.edu/ois/systems/drs/index.html.

30. California Digital Library, UC Libraries Digital Preservation Repository, July 14, 2005, www.cdlib.org/inside/projects/preservation/dpr.

Evaluating Museum Technology: Experiences from the Exploratorium

Sherry Hsi

As networked technologies like the World Wide Web, Wi-Fi, personal digital assistants (PDAs), cell phones, mixed-reality immersives and digital libraries enable international audiences to engage with interactive media and online exhibitions created by local museums, they are changing museums' reach on a global scale. Federally funded museum projects typically require evaluation to research and measure audience outcomes and long-term education impact. Given the global visibility of museum technology projects, evaluation can no longer be viewed as a luxury or an afterthought, but as necessary to developing high-quality museum technology programs. Evaluation not only influences the development of exhibit media and Web design but also informs online program assessment, education, membership and online marketing.

While many people would generally agree that evaluation is a good idea, museums are challenged to find resources for evaluation on projects as well as gain institutional support to invest in ongoing evaluation. Other museums face challenges implementing evaluation internally, yet hiring external evaluators is often treated with skepticism and sometimes hostility—much like inviting in tax auditors or termite inspectors. Evaluation can be more helpful when it is viewed as an opportunity for learning and open communication between the artist or scientist and the public, or between the media developer and the user, providing a continuous cycle of audience feedback, refinement and innovation of designed media technologies. In this chapter, I share perspectives and strategies on conducting evaluation for museum technology projects drawn from my

experiences working both as an external evaluation consultant and an evaluation manager responsible for designing and planning learning technologies and Web-based and new media evaluations at the Exploratorium, a museum of science, art and human perception in San Francisco. To help demystify the process and bring technology evaluation into everyday museum practices, I also describe methods that range from inexpensive ad hoc strategies to structured evaluations that can be used to engage museum visitors and online remote audiences in the design process. When conducted formatively, evaluation has a better promise of improving technology-mediated museum experiences and supporting museum-wide operations to maintain a healthy and innovative institution.

GARNERING SUPPORT FOR EVALUATION

A productive step in starting a technology evaluation is to demonstrate the importance of this process by identifying staff members who value data-based decision-making and collect data to answer questions. For example, a store manager may be interested to learn which and how many items are sold via the website, or a development director may want to know whether the placement of a donation request on a webpage will generate revenue for the institution. A field trip manager may be curious to know how many educators use pre- and post-field trip activities in the classroom and whether they prefer HTML or PDF file formats. A board member may wonder whether the website audience has grown in the past year. Media designers and Web developers who rarely get a chance to meet their remote audiences may be eager to learn how online visitors experience different interactives created from a specific media project so they can make revisions before the next launch. Staff across the museum will be interested in the evaluation data if some of their key questions are addressed. Resources and support, however piecemeal, can then be leveraged toward evaluation, making it a more legitimate function outside one department and a justifiable expense at the institutional level.

INTERNAL AND EXTERNAL EVALUATORS

Evaluation is also enabled when a staff person can advocate for technology evaluation within the institution. External evaluators can bring a wealth of expertise, repertoire of tools, advice, objectivity and energy to a technology project. Being external to the institution, however, they are often blind to the day-to-day workflow of media production, team dynamics, spontaneous creative brainstorming sessions, decision-making and negotiations of multiple objectives and constraints of a museum setting. Technology-rich projects, in particular, also require coordination with Web and/or IT departments to gain

secure access to configure servers, survey software, data files and other evaluation tools that are more easily accomplished with an internal staff evaluator. At the Exploratorium, technology evaluation was enabled initially by hiring a part-time internal evaluator who helped to design evaluations in partnership with external contracted evaluation and serve as a facilitator between the design team and external evaluators. The internal evaluator can also provide steering and continuity for evaluations that take place over time. The best evaluation results when the developer and evaluators partner together to create an evaluation plan early on and develop shared questions.

SELECTING METHODS

Evaluation is commonly categorized into phases depending on when it takes place. Front-end evaluation is conducted before the start or at the beginning of a project to help guide planning and decisions around audience ideas and expectations. Formative evaluation occurs concurrently with prototyping in the middle stages of a project to provide feedback on components of an exhibition or website; summative evaluation attempts to measure the design efficacy and impact—whether the design did what it was intended to do for its user.

When considering which evaluation approaches to use, it is helpful to frame it in four descriptive categories: quiet capture, active elicitation, embedded evaluation and cooperative inquiry. While the specific kinds of tools used may change over time with new innovations on the horizon, this framing can be useful for planning and evaluating museum technology experiences.

1. Quiet Capture

Quiet capture methods allow the evaluator to document the interactions of users, whether engaged in play with a website or walking through an immersive interactive. The idea behind this approach is to collect data while not disturbing or interrupting the user. For example, in the evaluation of the Exploratorium's website, Web traffic software is used to capture which areas on a page generate the highest traffic, the duration of webpage visits, frequency of use and the popularity of frequented websites by using "cookies," a piece of code that is downloaded to the user's machine and scripted to collect specific data. As this data is collected over time, trends can be gleaned quarterly or annually. Some examples of Web metric software include Summary, SawMill, Hitwise and Google Analytics.

Another quiet capture method includes open source and commercially available software installed on a floor kiosk (e.g., SpectorSoftware, TypeRecorder) to

capture digitally the computer's screen every few seconds without interrupting the visitor's activity. Lower cost approaches can involve the evaluator simply observing unobtrusively by standing nearby or following behind, then asking for consent to use the data as the visitor leaves the museum. A low-cost webcam can also be mounted near the ceiling to record how long visitors stay at a given technology exhibit as well as the flow within an exhibition area. The lack of camera focus can provide enough detail to record movement of visitors but not enough resolution to personally identify any individual.

Quiet capture approaches have the benefit of not interfering with the activity of the participant, but also require in most cases getting consent from the evaluation participant. Ideally, additional data sources are collected from other methods to help validate data collected using these methods.

2. Active Elicitation

A second category of methods—active elicitation—involves actively recruiting visitors to participate in evaluation through the museum's entrances or exits, membership lists, websites or commercially purchased contact lists. For example, an evaluator of webcast programs at the Exploratorium stands near the theater exit and counts the attendees leaving, asking every fifth or tenth person his or her thoughts about the program or asking attendees to fill out a short survey in exchange for an incentive. Similar kinds of techniques can be designed into media interactives and websites that periodically ask the online visitor to provide written feedback.

Visitors can also be recruited from the museum floor to conduct hour-long evaluations involving usability tests, providing a formative evaluation of media prototypes. At the Exploratorium, an "evaluation corral" was created using stanchions to cordon off a space adjacent to high-traffic museum exhibits. This corral had enough space for small tables on wheels, each with a wireless laptop, computer mouse and headphone set. During the formative evaluation of components for the Exploratorium Evidence website, individual visitors were asked to take as much time as they wanted to complete a specific task (e.g., "Write down questions that come to mind when reading these pages"). In this process, the developer and evaluator take turns observing behaviors while visitors are seated at the computer. When visitors indicate they are done, evaluators conduct follow-up interviews at a small table to gain deeper insight into the visitor's behaviors. This also provides visitors an opportunity to share any other comments they had about their experience. Over-the-shoulder observations are

a low-cost alternative to doing usability studies to quickly test one's assumptions about a design or concept under development.

3. Embedded Evaluation

New media websites can be designed to embed evaluations and measurement. The Exploratorium's Institute for Inquiry website requires users to fill out an eight-item pop-up survey before being allowed to download a free publication.[1] In three months, evaluators were able to determine that 35 percent of online downloads were made by K–12 educators. The pop-up also served as a recruitment mechanism to collect e-mails from people who participated in follow-up interviews. Thus, only online visitors to specific activities on the website were recruited to offer feedback to the site, rather than drawing individuals from a membership list or other contact source.

Online bulletin boards are another example of embedded evaluation. In the Science of Cooking website from the Exploratorium's Accidental Scientist project, chefs posted to and moderated discussion on an online bulletin board.[2] The postings on the board allowed evaluators to see the kinds of audiences discovering the site, examine the conversations and determine whether visitors returned to post a follow-up. The bulletin board served as both an activity and an assessment, requiring some monitoring. Similarly, after the Exploratorium's live webcast of a solar eclipse from Turkey in 2006, broadcast at the museum and simultaneously online in Second Life, a 3-D online world imagined, created and owned by its residents, we created a Web-based guestbook to aggregate comments from online visitors. Comments were used to complement the Web metric data and provided more insight about audience data from viewers who included educators and multigenerational families around the world.

In the Exploratorium Mind project, several prototype interactives were placed on an Internet-based kiosk in the museum to rapidly collect a high volume of user data.[3] The kiosk had a wireless Internet connection, a secure keyboard (i.e., an inexpensive keyboard with glued-down function keys), a trackball, a touch screen and room for Universal Serial Bus (USB) peripherals. The website with Web components to be evaluated ran on the kiosk computer and was reconfigurable remotely via the Internet. This allowed changes—by the Web developer, evaluators or a scheduled computer script—to be easily made during development. Meanwhile, a simple tracking script in PHP and MYSQL, logging every screen jump, ran on each Flash interactive and webpage. This clickstream data indicated which interactives were being used and which pages of each

interactive were visited. In six months, the kiosk logged more than 200,000 interactions, providing useful feedback to developers.

4. Cooperative Inquiry

A final category of methods includes "cooperative inquiry" approaches to research and evaluation, which ask visitors to serve as their own data collectors about themselves and/or others in their group. For example, after visiting a museum parents and their children can keep a diary of the proceeding conversations and activities and document whether and how they use the museum's website. Parents can participate as researchers by documenting the questions raised by their children in everyday activities.[4]

In a technique called Video Traces select museum visitors interact with an exhibit while being videotaped. After their interaction with the exhibit, visitors are asked to view the videotape of themselves and provide insights into their thoughts and actions.[5]

Given that more and more technology-based experiences involve the user authoring content and creating media, another approach to evaluation is to create "technology probes," an online data collection tool in the form of an online "pal," an avatar customizable by children.[6] Examining how people choose to design and operate their online avatar provides insights into what visitors value. Thus, conversation and artifacts together serve as evaluation data. This approach outweighs active elicitation approaches, especially with younger children who have difficulty articulating their learning and rationale for activity. A similar approach uses a video camera near the participant. The participant is encouraged to talk directly to the camera, which becomes an audience for the designs being produced.[7] These cooperative inquiry evaluation methods have the benefit of allowing the participant to engage in the design and evaluation process and contribute to the collection and interpretation of data through his or her own activity and accounts.

RECRUITING PARTICIPATION

Once a set of questions is identified, a plan is designed and methods are selected, the evaluation fun begins. A handy sample of testers can be floor visitors, staff, friends or family. Staff members are experts in their own fields and can serve as useful participants in an evaluation, but they should not be the designers and they must be willing to be evaluated.

Whether evaluators recruit on a weekend, weekday or day on which a specific group visits, the testers must be representative of the kinds of interactions that users have when accessing a globally available website. Membership lists are easy to gather, but sometimes the nonvisitor is the target audience because they provide more information about the barriers to using technology. At the Exploratorium, a useful technique has been to establish longer-term relationships with a cohort of evaluation participants or "beta testers" who, on a regular basis, critique technology designs under development. These beta testers can be deliberately selected to represent different demographic and psychographic profiles: senior citizens, young married couples, teenagers, middle-aged computer professionals, science-interested homemakers, Spanish-speaking immigrants, K–12 school educators, etc.

EVALUATION OF FUTURE MUSEUM TECHNOLOGIES

Future media and technology design will no doubt be more fluid, participatory and networked. In participatory media environments, visitors can now contribute stories, observations, photographs, scientific data, music, sketches, videos or other personal media messages onto publicly shared online graffiti boards, global earth watches or digital library collections. The onsite and remote online visitor can now participate in forums, multi-user online games and collaborative design experiences that shift one-way media consumption into museum experiences with artists, developers and other visitors. Online publishing and media production are becoming concurrently more distributed, global and democratic: artistic rendering, authoring and media production are placed in the hands of many rather than a few. Thus, visitors are shaping and in some cases driving the experience in ways that were not originally conceived by the technology designer. Evaluation will require expanding to include these virtual spaces and new virtual geographies that create opportunities for new forms of data collection, engaging visitors in a two-way dialogue as ongoing legitimate coproducers in the creative media design and development process and as co-evaluators rather than mere consumers of media and technology.

As an example of this, the Exploratorium has used the tools of Second Life to develop a virtual museum that houses online exhibitions, demonstrations and science experiments, in addition to explorable underwater areas, bungalows and tunnels. Exhibits no longer need to sit on the ground, but can float in space or be mounted on high vertical towers. Visitors sit in floating chairs that spin to view and experience optical illusions mounted on vertical walls, or walk through

largely scaled carbon nanotubes. Users who enter this world design their online identity by choosing a pseudonym and customizing a physical appearance through the features provided in the software. Evaluation tools can be built within the online environment to collect typical measures like time spent at exhibits, visitor traffic at specific exhibition entrances and exits and comments in guest books. Evaluation of the user experience will require designing new data collection tools to capture the individual and shared experience of participants, as well as new protocols and procedures to identify and contact individuals for follow-up interviews, given that their identities are usually hidden.

As more evaluation takes place in online environments such as Second Life, museums will need to be explicit about how visitors opt in or out of participating, ownership is determined and intellectual property is handled when content, stories, text and comments are contributed by users. An institutional privacy policy should be created and placed in an easily accessible and visible location on the website or new media piece that makes explicit the overall policies.

CONCLUSION

Evaluation provides an opportunity to gather useful information about audiences, online programs and technology-mediated experiences, and for everyone to learn from audiences including developers, evaluators, museum administrators, visitors and online users alike. Now and in the future, evaluating museum technology experiences will require ongoing institutional support beyond a single project. Evaluation in the formative improvement cycle, especially for new media, learning technologies, digital libraries, extended online learning experiences and networked designs, which have global visibility, can no longer be ignored. Evaluation should be a necessary part of everyday museum practice— to gather information that helps to make ongoing improvements. Become an evaluation advocate in your institution. A range of new possibilities exists for using technology for evaluation, and, in turn, for evaluating museum technology experiences to inform professional practices and improve user experiences.

NOTES

1. See www.exploratorium.edu/ifi.

2. See www.exploratorium.edu/cooking.

3. Sherry Hsi, et al., "From 'Guerrilla' Methods to Structured Evaluations: Examples of Formative Web Design from the Exploratorium's Evidence and Mind Projects," In Jennifer Trant and David Bearman, eds., *Museums and the Web 2007: Selected Papers from an International Conference*, (Toronto: Archives and Museum Informatics, 2007), www.archimuse.com/mw2007/papers/hsi/hsi.html.

4. Maureen Callanan and Lisa Oakes, "Preschoolers' Questions and Parents' Explanations: Causal Thinking in Everyday Activity," *Cognitive Development* 7 (1992): 213–233.

5. Reed Stevens and Rogers Hall, "Seeing Tornado: How Video Traces Mediate Visitor Understandings of (Natural?) Phenomena in a Science Museum," *Science Education* 81, no. 6 (1997): 735–747.

6. Allison Druin, "The Role of Children in the Design of New Technology," *Behavior and Information Technology* 21:1 (2002), 1–25; and H. Hutchinson, et al., "Technology Probes: Inspiring Design for and with Families," *Proceedings of the SIGCHI Conference on Human Factors in Computing Systems, Ft. Lauderdale, Fla.* (New York: ACM Press, 2003), 17–24.

7. Kristin Lamberty and Janet L. Kolodner, "Camera Talk: Making the Camera a Partial Participant," *Proceedings of the SIGCHI Conference on Human Factors in Computing Systems (CHI 2005), Portland, Ore., April 2–7* (New York: ACM Press, 2005), 839–848.

New Technologies, Old Dilemmas: Ethics and the Museum Professional

Holly Witchey

Would you live with ease, do what you ought, not what you
please. —*Benjamin Franklin*

Museums face a broad range of ethical issues in the twenty-first century. Many of
these ethical issues are well known and our expected responses to them, as museum
professionals, are documented in the American Association of Museums' Code
of Ethics and the International Council of Museums' Code of Ethics.[1] Both of
these codes deal with issues of governance, care of collections, interpretation and
programs. The advent of new tools and technologies, however, has introduced a
more ambiguous set of ethical issues and challenges that contemporary museum
employees must face.

The AAM Code of Ethics clearly outlines the primary stewardship responsibilities
of museum professionals:

> Taken as a whole, museum collections and exhibition materials
> represent the world's natural and cultural common wealth. As
> stewards of that wealth, museums are compelled to advance an
> understanding of all natural forms and of the human experience. It
> is incumbent on museums to be resources for humankind and in
> all their activities to foster an informed appreciation of the rich and
> diverse world we have inherited. It is also incumbent upon them to
> preserve that inheritance for posterity.

New tools and technologies that allow us to fulfill these mandates more efficiently are always developing. They are also changing the way we think and the way we do business. These tools give us tremendous power over information and intellectual property; consequently, we need to take the responsible use of such tools seriously. What does this mean for museum professionals? How do these comments relate to the mandates set out in our professional codes of ethics?

The use of new technologies is ubiquitous in today's museums—phone systems and networked computers; security systems and ticketing terminals; collections, content and digital asset management systems; interpretive audio guides and interactive kiosks, distance learning studios, podcasts, websites and online communities. The average employee at a museum, science center, zoo, aquarium, historic home or living history site may be well trained in working with collections or managing volunteers, skilled at marketing or finance, an effective registrar, a gifted curator or a charismatic director—but very few have had any training with these new technologies. Fewer still, given their workloads, have had time to consider the ethical dilemmas that these new tools raise in the workplace. How can we train current and future generations of museum employees in general business ethics in an environment where the tools and rules for use seem to be constantly changing?

There are surprisingly few discussions—at conferences, in professional journals or on popular list-servs—on the topic of general business ethics as they apply to cultural heritage organizations. There are even fewer discussions about how new tools can affect (for better or worse) the ethics of a community (whether a department, division, institution or consortium). Museums need a flexible system that looks at the human issues involved, not at the individual technologies. We, as individuals, need to step up to the huge underlying challenge of the situation: Do we understand the ethical implications of the decisions we make on a daily basis?

I come to this discussion with an almost entirely western education and viewpoint, and I assume that I am speaking to a primarily westernized audience. This chapter is not designed to be a review of museum ethics through time, history and geography; it is designed to encourage discussion about why and if it is important, if not always easy, to remain conscious of the decisions we make as individuals. In particular, these decisions relate to the uses of new technologies and how these decisions affect museum culture and practice as a whole in the twenty-first century. I also seek to articulate the opportunities offered to

museums to encourage a climate of good business ethics on an individual as well as an institutional level. Not only will museums be better prepared to face ethical dilemmas as they arise, but employees will learn to critically evaluate the uses of new technologies before adoption.

ETHICS IN MUSEUMS: AN OLD DILEMMA

There can be no discussion about the history of ethics in museums without a discussion of trust. Museums hold collections in trust for future generations. It is our responsibility to see that these objects—representing the cultural heritage of more than 8,000 years of civilization—are passed on to the next generation in the same condition or, if at all possible, in better condition than was previously possible due to advances in the science of collection care. The next generation may choose to look at objects afresh—without our carefully collected input—and form its own opinions about their purpose, history or intended use. What is important is that future observers have at their disposal the records of what was known or believed at the time.

Given that we have a basic understanding of our mission, how do we chart a path through the mire of ethical questions that arise because of new tools and technologies? The adoption of new technologies into the museum workplace has historically brought about unimagined ethical scenarios that resulted in problems requiring discussion and resolution. Usually the resolution of such issues involves the adoption of policies and procedures, or at least normative standards of behavior, with regard to what is considered use or abuse of a new tool or technology.

For example, when telephones were first installed at museums the price of a phone call, particularly a long-distance phone call, was prohibitive. It would have been unthinkable for a museum employee to use the company line to make a personal phone call unless it was an emergency. It was not until telephones became more universally available that a group of phone-related ethical issues developed—not just in museums but also in workplaces across the business world. This required administrators to establish policies about expected behaviors.

The problem in the current climate is that new tools and technologies are being adopted for use at a staggering rate. There is little time to step back and reflect on how these tools are going to change the culture of museums. There is even less time to consider how individuals are to educate themselves on what it means to correctly or incorrectly use these new additions.

SO, WHAT CAN MUSEUMS DO?

One pragmatic approach when attempting to address technology-related ethical issues is to ask scenario-based questions when adopting or implementing new technologies. The following list of questions was gathered from colleagues in the trenches at museums. All the questions involve technologies that were originally adopted to enable museum professionals to do their jobs more effectively or efficiently. For the purposes of this essay, consider these questions as if they are being asked in an environment without the benefit of an institutional policy or code of ethics. What do you believe?

Is it okay to…

- set up a webcam and film visitors without telling them for non-security purposes?
- use the color copier at work for personal projects?
- post and host personal material, either your own or for someone else, online on your work server?
- take an image or document you need from someone else's private folder without their permission?
- not have a privacy policy on your website?
- use equipment (cameras, PDAs, iPods, scanners) for personal use when it is not in use at the museum?
- archive instant messaging conversations without telling the other person?
- forward voicemails to a third party without telling the person who left the voicemail?
- edit e-mails or memos before forwarding or showing them to a third party?
- read and share misdirected e-mails?
- use images or text in a publication for which you have not yet obtained proper permissions?

CURRENT TRENDS ON ETHICS

When facing these questions many museum professionals find their ideas about truth and trust are muddied. Each question leads to more questions and the posing of real-life scenarios. Who will answer these questions for us? How do we know we can trust the answers? In the absence of an institutional or professional code of ethics or policy with regard to a difficult decision, you can only base your answers on your own sense of integrity tempered by knowledge (which you may already have, or may have to do some work to obtain).

As we learn more about how new technologies affect museum culture, we need to begin to ask questions. What is the right thing to do? What is the wrong thing to do? Is there any literature I can find that will help me decide? If I have perceived an issue as an ethical dilemma, might my colleagues also have similar concerns? If so, at what point does the administration need to be aware and weigh in on an issue? What if there is not a clear right or wrong answer?

Discussions in current literature on the topic generally follow one of two distinct theories: technological determinism or social determinism. Proponents of the theory of technological determinism believe technologies have the ability to predict how the cultural, social and business practices of societies will develop. Technologies come with the ability to affect and control our actions.[2] In technological determinism, society has very little control over technology, and an unaware society runs the risk of allowing tools to shape intentions. Consistent with this paradigm, we must work harder to make a conscious effort to understand the societal impacts of the tools we use.

On the other end of the philosophical spectrum, social determinism maintains that it is the society or economic system in which a tool is developed or used that decides the impact the tool will have. There is no inherent harm or goodness in individual technologies—technology is neutral. This theory is often called on to argue that "guns don't kill people, people kill people." New technologies are simply new tools that are used, driven and shaped by societal forces.[3] Thus, if we are going to change how these neutral tools are used, we must have the power to shape the society that created them.

An alternate theory—pragmatism—was introduced in a 1997 book by Lori Allen and Don Voss, *Ethics in Technical Communication: Shades of Gray*. While the book primarily addresses, as the title suggests, the ethics of technical communications, it also introduces the concept of "shades of gray" as a means for looking at decisions.[4] The authors identify two types of gray issues: solid (or legitimate) gray issues and chameleon (or self-serving) gray issues.

Legitimate gray issues are those in which basic ethical values may be in conflict and in which there appears to be no correct answer. In this case, an institution has to make hard choices. For example, museums with Internet access must address what access employees should have to the Internet for personal concerns.

Chameleon gray issues, on the other hand, are those in which situational ethics come into play. This means that when there is no clear right or wrong

answer to a question, employees or institutions will alter their ethics to meet the situation. Ethical conflicts are resolved in a way that satisfies the self-interest of the institution. For example, consider the museum community's tendency to subtly shift its ethics on the interpretation of copyright laws based on current institutional needs.

Allen and Voss ultimately propose four guidelines for dealing with ethical conflicts in an institution:

1. Communicate with others about potential ethical issues and conflicts.
2. Analyze the values that are involved.
3. Personalize the problem to see how the potential institutional answers to the question measure up to your personal values.
4. If necessary, escalate the discussion higher up on the company ladder for resolution.

These guidelines are rich in common sense and, as such, ought to be easily adopted. The problem is communication and internalization—how do we make these guidelines a part of our business culture? And do we want to? Recognizing and resolving these new ethical issues as they arise is going to require more than the simple guidelines proposed by Voss and Allen, but they are a start.

The museum community might find one more document helpful in this discussion. In 1991, Dr. Ramon C. Barquin authored what has become known as the "Ten Commandments of Computer Ethics."[5] With slight alteration, this list offers ten simple do's and don'ts for dealing with the human aspects of adopting new technologies:

1. Museum professionals shall not use technologies to harm other people.
2. Museum professionals shall not use technologies to interfere with other people's work.
3. Museum professionals shall not use technologies to snoop around in other people's files.
4. Museum professionals shall not use technologies to steal.
5. Museum professionals shall not use technologies to bear false witness.
6. Museum professionals shall not copy or use proprietary software for which they have not paid.
7. Museum professionals shall not use other people's resources without authorization or proper compensation.

8. Museum professionals shall not appropriate other people's intellectual output.

9. Museum professionals shall think about the social consequences of the technologies they are using.

10. Museum professionals shall always use technologies in ways that ensure consideration and respect for your fellow humans.

This list offers a useful tool for establishing a baseline for business ethics in the museum workplace. It is not intended as a panacea to the problem, but is offered more as starting place for discussions.

CONCLUSION

There is a lack of understanding and almost no discussion of general business ethics in museums today. The plethora of new tools and technologies, which are part of the tool kit offered to museum professionals, offer opportunities on an almost daily basis in which ethical decisions must be made or ethical dilemmas must be faced. How are we, as a profession, going to respond to this growing problem? This may not be the most important issue facing museums, but it ought to be the topic of more discussions.

Our governments, professional organizations and individual institutions can and will continue to create codes of ethics to which we, as individuals, may or may not subscribe. As our institutions grow and become increasingly complex, our codes of ethics may or may not someday include language that speaks more directly to general business ethics. The fact is that whether to make a decision based on principles of what is considered ethically appropriate in a given situation is invariably an individual choice. We must be responsible. We must make the right choices and, if we don't know what the right choices are, we must get more information, talk to one another and not simply let what is easy to do get in the way of what is right.

NOTES

1. See AAM's Code of Ethics for Museums, www.aam-us.org/museumresources/ethics/coe.cfm; and ICOM Code of Ethics for Museums, 2006, http://icom.museum/ethics.html.

2. For more information on technological determinism, see Jonathan B. King, "Tools-R-Us," Journal of Business Ethics, 13 (1994).

3. For more information on social determinism, see Langdon Winner, *The Whale and the Reactor: A Search for Limits in an Age of High Technology* (Chicago: University of Chicago Press, 1986).

4. Lori Allen and Don Voss, *Ethics in Technical Communication: Shades of Gray* (New York, Wiley Publications, 1997), 34.

5. Ramon C. Barquin, "In Pursuit of a 'Ten Commandments' for Computer Ethics," Computer Ethics Institute, May 7, 1992. The commandments were written as part of an initiative of the Brookings Institution, www.cpsr.org/issues/ethics/cei.

Glossary

NOTE: *This glossary was compiled collaboratively using a wiki (see definition below) open to all of the book's contributors. Definitions derived from other sources are indicated in brackets with a full citation below. The selection of terms and their definitions are intended to support the context of the essays of this book.*

ACCESSIBILITY: the degree to which a system effectively accommodates audiences with disabilities.

animatronics: the technology employing electronics to animate motorized puppets. [American Heritage Dictionary]

APPLICATION PROGRAMMING INTERFACE (API): the expression of an agreed-upon set of functions and syntax by which software developers can use another set of code without having to directly attach to or modify it.

ASYNCHRONOUS (COMMUNICATION ONLINE): describes a Web interaction in which participants are not required to be online at the same time in order to engage in the activity (e.g., threaded discussions, blogs and e-mail).

AVATAR: a visual representation of a user that appears in a digital program or virtual world.

BIT-LEVEL PRESERVATION: a digital preservation strategy in which the sole objective is to ensure that a digital file remains unaltered and intact on its storage media.

BLOG (WEBLOG): a dynamic online publishing system designed for two-way interaction by posting narratives and receiving responsive commentary.

BLUETOOTH: a specification for wireless personal area networks (WPAN) that provides a way to connect and exchange information between devices such as mobile phones, laptops, PCs, printers, digital cameras, etc.

BOOKMARK (COMPUTERS): a means by which relevant URLs are collected and saved for future reference on the World Wide Web.

BORN DIGITAL: material created and existing only in digital form; no analog original or equivalent.

CHAT (ONLINE): exchange of synchronous text messages through an application via the Internet.

CLICKSTREAM DATA: a record of the sequence of links clicked on by a computer user while browsing a website or series of websites.

CODE DIVISION MULTIPLE ACCESS (CDMA): a method of multiple access to a physical medium such as a radio channel, where different code sequences allow different users to use the medium at the same time. Also refers to digital cellular telephony systems that use this multiple access scheme. [Wikipedia]

CODEC: abbreviated from COmpressor/DECompressor; a device or program that enables the compression or decompression of digital data.

COMPACT DISC READ-ONLY MEMORY (CD-ROM): a type of compact disc that stores digital files.

COMPACT DISC-RECORDABLE (CD-R): a type of compact disc that can be recorded once only. No data can be erased or added.

CONTENT MANAGEMENT SYSTEM (CMS): a computer software system to organize and manage digital files.

COOKIE: parcels of text sent by a server to a Web browser and then sent back unchanged by the browser each time it accesses that server. Used for authenticating, tracking and maintaining specific information about users. [Wikipedia]

DIGITAL ASSET MANAGEMENT SYSTEM (DAMS): software and hardware that centrally organizes, stores and distributes digital files, aiding in the process and workflow of digital asset management.

DIGITAL OBJECT: a discrete unit of information in digital form (e.g., a representation, file, bitstream or filestream). [PREMIS]

DIGITAL PRESERVATION: managed activities necessary for the long-term maintenance and access of a digital file so its display, retrieval and use remain possible.

DIGITIZATION: converting analog data into digital form through the process of scanning, or direct digital camera capture.

EMULATION: (1) a preservation strategy for overcoming the obsolescence of hardware and software by developing ways for contemporary systems to imitate obsolete systems; (2) the re-creation of the technical environment required to view digital assets from previous times on current hardware.

END-USER: expected or target user.

E-NEWSLETTERS: a form of electronic communication/publication whereby a newsletter is sent to constituents via e-mail on a regular basis.

EXTENSIBLE MARKUP LANGUAGE (XML): a general-purpose markup language to facilitate sharing data across different information systems, particularly via the Internet. [Wikipedia]

FACTORY AUTOMATION: manufacturing driven by computers and programmable controllers including assembly lines as well as stand-alone machine tools and robotic devices.

FLASH: a program used to create vector-based animation and interactivity on webpages.

FOLKSONOMY: a user-generated taxonomy used to categorize and retrieve online objects such as webpages or images, consisting of labels or tags that employ a shared vocabulary derived from and familiar to its users.

FORMAT MIGRATION: conversion of a digital file from an eclipsing format (increasingly incompatible with contemporary software and hardware environments) to a contemporary and therefore compatible format.

GAME CONSOLE: a consumer interactive entertainment device used for playing video games, typically on a television or monitor.

GBPS: a gigabit per second (Gbit/s or Gbps), a unit of data transfer rate equal to 1,000 megabits per second or 1 billion bits per second.

GEOGRAPHY MARKUP LANGUAGE (GML): the standardized XML grammar used to express geographic features similar to how HTML is a grammar for expressing the layout of webpages.

GEORSS: a proposed GML profile for RSS feeds to also be described by geographical location.

GEOTAGGING/GEOBLOGGING: the process of adding geographical identification metadata to various media such as websites, RSS feeds or images. [Wikipedia]

GLOBAL SYSTEM FOR MOBILE COMMUNICATIONS (GSM): the most popular standard for mobile phones that makes international roaming common between mobile phone operators and enables subscribers to use their phones in many parts of the world. [Wikipedia]

GOOGLE INC.: provides Internet search and online advertising as well as web-based e-mail, online mapping, office products and video sharing, among other services.

GLOBAL POSITIONING SYSTEM (GPS): a system of satellites, computers and receivers that is able to determine the latitude and longitude of a receiver on Earth by

calculating the time difference for signals from different satellites to reach the receiver. [American Heritage Dictionary]

GROUPWARE: software designed to help multiple users involved in a common task achieve goals with tools for communication, transaction and/or collaborative production.

HYPERLINK: text, images, or graphics in a document that when clicked takes the user to another document or to a different section of the same document.

HYPERREALITY: the meticulous, artificial recreation of reality; a plausible simulation of perceived reality.

HYPERTEXT MARKUP LANGUAGE (HTML): the main authoring software language used to create webpages.

INFORMATION ECOLOGY: a system of people, practices, values and technologies in a particular local environment. In information ecologies, the spotlight is not on technology, but on human activities that are served by technology. [Nardi and O'Day]

INFRARED TRIGGERS: location-specific infrared transmitters that emit a code capable of triggering the presentation of location-specific information on infrared compatible handheld devices.

INTERACTIVE VOICE RESPONSE (IVR): a computerized system that allows a person, typically a telephone caller, to select an option from a voice menu and otherwise interface with a computer system.

INTERNET: a worldwide system of computer networks that transmit data by packet switching using the standard Internet Protocol.

INTERNET PROTOCOL (IP): provides global addressing of and communication between individual networked computers and devices.

INTERNET2: a nonprofit consortium that provides partnership opportunities to research and education communities and develops and deploys advanced network applications and technologies. See www.internet2.edu.

INTRANET: a private computer network that shares information securely within an organization to its employees.

JPEG: a commonly used method to compress digital images created by the Joint Photographic Experts Group.

MACHINIMA: a combination of machine and cinema, a movie that is created within a 3-D virtual world, often using video game technologies and capturing the actions of players and events in real time.

MASHUP: the recombination and layering of unrelated music tracks, photographs, videos, maps, data sets or other found digital components into a new original work or application.

MEATSPACE: the physical world, as opposed to cyberspace.

MEDIA MIGRATION: the process of copying a digital file from a degrading to an intact storage media, or from a storage media in danger of obsolescence to a contemporary media.

MIGRATION: a preservation strategy in which a transformation creates a version of a digital object in a different format that is compatible with contemporary software and hardware environments. [PREMIS]

MIXED-REALITY IMMERSIVE: When one or more forms of multimedia are used together to create a space in which a visitor can navigate him or herself, or an avatar, in an online, physical or blended context.

MOBILE WEB: an initiative by the W3C to improve access to the Web on mobile devices.

MOTION-BASED SIMULATION: a mechanism that creates the sensation of being in or on a moving object, usually by rocking or rolling riders on a platform or in a capsule.

MP3 PLAYER: a portable digital audio player that stores, organizes and plays the MP3 (audio/mpeg) format.

MULTI-USER DOMAIN (MUD): a multiplayer computer game that combines elements of role-playing, dramatic narrative and social chat rooms.

OBJECT THEATER: broadly defined, museum-based automated theatrical presentation involving sets, lighting and audio cues.

OPEN ACCESS SOFTWARE: software whose capabilities are available for use through the definition of an application programming interface (API) that is free to develop outside of the originating institution; can be seen as a middle ground between open source and proprietary software.

OPEN SOURCE SOFTWARE: any computer software whose source code is available under a license (or arrangement such as the public domain) that permits users to study, change and improve the software, and to redistribute it in modified or unmodified form; often developed in a manner that encourages public and collaborative software development.

PARTICIPATORY MEDIA: media-based experiences that allow users to participate in some way to contribute personal media messages in publicly shared spaces.

PEPPER'S GHOST: an illusionary technique used in theater and in some magic tricks, in which a plate glass and special lighting techniques can make objects

seem to appear or disappear, or make one object seem to morph into another. [Wikipedia]

PERSONAL DIGITAL ASSISTANT (PDA): a pocket-sized computing device, typically comprising a small visual display screen for user output and a miniature keyboard or touch screen for user input.

PHP HYPERTEXT PREPROCESSOR (PHP): a programming language used to produce dynamic webpages that allows user input and runs a script directly on the Web server.

PODCAST: a digital media file that is distributed by subscription (paid or unpaid) over the Internet using syndicated feeds (see RSS), for playback on mobile devices and/or personal computers.

PORTABLE DOCUMENT FORMAT (PDF): an open file format created by Adobe Systems, in which the original characteristics of a 2-D document are retained and it can be viewed independently from specific software, hardware or operating systems.

RADIO FREQUENCY IDENTIFICATION (RFID): an automatic identification method, relying on storing and remotely retrieving data using devices called RFID tags or transponders. [Wikipedia]

REALLY SIMPLE SYNDICATION (RSS): a family of Web-feed formats used to publish frequently updated digital content, such as blogs, news feeds or podcasts. [Wikipedia]

SECOND LIFE: a 3-D virtual reality world that is created and owned by its "residents." See www.secondlife.com.

SHOW CONTROL: use of technology to link together and operate multiple entertainment control systems—such as lighting, sound, video, rigging or pyrotechnics—in a coordinated manner. [Wikipedia]

SOCIAL TAGGING: the collaborative process of building a folksonomy.

SHORT MESSAGING SERVICE (SMS): using a handheld device to send short text-based messages to other handheld devices.

SMART TABLES: as originally developed by the MIT Media Lab, "a table that can track and identify multiple objects simultaneously when placed on top of its surface." The objects carry tags recognized by a camera above or below the table, which then trigger playback of stills or animated information across all or part of the surface. Surround sound: an application of multichannel audio that expands the spatial imaging of audio playback from one dimension (mono/Left-Right) to two or three dimensions in order to simulate an actual sound environment.

SYNCHRONOUS (COMMUNICATION ONLINE): communication or exchanges taking place between two or more people in real-time over the Internet.

TANGIBLE INTERFACE: a user interface in which a person interacts with digital information through the physical environment. [Wikipedia]

TELEPHONY: encompasses the general use of equipment to provide voice communication over distances, specifically by connecting telephones to each other. [Wikipedia]

THREADED DISCUSSION: a forum of individuals connected via an electronic network, such as an e-mail list or blog, in which messages or postings are grouped according to topic thread and members are able to participate asynchronously.

TRANSFORMATION: a process performed on a digital object that results in one or more new digital objects that are not bit-wise identical to the source digital object. [PREMIS] Trusted digital repository: provides reliable, long-term access to managed digital resources to a designated community.

UNIVERSAL SERIAL BUS (USB): allows peripherals to be connected using a single standardized interface socket to improve plug-and-play capabilities by allowing devices to be connected and disconnected without rebooting the computer. [Wikipedia]

UNIFORM RESOURCE LOCATOR (URL): a technical, global identifier for documents on the Internet.

USABILITY: a term used to denote the ease of use of a particular tool or a website interface.

USER-GENERATED CONTENT: refers to media content (e.g. blogs, wikis, or video) primarily produced by end-users rather than hired personnel.

VIRTUAL REALITY (VR): a computer generated three-dimensional space that enables a participant to enter and interact with an artificially simulated environment.

VODCAST: also referred to as a video podcast, the online delivery of a video on demand or video clip content via a syndicated feed (see RSS). [Wikipedia]

VOICE OVER IP (VOIP): a routing service that uses the Internet or other IP-based network to transmit voice conversations.

VOICEXML (VXML): an XML-based language that specifies interactive voice dialogues between a human and a computer and enables telephones and other voice-activated devices to connect to the Internet.

WEBCAST: a live or archived broadcast of digital audio and/or video that is transmitted over the Internet.

WEB METRICS: a system of parameters used to assess and monitor the activities of website visitors and use the data to determine how well the site meets its objectives.

WEB 2.0: the second generation of Internet-based services and tools that emphasizes online collaboration and sharing among users.

WIKI: an online tool that enables users to add, remove, edit and change content remotely and collaboratively.

WIRELESS FIDELITY (WI-FI): the underlying technology of wireless local area networks used to provide Internet connectivity.

WORLD WIDE WEB (WWW OR WEB): a system of interlinked, hypertext documents accessed via the Internet.

WORLD WIDE WEB CONSORTIUM (W3C): the main international standards organization for the World Wide Web (www.w3.org).

XML: see Extensible Markup Language

SOURCES

The American Heritage Dictionary of the English Language, 4th ed. (Boston: Houghton Mifflin Company, 2007).

Bonnie Nardi and Vicki O'Day, *Information Ecologies: Using Technology with Heart* (Cambridge, Mass.: MIT Press, 1999), www.firstmonday.org/issues/is-sue4_5/nardi_chapter4.html.

PREMIS (Preservation Metadata: Implementation Strategies) Working Group, jointly sponsored by OCLC and RLG, Data Dictionary for Preservation Metadata: Final Report of the PREMIS Working Group, May 2005, ww.oclc.org/research/projects/pmwg/premis-final.pdf.

Wikipedia contributors, Wikipedia: The Free Encyclopedia, http://en.wikipedia.org.

CONTRIBUTORS

ALLEGRA BURNETTE

Allegra Burnette is the creative director of digital media at the Museum of Modern Art, New York, overseeing design and production for the museum's website, MoMA.org, as well as interpretive kiosks and digital displays. Projects on MoMA.org have included the site redesign; the online collection and e-cards; audience-specific sites such as Modern Teachers, Red Studio and Destination: Modern Art; podcasts; and MoMA's ongoing series of exhibition subsites, including Tall Buildings, Eye on Europe and Contemporary Voices. Prior to working at MoMA, Allegra was responsible for creating and running a media department at the world-renowned museum exhibition planning and design firm Ralph Appelbaum Associates. Allegra has an MFA in museum exhibition planning and design from the University of the Arts in Philadelphia, where she has also taught graduate courses in museum media, and a BA from Dartmouth College in art history.

SUSAN CHUN

Susan Chun consults with cultural heritage organizations on information management and intellectual property strategy and policy. Her clients include museums, libraries, universities, academic consortia and funders. She is a founder of the steve project, which is investigating the value of social tagging to improve access to museum collections. Until 2007 Susan was general manager for collections information planning at the Metropolitan Museum of Art, New York, where she was responsible for institutional strategy and for developing and managing projects involving intellectual property, asset management and

archiving, digital imaging and licensing, publishing and standards. Prior to that, Susan was involved in all aspects of the Met's scholarly and exhibition publishing program in the museum's editorial department. She writes and lectures regularly on copyright, publishing, open content initiatives and social software.

HERMINIA WEI-HSIN DIN

Herminia Din is a faculty member at the University of Alaska Anchorage. Prior to this position, she was the Web producer at the Children's Museum of Indianapolis and education technologist at the Indianapolis Museum of Art. In the past few years, she has worked with the University of Alaska Museum of the North in Fairbanks on the LearnAlaska project—an educational tool to sort, display and share digital museum objects and historical images selected from the Alaska Digital Archives. In 2005 she facilitated a docent-training program using Internet2 videoconferencing for a traveling exhibit in Alaska, "Light Motifs: American Impressionist Paintings from the Metropolitan Museum of Art." She is on the board of the Media and Technology committee of AAM, currently serving as the program chair. She was also the MUSE Awards chair for two years. Herminia presents regularly at national and international conferences on museums and technology. She holds a doctorate in art education from Ohio State University.

ROBIN DOWDEN

Robin Dowden is the director of new media initiatives at the Walker Art Center, Minneapolis. She develops interactive and emerging technologies for the center, including multimedia computer applications (Dialog table), telephony-based audio-information resources (Art on Call), the Walker's website and projects to create digital resources. Robin directs Internet-based special projects including ArtsConnectEd, a joint initiative of the Walker and the Minneapolis Institute of Arts, and mnartists.org, an online resource for Minnesota artists developed by the Walker and the McKnight Foundation. Prior to joining the Walker, Robin was the collections systems and website manager at the National Gallery of Art, Washington, D.C.

SUSAN E. EDWARDS

Susan Edwards has developed online educational resources for the education department of the J. Paul Getty Museum in Los Angeles for more than five years. She works closely with museum educators to write and edit online curricula and lessons, create online tools for teachers and develop online games in GettyGames (www.getty.edu). Susan was instrumental in creating a virtual Getty Museum on Whyville, an educational online world for kids (www.whyville.net), which

included development of two games—an art treasure hunt and a multiplayer card game called ArtSets. She began developing online educational interactive experiences at the Seattle Art Museum in 2000, where as a curatorial research assistant she worked closely with the education department to build My Art Gallery (www.seattleartmuseum.org/myartgallery), which teaches kids the steps of creating an exhibition. Susan has MA and MPhil degrees in art history from the University of Michigan.

JONATHAN FINKELSTEIN

Jonathan Finkelstein is founder and executive producer of LearningTimes.org and president of the LearningTimes Network (www.LearningTimes.net). He works closely with museums, educational institutions, libraries and other organizations to build online communities and foster engaging human interaction and professional development. Jonathan's book, *Learning in Real Time* (Jossey-Bass, 2006), translates many years of experience facilitating online learning into a practical resource guide for anyone teaching or leading collaborative activities online. He also hosts the "Real Time Minute" (www.realtimeminute.com), a regular Internet video program about online collaboration. Jonathan, who serves on several editorial and advisory boards, is a Certified Synchronous Training Professional (CSTP) and received his AB degree with honors from Harvard University.

PHYLLIS HECHT

Phyllis Hecht is associate chair of the museum studies graduate program at Johns Hopkins University. She is also a media consultant for museums and nonprofits, specializing in strategic planning, project management, art direction and evaluation for multimedia projects. Previously, Phyllis was manager and art director of the website of the National Gallery of Art, Washington, D.C., and has more than 25 years of museum publishing experience in print and new media. She has spoken and written on topics ranging from developing the Web skills of K–12 teachers to using new methodologies for evaluating websites. She was on the board of the Media and Technology Committee of AAM from 2002–2007, serving as the MUSE Awards chair for three years. Phyllis holds a master's degree in museum education from George Washington University and undergraduate degrees in journalism and art history from the University of Maryland.

NIK HONEYSETT

Nik Honeysett is head of administration for the J. Paul Getty Museum, Los Angeles. Prior to his current role, he managed the Getty's Web Group, and was responsible for all aspects of its website and intranets. Before joining the Getty in

2000, Nik was the head of production at Cognitive Applications, Ltd., a United Kingdom consultancy firm working exclusively with museums and galleries in Europe and the U.S. Nik currently chairs AAM's Media and Technology Standing Professional Committee and sits on a number of other AAM committees, including the Standing Professional Committee Council and the National Program Committee for AAM 2008. He holds a bachelor's degree in physics and a master's degree in microprocessors.

DEBORAH SEID HOWES

Deborah Seid Howes is the museum educator in charge of educational media at the Metropolitan Museum of Art, New York. Her staff supports all of the museum's audiovisual services and educational publishing efforts, including the Timeline of Art History and Explore and Learn on the museum's website (www.metmuseum. org), videos, interactive kiosks and a wide-range of print materials including the award-winning teacher resource series about the museum's collection. Deborah currently supervises the technical planning and execution of the Met's new education center and library, scheduled to open in Fall 2007. Prior to coming to the Met 11 years ago, she was an educational technology consultant and taught interactive multimedia at the Austin Children's Museum. From 1986 through 1992 she was a lecturer for modern and contemporary art at the Art Institute of Chicago (AIC) and co-produced With Open Eyes, an interactive videodisc and later CD-ROM designed for young children to explore the AIC collection.

SHERRY HSI

Sherry Hsi researches how people learn from new media, handheld devices, science websites, digital libraries and other informal science resources at the Exploratorium, San Francisco. She was awarded grants from the NSF National Science Digital Library program to create a digital library for use with K–12 audiences, classroom teachers and after-school educators and a MacArthur Foundation grant to explore digital-mediated learning among next generation youth. As early as 1996, she helped the Concord Consortium develop online faculty and teacher professional development for the first virtual high school. Sherry is on the editorial board for the *International Journal of Science Education* and reviews for the *Journal of the Learning Sciences*. She also serves on the board of champions for the National Girls Collaborative in the Science, Technology Engineering and Mathematics program (STEM). She co-authored *Computers, Teachers, Peers: Science Learning Partners* (Lawrence Erlbaum Associates, 2000).

MICHAEL JENKINS

Michael Jenkins is general manager for collections information planning at the Metropolitan Museum of Art, New York. In this role, he advises the Office of the Director on policy and projects that make information about the museum's encyclopedic collection available through digital networks. Prior to his current position, Michael managed a comprehensive initiative to preserve and protect the Met's archive of digital images through a secure centralized repository for the storage, management and distribution of images. He has spoken and written about topics including digital asset management in the museum space and improving access to collections online. Michael serves on the RLG Programs Collections Sharing Working Group, the Categories for the Descriptions of Works of Art (CDWA) Lite Advisory Board, and is a member of the steering committee of steve, an open source project investigating the usefulness of social tagging in the museum space.

VICTORIA LICHTENDORF

Victoria Lichtendorf is an associate educator at the Museum of Modern Art, New York, overseeing distance-learning programs and the museum's teen website, Red Studio. She develops programs for diverse audiences at the museum, online and via videoconference, and has created teaching materials such as MoMA in a Box, a teaching kit for distance learning. She conceived and oversaw the production of *Seen Art?*, a children's book by Jon Scieszka and Lane Smith (MoMA/Viking Press Books, 2004), and authored educators' guides, *Modern Art and Ideas IV: Suprematism, Contsructivism, De Stijl, and the Bauhaus* and *Picturing People: Photography in MoMA's Collection*. A member of the Technology Practice and Policy Council, an advisory to University of the State of New York Board of Regents, Albany, N.Y., Victoria has presented at conferences including those of the American Association of Museums, National Art Educators Association and the National Educational Computing Conference. Prior to coming to MoMA in 1999, Victoria attended Bowdoin College Museum of Art through a grant from the Andrew W. Mellon Foundation.

MATTHEW MACARTHUR

Matthew MacArthur is director of the new media program at the Smithsonian's National Museum of American History (NMAH), Washington, D.C. At the Smithsonian, he has worked on a variety of initiatives that employ technology to teach history and material culture, including CD-ROMs, websites and handheld applications. A number of these groundbreaking projects, including Revealing Things and HistoryWired, have experimented with innovative interface tech-

niques. During his tenure, NMAH sites have won recognition from such organizations and publications as the American Association of Museums, New York Festivals, *HOW*, *Communication Arts* and *I.D.* magazines. He holds a BA in American studies from the University of Oregon and an MA in history from Claremont Graduate School, where he focused on history and new media.

MICHAEL MOUW

Michael Mouw works as a creative and technical director, collaborating with the Minnesota Historical Society's exhibitions teams to develop multimedia for a statewide network of museums and historic sites. Much of this work is documentary-based, drawn from stories told by diverse communities. These documentaries are often delivered through immersive multimedia experiences, such as the "Flour Tower" elevator ride at the Mill City Museum, and the tornado-themed object theater "Get to the Basement!" at the Minnesota History Center. Michael is a graduate of the affiliated fine arts degree program between Tufts University and the School of the Museum of Fine Arts, Boston.

PETER SAMIS

Peter Samis is associate curator of interpretation at the San Francisco Museum of Modern Art (SFMOMA). Together with his team, he produces innovative content for the museum's galleries, website, podcasts, and Koret Visitor Education Center. He served as art historian/content expert for the first CD-ROM on modern art, and then spearheaded development of multimedia programs for SFMOMA's new building in 1995. Since then, SFMOMA's Interactive Educational Technologies (IET) programs have received numerous awards from sources as diverse as the American Association of Museums, Museums and the Web, the Webbys, the National Educational Media Network, and *I.D.* magazine. Peter serves as adjunct professor in the graduate program for Technology-Enhanced Communication for Cultural Heritage at Switzerland's University of Lugano, and sits on the advisory councils for IMLS-funded open source initiatives Pachyderm 2.0 (www. pachyderm.org) and steve (www.steve.museum). He holds a BA in religion from Columbia College in New York, and an MA in the history of art from the University of California, Berkeley.

SCOTT SAYRE

With more than 15 years experience in guiding museums to select, develop and apply educational and business technologies, Scott Sayre is the co-founder and a principal of Sandbox Studios. In 2005 Sandbox Studios formed Museum 411, a new division focusing on the design, production and hosting of mobile

phone-based museum information systems. From 2002–2003 Scott served as the Art Museum Image Consortium's (AMICO) director of member services and U.S. operations. From 1991–2002 he was the director of media and technology at the Minneapolis Institute of Arts, where he led the museum's Interactive Media Group in the development of ArtsConnectEd.org (1997), the institute's website artsMIA.org (1993) and 16 interactive multimedia programs installed throughout the museum's galleries. Scott has also served as the chair of the American Association of Museums' Media and Technology professional committee. Prior to his work with museums, Scott was an Applications Specialist at the University of Minnesota's Telecommunications Development Center. He has a PhD in education from the University of Minnesota, as well as an MEd in training and a BA in visual communications technology.

DAVID T. SCHALLER

Dave Schaller has been a media developer since first picking up a Super-8 camera in the third grade. Two decades later he founded eduweb, a developer of digital learning games and interactives, where he is responsible for the company's perpetual quest for the sweet spot where learning theory, digital media, and fun meet. As principal of eduweb, he has led the development of award-winning media projects for museums and educational organizations around the country. He is currently working on several 3-D learning games including WolfQuest, funded by the National Science Foundation (NSF). He recently completed an NSF-funded research study examining learning styles and digital interactives. Dave has nearly 20 years of experience in natural history and social science interpretation, working in print, exhibit and digital media. He holds a BA in humanities and an MA in geography and museum studies.

ANGELA SPINAZZE

Angela Spinazze founded ATSPIN consulting in 1997 and has worked with institutions worldwide on integrating technologies into the museum ecology to improve access to collections information for both staff and public audiences. She began her career in the development office at the Art Institute of Chicago, where she joined a multidisciplinary team to inventory and design a database for the museum's collections. Angela managed the conversion of the index card file (representing approximately 150,000 works of art) into electronic form and helped develop the application architecture and user interface. Angela also served as director of marketing for a leading collections management system developer, where she managed all marketing and sales activities worldwide. Angela received a bachelor's degree from Miami University in 1986 and a master's degree in art history, theory

and criticism from the School of the Art Institute of Chicago in 1992.

DANIEL SPOCK

Daniel Spock has spent 24 years in the museum field, starting as a planetarium guide. Over the course of his career he has worked as an exhibition designer and developer, including 13 years at the Boston Children's Museum, before moving into the realm of administration and program leadership at the Minnesota Historical Society, where he is now the director of the History Center Museum. Daniel is an ardent proponent of visitor-centered, experiential interpretive approaches that value visitors as active learners. He has consulted and lectured at a variety of museum and learning institutions. Daniel has a BA in art from Antioch College.

ROBERT STEIN

Robert Stein is the chief information officer and director of museum information systems at the Indianapolis Museum of Art, where he has developed public uses of technology in the museum and online as a way of informing and engaging visitors with art. A long-time proponent of unique interface technology, Robert joined the museum in 2006 after spending several years as the assistant director of the Visualization and Interactive Spaces Lab, one of the Pervasive Technology Labs at Indiana University. His research there involved the integration of scientific visualization practices with novel interface technologies to share information from a variety of domains. Prior to joining Indiana University, Robert served as a senior visualization specialist at the National Center for Supercomputing Applications at the University of Illinois. There, he developed custom visualization software for domain specialists. Currently he serves as technical lead and project manager on the open source project, steve, which supports social tagging for art museums.

LEONARD STEINBACH

Leonard Steinbach is technology strategist for the Walters Art Museum in Baltimore and principal of Cultural Technology Strategies, which provides technology consultation services to a broad range of cultural institutions. Previously he was chief information officer at the Cleveland Museum of Art, where he was responsible for implementing information technology initiatives. These activities garnered two American Association of Museum Media and Technology Committee MUSE Awards for the museum, among other national recognition. He has been president of the Museum Computer Network and chaired its national conference and served on advisory boards for the New Media Consortium's Horizon Report on Technology and Higher Education, Internet2's K20 Initiative, various museums

and other cultural and civic institutions. Leonard was the former chief technology officer for the Solomon R. Guggenheim Museum, New York. He has spent more than 20 years in technology management in higher education, research and the arts and is an outspoken advocate for professional, creative and cost-effective IT management in the museum and cultural communities.

LAWRENCE SWIADER

Lawrence Swiader joined the United States Holocaust Memorial Museum in 1998 and established an award-winning museum website that receives millions of visitors every year from more than 100 countries daily. As chief information officer, he oversees programs ranging from business process and customer relationship management, e-government and collections digitization, to the creation of the museum's websites, televised programs and podcasts. He participates in several CIO councils and speaks regularly at conferences and events with emphasis on the intersection of technology and education. Lawrence has worked on various multimedia projects including kiosks for the Athens Metro and the Foundation of the Hellenic World's websites on Greek history. He graduated from the S. I. Newhouse School of Public Communications at Syracuse University in 1989 with a degree in television, radio and film and in 1993 earned a master's degree in instructional design, development and evaluation from Syracuse University's School of Education.

SELMA THOMAS

Selma Thomas is the founder and president of Watertown Productions, Inc., a media design and production firm based in Washington, D.C. A filmmaker with a background in history, Selma produced several award-winning public television documentaries before beginning her work with museums and libraries. She has designed and produced interpretive media, both site- and Web-based, for cultural institutions throughout the United States. A frequent lecturer and author, Selma is particularly interested in the many ways that media defines and alters the relationship between museums and their multiple audiences. Selma co-edited and contributed to *The Virtual and the Real* (AAM, 1998) and is media editor of *Curator: The Museum Journal*.

GÜNTER WAIBEL

Günter Waibel is a program officer in the programs and research division of the Online Computer Library Center (OCLC). He specializes in standards for representing cultural materials in a networked environment, and serves as a

liaison to the museum and art libraries affiliated with RLG Programs. Prior to this position, he was digital media developer at the University of California Berkeley Art Museum and Pacific Film Archive, where he worked on the Museums and the Online Archive of California project. Günter is a board member of the Museum Computer Network and American Association of Museum's Media and Technology Committee. He has published widely on issues of description and digital preservation, including guest-editing a special issue of *RLG DigiNews*, entitled "Managing Digital Assets in U.S. Museums" (December 2006), and blogging at www.hangingtogether.org. Since 2004, he has been adjunct teaching in the School of Information Studies at Syracuse University, New York.

HOLLY WITCHEY

Holly Witchey is currently director of new media at the Cleveland Museum of Art and immediate past chair of the American Association of Museum's Media and Technology Committee. In addition, she serves as a member of the board of directors of Museum Computer Network, and is an AAM-appointed member to the National Committee for Archives, Libraries, and Museums. Holly has a doctorate in fifteenth-century Italian painting and sculpture and was associate curator of European art at the San Diego Museum of Art, where she developed projects for museums using new technologies. In 2000 she left the curatorial world to start the New Media Department at the Cleveland Museum of Art. Holly writes and speaks about museum ethics, accessibility and issues that arise with the use of new technologies in museum settings.

Index

weblog. *See* blog

websites, 3, 5, 75, 148, 149
 alternatives, 154
 cost, 148
 development survey, 155n6
 motivation, 167
 museums that have, 154n1
 online visits, 150
 survey, 149–150
 teen, developing, 93–94
 visit statistics, 155n7

Web 2.0, 40, 57–63, 119
 applications, 38
 barriers to participation, 60–61
 methods, 159

Weinberger, David, 58

Whitney Museum of American Art, 84

Whyville, 103, 108n30

wikis, 57, 59, 63, 75, 164

Williams, William Carlos, 23–24

Wired Museum, The, 16, 59–60

wireless fidelity (Wi-Fi), 25, 37, 179

WolfQuest, 101, 102

World Wide Web, xi, 35, 45, 79, 134, 179.
 See also Internet

Y

Yahoo, 137, 151, 152